A Year in the A

An Insid...

Matthew Israel

A Year in the Art World

An Insider's View

Matthew Israel

This book is for Ben, Amina, and Samara.
*It would never have happened without all of
your love, support, patience and humour.*

Cover image: Amer Ghazzal/Alamy Stock Photo

First published in the United Kingdom in 2020 in hardback by
Thames & Hudson Ltd, 181A High Holborn, London WC1V 7QX

First published in the United States of America in 2020 in hardcover by
Thames & Hudson Inc., 500 Fifth Avenue, New York, New York 10110

This paperback edition published in 2023

A Year in the Art World © 2020 and 2023 Thames & Hudson Ltd, London

Text © 2020 and 2023 Matthew Israel

British Library Cataloguing-in-Publication Data
A catalogue record for this book is available from the British Library

ISBN 978-0-500-29708-7

Printed and bound in the UK by CPI (UK) Ltd

MIX
Paper | Supporting
responsible forestry
FSC FSC® C171272
www.fsc.org

Be the first to know about our new releases,
exclusive content and author events by visiting
thamesandhudson.com
thamesandhudsonusa.com
thamesandhudson.com.au

Contents

PREFACE

Looking Back at A Year in the Art World

I finished writing *A Year in the Art World* in January 2020, a few months before the beginning of the COVID-19 pandemic. I'm writing this almost exactly three years later, in January 2023. The world – and the art world – have changed so much.

During the pandemic's initial phase, in most countries, the art world was essentially shut down. You couldn't visit museum exhibitions or gallery shows. You couldn't attend art fairs or auctions. You couldn't access any real life art-world activity. Artists couldn't run functional studios because people couldn't work together. And almost all other kinds of art business, many of which had no experience supporting remote work, had to figure out how to run in entirely new ways. This state of affairs lasted for months, if not years, depending on location. So many individuals and organizations in the art world suffered during this time. Much of this suffering happened in private.

The pandemic did have a positive impact on some aspects of the art world. The necessity of online and digital initiatives made them skyrocket in importance. One such example is the widespread adoption of Online Viewing Rooms (OVRs), which offer a way for art consumers to view and buy artworks online. Buying art online was previously possible, but OVRs were adopted by many more organizations – predominantly galleries – needing to connect with their audiences in this new world. NFTs (Non-Fungible Tokens, or unique digital files) also experienced exponential growth in interest and value in the art world. This was due mostly to the lack of ability to engage

with physical artworks, as well as the record-breaking, watershed $69 million sale at Christie's of the artist Beeple's NFT, *Everydays – The First 5000 Days*, in March 2021.

Attention to diversity, equity and inclusion (DEI) in many aspects of the art world has also increased markedly. In the United States, the murder of George Floyd in May 2020 and the Black Lives Matter movement were significant catalysts, reverberating worldwide and prompting museums, among others, to publicly state their commitments to dismantle systemic racism, improve hiring practices, better engage with their communities and exhibit a more diverse array of artists. Recent research, however, has shown that triumphant headlines may have masked less-triumphant progress.

I acknowledged at the end of *A Year in the Art World* that the project would be a time capsule. The situation in 2020 – especially the shutdown of so many aspects of the art world – made me feel that the project was woefully outdated even before publication. I wondered if I had not just been writing about a different art world, but another planet entirely. I had wondered how my snapshot of the art world would look in 'five, ten, twenty or even thirty years'. I knew a lot of change was going to be 'inevitable'. But this felt unprecedented. Beyond the pandemic, in the 2020s we have seen climate activists targeting famous artworks, the rise of VR or the metaverse, and new art and technology projects such as those promoting fractional ownership of art. A host of people discussed in this book have altogether new jobs; in the past few years, I worked at Meta (the parent company of Facebook, Instagram and WhatsApp) with the ambitious goal of defining 'the future of art' at the company.

Yet in recent months I've been shocked to see the art world assume, for better and for worse, some of the shape it was in when I completed this book. The discussions in *A Year in the Art World* – about the past, present and future state of so many aspects of the contemporary art ecosystem – suddenly seem

relevant again, and like they're speaking about an art world that we're experiencing today. Its learnings still feel valuable. So I again feel confident sharing it with you in this new paperback edition.

A Year in the Art World remains what it set out to be: an accessible overview of the contemporary art world. It introduces a diverse array of the people and institutions in the world of contemporary art; the artists, curators, critics, and gallerists discussed in this book remain some of the best-known. It provides valuable insight into the art world for anyone contemplating working in the industry, and it exposes some quite niche art activities, such as fabrication, conservation and storage, for the general reader. It contains unique insights and entertaining stories from various art-world leaders, and shares rarely discussed information about how museum curators and biennial directors are chosen, or how a gallery leader would suggest running a gallery, or how curators interpret their profession and deal with criticism when putting on large-scale shows. It spends time discussing the value of art criticism and how crucial access to information is to the business of art advising.

Reviewing this book in advance of publishing the paperback has also made me think about a lot of new projects – books and otherwise. I would love to re-interview everyone I interviewed for this book, to understand how their lives have changed since I first spoke to them, due to the pandemic and other forces. *A Year in the Art World* did not have a chapter on a collector – though I planned one – and this has made me want to write an entire other book on collectors. I would like to do a project particularly focused on Asia, as the art world expands outside Hong Kong due to its stricter political environment and China's approach to the pandemic. I greatly enjoyed my conversation with writer and curator Jarrett Earnest and would like to dig deeper into the subject of the state of art writing. I'm curious about new online art ventures and would like to survey them to see what new directions the field of art and technology

is taking. I'd like to spend time thinking about the state of museums, and what their future will be. I'd love to explore whether there is an art of the COVID-19 pandemic.

Hopefully, by the time you read this, I'm occupied by one or more of these projects, and I hope one of them will reach you sooner rather than later. Until then, I sincerely hope you enjoy (and benefit from) *A Year in the Art World*.

Please feel free to reach out to me with any feedback about this book or any of my projects through my website, www.matthewisrael.com, or social media.

Introduction

A Year in the Art World is an insider's overview of the contemporary art world – the people and institutions with a connection to the creation, promotion, exhibition and collection of works of contemporary art. It takes the reader on a journey through fifteen chapters and a calendar year, from an artist's studio to an auction house to a storage facility; it features some of the world's best-known artists, curators, critics and gallerists, and takes in the year's most significant art events in cities such as New York, Los Angeles, Paris and Hong Kong.

My aim in this book is to go deep inside what's often regarded as a niche, elitist industry and to present an accessible, engaging and historically informed view of what makes the art world go round – as well as to illustrate what people actually *do* in this world. The book balances overviews of art world professions and institutions with in-depth profiles of individuals, illuminating the details and nuances of their work and exploring what occupies, inspires and frustrates them.

This book is the product of obsession, experience and curiosity. I have been completely enamoured by the contemporary art world since I first came into contact with it as an undergraduate; even now, having spent almost twenty years within it, I'm still interested in figuring out its inner workings. Writing about it is also, most importantly, a way for me to offer something I wish I'd had when I first ventured into this industry. At that point, even though I had grown up creating art and identifying as 'artistic' and 'creative', I was not part of a family or community engaged with art, so I had very little sense of

which institutions were significant, the roles people played within them, or how the institutions and the people related to each other. I also didn't really understand how an artist's career functioned, or many of the variables that might play into them becoming well known – or not.

I've since worked for galleries (like Matthew Marks and Gagosian), as a freelance writer (for magazines such as *Artforum*, *Artnews* and *Art in America*), for collectors, and then as a researcher for museums (such as the New Museum). I spent six years getting a PhD in modern and contemporary art at NYU's Institute of Fine Arts, with the aim of becoming a professor. I also taught art history and contemporary art courses at NYU and at Parsons, managed the estates of two artists (Peter Hujar and Felix Gonzalez-Torres), served on an authentication committee (for the Keith Haring Foundation) – and then entered the world of art online, at Artsy, the contemporary art education and marketplace site. I spent eight and a half years there, and in that time published my previous two books (*Kill for Peace: American Artists Against the Vietnam War* and *The Big Picture: Contemporary Art in 10 Works by 10 Artists*). I hope this book can bring together some of what I've learned in all that time and offer insight to anyone with an interest in working in the art world or simply understanding how it operates.

People do many things in the art world, and while there isn't space here to tell all of their stories, I've tried to tell a lot of them. The book begins in the New York studio of contemporary artist Taryn Simon. It then takes the reader to Los Angeles, Hong Kong, Paris and other art centres, exploring different facets of the art world: art fabrication, galleries, museums, art fairs, artists' estates and foundations, art writing, curating, biennials, art schools, art online, art advising, auctions, conservation – and finally storage, shipping and installation. Some of the people I speak with or discuss, such as Jeff Koons or Klaus Biesenbach, are high-profile figures in the art world and to an extent in the wider culture; others are less well known,

but still play essential parts. Art collectors, whose influence is key to so many elements of how the art world operates, are present throughout the book rather than being covered in a single chapter.

In the process of writing this book I've tried to push back against some of the inequality of the art world by highlighting the work of female-identifying and historically under-represented artists and art world professionals. At the same time, because the book is largely concerned with shedding light on current arenas of art world power and the people who control the majority of art world capital, it inevitably reflects inequalities. These include, but are not limited to, a lack of diversity among artists and art buyers as well as others in powerful professional roles.

It's important to me that the reader understands the current power make-up of the art world, which can be sketched out in a few statistics about the US art industry. A 2016 study found that among the 1,300 artists represented at the forty-five most successful New York City galleries, 80.5 per cent were white (and if just US artists were considered, that figure rose to 88.1 per cent). African Americans made up only 8.8 per cent of artists represented. Consider that, by comparison, whites are 64 per cent of the US population and African Americans are 16 per cent; and note that Latinx only made up 1.2 per cent of represented artists, while being 16 per cent of the national population.[1] A 2019 study of the public online catalogues of eighteen major US museums and ten thousand artist records found that 85 per cent of artists were white, and 87 per cent were men.[2] A recent Mellon Foundation report found that 88 per cent of people hired for executive and conservation roles in museums were white.[3] While there have been changes in the last decade – with top galleries taking on more female and non-white artists, women and minorities being hired at larger percentages in museums and into top art world positions, and art buyers diversifying nationally, ethnically, culturally and

gender-wise – recent data makes it clear that the gains have been limited. There is also a need in the US not only to diversify traditionally white-dominated institutions, but to invest in the leadership and creative output of institutions run by or conceived to primarily serve non-white people. On the whole, such institutions are still significantly underfunded. Every action taken in relation to the art world, from financial contributions to showing an artist to writing an article or a book, is an opportunity to raise awareness and encourage further action.

What do I want readers to take away from this book? First, I hope they'll see that art history is not just the story of artists and movements, but of all the people and institutions that collaborate with and support those artists and their work. This was something that only became clear to me after I started working in the art world myself. It was fascinating to realize just how much a great gallery can influence an artist's career; how a talented studio manager can enable an artist to multiply their productivity exponentially; and how many individual pieces and people can be involved in creating an exhibition.

I'd also like to show readers that within the larger art world are many smaller worlds, each one complex and fascinating in its own specific way. And the stakes are high in these worlds. You may never have heard of some of these professions or communities, but for the people that work in them, their daily goings-on – changes in institutional hierarchies, press attention or lack of it, new developments in the technology they use – can be major issues in their lives, sometimes just as important as national or global events.

Finally, I hope readers will discover that the art world has much more to offer than eccentric celebrities, pretentious ideas and stories of record-breaking auction prices. Stars, shocking superficiality and huge sums of money easily make headlines, but the art world also engages countless people with its unexpected challenges and big, compelling questions. And there are aspects of working within it that resonate widely: for

example, in just the first two chapters this book touches on how new ideas can be generated, how to get satisfaction from one's work, how to start up and scale a business, how to find skilled workers, how to find career paths, how to learn on the job and how to deal with difficult bosses and geniuses.

The story of the art world is an exciting story of creative lives – of the serious, funny, frustrating, dramatic and sad things that can happen to the people in our culture involved in making meaning. These people might spend their days working in highly unusual or unconventional ways; but just like everyone else, they struggle to be happy, find meaning in their lives, create great work, manage criticism, maintain a work–life balance and play well with others.

Part I **Winter**

Chapter 1

A Studio Visit

Artists today can make basically anything. For this reason, many people believe we are living in a pluralist art moment, in which no one form dominates or is considered superior to any other. Today in exhibitions around the globe we find sculpture, photography, painting, works on paper, video, film, new media, multimedia works, installation, conceptual work, performance, sound art, books and a myriad of forms and approaches within these categories, all of which can overlap and combine with each other in the same works.

Artists do many things with their time. They make work in and out of their studios. They work with museums and galleries to plan and install exhibitions. They engage with collectors, curators, gallerists and writers. They lecture about their work and manage the countless affairs of their studios – on their own, or through a studio manager or staff if they're lucky.

Importantly, every artist is different. Some embrace the solitude inherent in certain artistic practices, while others maintain active social calendars either as extensions of or as counterpoints to their studio lives. Some artists are incredibly prolific, creating hundreds of works a year, while others invest their time in a much smaller number of works. Although it's possible to identify a handful of 'types' among pop-culture representations of artists, real-life artists are as diverse a group as people in general.

It's a chilly midwinter day in February 2019, and I'm talking with the artist Taryn Simon in her New York studio.

Some studios today, particularly those of painters, don't look very different from the ones occupied by artists as far back as the Renaissance. While there may be a few items (like laptops) that would obviously not have been employed by da Vinci, the tools of the trade are basically the same, as is the need for light and space. Yet for artists from the 20th century onwards who pursue mediums other than painting, printmaking or sculpture with traditional materials, the typical studio tools are quite different, and they vary widely. If anything can be art, it follows that almost anything might legitimately be in your studio.

Then there are the so-called 'post-studio' artists, a term coined in the 1990s to identify artists who don't particularly need studios for what they do. Artists labelled 'conceptual' originally pursued this type of setup, as they believed that the idea of an artwork was more significant than its actual execution in the form of an object. Today, a wide range of artists work outside the studio environment, especially those who change mediums a lot or who work on ambitious projects involving materials, specialists or facilities far beyond the capacity of a studio.

Even when her work was primarily photography-based, Taryn Simon's workspace has never resembled a traditional photographer's studio – in large part because her work has always been post-studio, produced in locations ranging from crime scenes to customs facilities to the CIA building housing the agency's abstract art collection. Now that her work also includes sculpture, installation and performance, her studio looks even more like an office – or even an airport control room from which she directs multiple projects with wildly diverging requirements.

The studio's principal components are multiple desk setups, scanners and filing cabinets. Its contents still testify, however, to many of the analogue and technical aspects of

Simon's photographic work. Behind me is Simon's Sinar 4 × 5 camera; to my right are backdrops where she stages and shoots images, and there are printed photographs all over the place. Some are new and taped to the wall, I assume up for her review; others are older and framed. Lining the walls of the space is a large collection of books, including various titles that Simon has authored, and which constitute an important part of her production as an artist. In addition to Simon, in the studio are her two assistants, who wear headphones (probably because our talking is distracting) while they work at the computer and scanning stations. Finally, there is a small room at the side of the studio: a 'cold room' housing all of Simon's negatives, in floor-to-ceiling stacks of variously sized archival boxes.[4]

Institutions began exhibiting Simon's work very early on in her practice as an artist, and these exhibitions were met with critical acclaim, marking her as one of the most important artists of her generation. Simon is well-spoken and insightful and works in a staggering range of media, and I hope that our conversation will shed some light on the experience of what it is like to be an artist today. Importantly, because of the wide range of possible ways to practise art, she doesn't speak for all artists, but to her individual approach. She sits across from me at a spare wooden table wearing her signature 'uniform' consisting of utilitarian suspender skirts that she makes herself, and which have been a rare point of constancy throughout twenty years of radical reinvention in her work.

—

Simon was, in many respects, born to be a photographer – particularly one whose work mixed images and text. Though her father worked for the US State Department before she was born, and later invented and manufactured video games, he was also an obsessed photographer. Simon recalls him returning home from work trips to Russia, South-east Asia and the Middle East with images that he would craft into elaborate slideshows. Her

maternal grandfather, who built telescopes, was also a passionate photographer. Unlike her father, however, who was interested in portraiture and the built environment, Simon's grandfather was interested in the details of the natural world – moss, snow, rocks, minerals – which he would photograph and then classify into idiosyncratic categories. Though he never published, Simon's grandfather was also a highly prolific writer, producing over sixty novels in his lifetime. One of the first things I noticed when I walked into Simon's studio was a large black-and-white photograph of a family that loomed over the entire space; Simon pointed out her grandfather among his nine brothers and sisters, pictured as children in Russia.

During her own childhood, inspired by nature photographers in the vein of Eliot Porter, Simon began to make images alongside her father and grandfather. Her interest in photography took a more serious turn during her college years, leading her to supplement her coursework in environmental studies and semiotics at Brown University with photography classes at the nearby Rhode Island School of Design. After Brown, Simon spent several years working for other photographers. Her first major public project, *The Innocents*, documented cases of wrongful convictions throughout the United States, investigating photography's role in mistaken identification and the criminal justice system. In an early article on this body of work published in *The New York Times Magazine*, Simon describes the project:

> In recent years, DNA evidence has exonerated 123
> people in the United States convicted of violent
> crimes, including 12 who had been on death row. In
> most of those cases, as with the men photographed
> on the following pages, the cause of their wrongful
> conviction was mistaken identification by a victim or
> eyewitness.
>
> Standard police procedure encourages witnesses
> to identify suspects through the use of photographs

and lineups. This process relies on the assumption of precise visual memory. But through exposure to composite sketches, mug shots, Polaroids and lineups, eyewitness memory can change; victims may think they recognize a face, but it will not necessarily be the face they saw during the commission of the crime...

I photographed these men – whom I contacted through the Innocence Project, a legal advocacy group – at sites that had particular significance in their wrongful convictions or imprisonment: the scene of the arrest, the scene of the alibi or the scene of the crime. In the history of these legal cases, these locations have been assigned contradictory meanings. The scene of arrest marks the starting point of a reality that is based in fiction. The scene of the crime, for the men in the photographs, is at once arbitrary and crucial: a place that changed their lives forever, but to which they had never been. Photography's ability to blur truth and fiction is one of its most compelling qualities. But its use by the criminal justice system reveals that this ambiguity can have severe, even lethal, consequences.[5]

Simon's compelling images, but just as much her prescient and conceptually nuanced text, evinced a promising artist and deep thinker about photography, image-making and human nature. The project was exhibited at MoMA PS1 in June 2003 and continues to tour internationally.

Since *The Innocents*, Simon has maintained an unrelenting pace, producing rigorously researched projects that combine image and text in radical ways that expose the often-concealed scaffolding of power. Among the standouts for me in her oeuvre is her 2007 project, exhibited the same year at The Whitney Museum of American Art, titled *An American Index of the Hidden and Unfamiliar*. This series comprised

photographs and detailed texts revealing spaces that are unseen yet foundational to American mythology and daily functioning, such as the abstract art collection of the CIA; a cryopreservation unit containing the bodies of the mother and wife of cryonics pioneer Robert Ettinger; a young woman in Fort Lauderdale undergoing hymenoplasty (the repairing of the torn hymen to simulate virginity); and forty-eight hours' worth of agricultural seizures from the US Customs and Border Protection Contraband Room at John F. Kennedy International Airport.

Simon spent the next four years creating what was then considered her most ambitious work to date, *A Living Man Declared Dead and Other Chapters, I–XVIII*, which was exhibited at New York's Museum of Modern Art (MoMA), Tate Modern and Neue Nationalgalerie. (Such exhibition venues would be lifetime goals for any artist; Simon was just thirty-eight at the time.) To produce the project, Simon travelled around the world researching eighteen different bloodlines and their related stories, which were then presented in large-scale gridded panels featuring images and text. On the left of each work (which Simon calls a 'chapter') are one or more large panels that systematically order a number of individuals directly related by blood, including the living ascendants and descendants of a single individual. Each sitter is photographed with a neutral facial expression against an off-white backdrop. The portraits are then followed by a central panel of text presenting a detailed narrative about the people in the bloodline. To the right of each text panel are the images that Simon describes as 'footnotes' to the central narrative. Notably, in the bloodlines there are often empty images. If Simon wasn't able to photograph someone, they were represented by a blank off-white rectangle, as if the sitter wasn't able to be physically present. Simon's wall text for the project notes that the reasons for these absences 'include imprisonment, military service, dengue fever and women not granted permission to

be photographed for religious and social reasons'. Simon has summarized one of her driving interests in the project as the collision of the external forces of territory, power, circumstance or religion with the internal forces of psychological and physical inheritance.

I first met Simon at a walk-through of her exhibition 'Paperwork and the Will of Capital' at Gagosian Gallery in New York in March 2016. The show consisted of luscious, large-scale, wooden-framed photographs of bouquets based on the centrepieces that accompanied landmark but often failed diplomatic accords signed by world leaders whose countries organized the establishment of the International Monetary Fund and the World Bank at the 1944 Bretton Woods conference. Each photograph was seven feet tall and six feet wide (2.1 x 1.8 m) and featured a flower arrangement set in front of a two-colour background. The colours were sourced from the wall and the table of the room in which the original accords were signed. Inset into each of the mahogany frames, which call to mind the bureaucratic furniture of boardrooms and sites of diplomatic exchange, was a description of the accord for which the arrangement was prepared. According to the wall text, 'the recreated centrepieces from these signings, together with their stories, underscore how the stagecraft of political and economic power is created, performed, marketed and maintained'.

During the walk-through, Simon explained she had the idea for this series in 2012 when she discovered a photograph of Adolf Hitler, Benito Mussolini and Neville Chamberlain at the Munich accords, with a bouquet positioned between them. Struck by the presence of flowers in the middle of this moment, she then started to research historical images of accord signings – and to think about the strangeness of flowers always being present. She imagined the bouquets 'listening' to what was going on around them, and considered how their presentation of artificial, castrated nature seemed to fit into a setting where powerful men signed papers that would influence the lives of millions.

During the last few years, Simon has taken an unexpected shift into sculpture, performance and installation works. The first example of this was a performance piece called *An Occupation of Loss*, which was co-commissioned by Artangel and Park Avenue Armory and was staged for the first time in September 2016 in the Park Avenue Armory Drill Hall. A meditation on the intricate systems we use to manage uncertainty and loss, the work consists of professional mourners simultaneously enacting rituals of grief, including 'northern Albanian laments, which seek to excavate "uncried words"; Wayuu laments, which safeguard the soul's passage to the Milky Way; Greek Epirotic laments, which bind the story of a life with its afterlife; and Yezidi laments, which map a topography of displacement and exile'.[6] The laments were enacted inside eleven 48-foot-tall (14.6 m) concrete pipes that looked like above-ground wells or pipe organs, which Simon designed in collaboration with the architect Shohei Shigematsu of the architecture firm OMA. When the performance was undertaken for a second time in 2018, it was performed in a monumental unfinished underground space in Islington, London, selected by Simon for its deeply unusual sonic properties.

In 2018, Simon created two immersive performative works, *A Cold Hole* and *Assembled Audience*, which were installed at the Massachusetts Museum of Contemporary Art. Visitors to *A Cold Hole* entered a vast dark room opposite a bright white aperture framing a frozen body of water with a dark hole at its centre. At unannounced times throughout the day, participants – performers and members of the public – walked across the ice, plunged into the hole and emerged with a gasp that Simon noted 'is heard only in birth, death and sleep arrhythmia'. Following a cold-water plunge of her own, Simon became interested in how the ritual has functioned in a variety of historical contexts as a psychological and spiritual reset, attracting practitioners ranging from the Apache leader Geronimo, who used cold-water plunges to prepare boys for manhood and

battle, to the biologist Charles Darwin, who hoped it would cure his chronic illness, to Russian president Vladimir Putin, who opted to participate in an Eastern Orthodox Epiphany plunge rather than watch Donald Trump's inauguration.

———

I start our conversation by asking Simon if she uses any systems or strategies to come up with her ideas.

'Torturing myself?' she says, laughing. 'I read, I stall a lot, I doubt myself. I usually have things in mind that I want to do, and then it requires research to figure out if it's possible – then it mutates into something else. It's usually quite simple at the start and then unfolds from there. I rarely begin with aesthetics, but I have on occasion.'

'What was an example of a recent project that worked like this?' I ask her.

'In *Paperwork and the Will of Capital*,' she says. 'I wanted to work with herbarium specimens. I had seen a 19th-century book of George Sinclair's preserved grass specimens. The book centred on manufactured competitions between different species of grass, planted side by side; it recorded their mutations and struggles to survive. Darwin cites these experiments in his theories of evolution. There was something I found moving about the preservation of just a blade of grass alone on a page for hundreds of years. That led me to the concrete presses in that work.'

Simon by no means works alone. She has a studio manager and producer; for many of her early projects, her younger sister worked in these roles. She also collaborates with other people who have expertise in areas relevant to specific projects. 'Beyond the constant back and forth in studio, I've collaborated with musicologists, the Department of Homeland Security, botanists, anthropologists, customs officials, linguists – whatever the project requires,' she says. Yet the number of people she involves at the idea stage is very small.

I wonder about Simon's ambitions right now as an artist, as she seems already to have met what many artists would regard as lifetime exhibition goals. She says her goal is 'making the work'. I also wonder how she maintains her pace, the high level of ideas and work that she puts out – and the finish on everything. I wonder how she maintains her stability, and ask whether she has experienced periods of burn-out. She responds, 'Yes, of course. It's not enjoyable – assembling information, fact-checking, writing, editing, petitioning for access. But it's definitely a pattern that I've become accustomed to. It's just what it takes to get the work done. I fool myself and the people I'm working with at the start, imagining this is the one we can accomplish simply. And then it quickly splinters into the opposite.'

I ask Simon if she finds joy in her work. 'Joy?' she asks, a bit incredulously. 'No – I don't. I guess I don't think about the work in those terms.'

Simon spent four years making *A Living Man Declared Dead and Other Chapters*. There's a vastness to the work, both in terms of its thematic content – chance, power, territory, blood – and its geographical reach. She documented feuding families in Brazil, the living dead in India, Bosnian genocide victims, the body double of one of Saddam Hussein's sons. When I ask her if she could imagine making a work like that again, she says she considers the project unrepeatable.

On one hand, the reasons are practical. She explains, 'Technology stood at a particular point between analogue and digital in the making of *A Living Man Declared Dead*. There's an unavoidable pile of labour involved in producing those works, accessing those subjects, travelling to those locations, securing the permissions, moving my equipment. The gear alone – six or seven cases all weighing about seventy pounds (*c.* 31 kg) apiece, and sheet film – can all take a radically different form today with advancements in digital technology. The work was produced on a very tight budget. Time spent

at each location had to be efficiently managed because of a number of limiting factors – access restrictions, van rentals, translators, daylight, security. It was pressured, sleepless, and relentless.' Yet on the other hand, the reasons also seem emotional and spiritual. 'Each project is its own life. And when I look at them, I feel like the person who made that is dead,' she says.

One of the biggest challenges for artists is to work with new mediums. Their new work can feel unsuccessful to them and awkward, alienating or uncharacteristic to their audience, and this can be quite dramatic if an artist has already garnered the (apparent) stability of critical acclaim and institutional embrace for their previous work. Simon, though, doesn't see her performance and installation works as a departure from her earlier projects, citing threads that run throughout her work. Moreover, she says, there is a certain inevitability to her choice of media, with each project being made in the medium demanded by its content.

'*An Occupation of Loss* was shaped by its subject matter,' she says. 'The installation's different forms are guided primarily by sonic properties, but also by the habit of marking invisibility, absence and loss with monument and scale. The laments insisted on being performed. They confront a sonic space beyond language, beyond the physical – through the voice of a bird, a *duduk*, an accordion. The mechanics of this very private space of grief in professional mourning are guided, programmed and performed.'

The same could be said of *A Cold Hole*, which Simon discusses in relation to photography. 'Viewers experience *A Cold Hole* through this exaggerated photographic aperture that captures extremes of human behaviour,' she comments. 'It's almost like a new kind of decisive moment – one decided by the subject, not the image-maker. But it's not just what's framed by the aperture that's on display, it's also the rabid behaviour of the viewer – impatience, entitlement, consumption.'

I ask Simon if anyone had questioned her decision to make work in media other than photography, given the accolades she has received for her photo-based work. But Simon's answer suggests that the risks associated with these new media, especially performance, appealed to her. She says, 'The thing I love but is also impossible about performance is how impractical and impermanent it is. It confronts my biggest fears because it's out of control and disappears. The audience, the performers – everything is in constant flux. *An Occupation of Loss* took me seven years and was performed for two weeks. There's a perversity and masochism to that.'

Simon occasionally speaks publicly about her work. 'I do believe in the importance of articulating intention – I guess it's an extension of the relationship between image and text.' But she is also acutely aware of the risks this entails. 'I think of these works as having a pulse and a heartbeat and living in the times in which they're seen, not just the times in which they were made. That makes speaking about the work complex because everything you say is captured and fixes the work to a definition that may tie its hands. At the same time, discussion around one's work – and the way that discussion morphs over time – is an outgrowth of the work being alive.'

Based on the diversity of Simon's past projects, it's not altogether clear what the next one will entail, especially as Simon avoids speaking about her work until it is fully realized. The response that comes closest to answering my questions about future endeavours comes about almost by chance, when, after commenting that many of her books read like fiction, I ask her if she would ever want to write a novel.

'Yes,' she says, with noticeably little hesitation.

'*Are* you writing a novel?' I ask.

'Yes.'

And that's as far as I get.

One of the subjects I like asking artists about is their influences. Simon tells me it's her least favourite question. I steal

a glance at the shelves of her sizeable library, where art books are greatly outnumbered by books on subjects ranging from criminal justice to nuclear disasters to plant identification.

The last question I ask Simon is: in her ideal scenario for someone seeing her work, what does she hope that people bring to it? 'Time. That people give the work time,' she says. 'That's something the work asks for. It's something that nobody has any more.'

Chapter 2

Fabricators

I'm now in Los Angeles, struggling to find my way around an unfamiliar neighbourhood. It's way too bright and sunny, as I often find LA to be when I first arrive from the East Coast, especially in the winter.

Eventually I see my destination: an unassuming, two-storey grey warehouse building covered with aluminium siding. Inside, I find a large workshop space. There is an area set up to paint sizeable objects (the size of a large van), and a milling station to form and sculpt shapes from a variety of materials. I'm here to speak with Chris Grant, founder of this enterprise, a sculpture fabrication company called Standard Sculpture.

Art fabrication is a blanket term for the various businesses that aid artists in the creation of large-scale or complex sculpture outside of their studios (for example, the creation of Taryn Simon's *An Occupation of Loss* structures). For the general public, which still tends to envision the art-making process as an individual genius labouring away in a studio, the concept of fabrication can be confusing, even frustrating; it could almost be regarded as cheating, since someone else is making the work on the artist's behalf. However, the reality is – and has been since the Renaissance – that successful individual artists routinely employ others to help them produce large-scale works, or art in large quantities. And at the end of the day, this art still is considered to be theirs alone. 'Fabricators' is just a modern term for these extended-studio assistants with specialized skills.

In general, there are currently two types of fabricators. On one hand, there are those who might be referred to as

technicians: people who specialize in a single process, like laser-cutting or metalwork. They might not necessarily know or care much about art, and their businesses often work with a wide range of clients beyond the art world. An artist might go to such a technician for something like bronze casting, mould-making or CNC (computer numerical control) milling, which allows for the robotic carving of organic and synthetic materials. Like any other client placing an order, the artist would typically provide the necessary specifications or model and then get back what they want in due course. There is little discussion or scope for variation in the process.

The other type of fabricators, more often referred to when the word is used in the art world, could be called producers. Rather than simply stamping things out on the basis of plans or models, these workers are artists in their own right. They will typically be provided with rough plans by another artist and then charged with thinking through and executing the project, helping to develop it over a longer period of time than a technician would typically take to produce something. This process makes it possible for the initiating artist to realize a piece they may not have fully worked out in their head. You could say that these fabricators are the art world equivalent of music producers, or editors supporting writers. Importantly, they often do not specialize in one process – the best of them have an encyclopaedic knowledge of what techniques and fabrication methods are available, and a strong sense of how to connect such methods to an artist's project or plan.

Methods of art fabrication have always evolved alongside new technologies, but in the last ten or fifteen years, digital technology has had a particularly dramatic effect. One of the most significant tools now available is 3D printing, which has opened up a new realm of possibilities. It's possible to print in almost any material now, allowing for extraordinary new ways to conceive and execute objects. The cost has come down and the resolution has increased markedly from when this

technology was first introduced; and the turnaround time has also dramatically shortened, to the point that for many types of projects you can email a file to a 3D printing company, and they will ship an object back to you three days later. Fabricators with enough business in the area will buy their own printers to do this work in-house. Another area where digital has made a profound difference is in the increased subtlety of 3D scanning, CAD sculpting and 3–7 axis CNC milling. On the more manual end, sculpting materials and tools as well as mould-making materials and casting resins have steadily improved in quality in the last few decades – but these are more insular improvements, only noticeable to experienced artists and fabricators.

The cost of fabrication varies widely. For an artist who needs a single piece fabricated using readily available, relatively inexpensive means and materials, the cost can be in the hundreds of dollars. At the other extreme, when fabricators are asked to strategize and even to invent new means of production to create objects, the costs can range from around $2,000 to – for some of the biggest artists working today, on the most ambitious projects – upwards of $1 million or more. These big-budget works usually require the involvement of many outside contractors, shippers, installers and others.[7]

Most fabricators find their way to the profession indirectly – there is no professional training specifically for becoming a fabricator. People generally find themselves in the field after pursuing something tangentially related, particularly sculpture; though there are also designers, architects and engineers and, in places like Los Angeles, people who work in special effects for film or TV, who get into fabrication as a way of supporting their own creative work while staying close to it (closer, at any rate, than working as a waiter or at an office desk job). This can then lead them to realize that they have a particular skill in this area. The risk, especially for artists, is that since the money is steady – or at least steadier than being an artist

– their 'day job' will take time away from their art practice. This is a constant struggle for artists who get involved in fabrication without giving up their own studio work.

Standard Sculpture is very much a producer-fabricator, and is one of the most respected fabricating firms on the West Coast. Since opening in 2010, they have worked with many famous contemporary artists, including Jeff Koons, Yayoi Kusama and Sterling Ruby. They have also worked with world-renowned museums and galleries including the Broad, The Whitney Museum of American Art, Centre Georges Pompidou, Gagosian, Maccarone and David Zwirner.

Standard's founding was the indirect result of a massive, unexpected failure – the dissolution of one of the West Coast's largest fabrication firms, Carlson & Company. Founded in 1971, Carlson had been the go-to place for world-famous artists like Isamu Noguchi, Ellsworth Kelly, Robert Rauschenberg, Claes Oldenburg and John McCracken, helping to create their monumental sculptural works. Most notably in recent history, Carlson was responsible for fabricating Jeff Koons' stainless-steel *Balloon Dog* sculptures, one of which set a record for the most expensive work ever sold by a living artist (it was sold for $58 million at Christie's in 2013, and held the record until 2018).

Yet Carlson suddenly closed up shop in April 2010. The exact reasons are the subject of much speculation; the company's founder cited the economy, and the decline of the art market. The closure left a lot of major artworks unfinished, and Carlson's ninety-five employees suddenly had to find new fabrication roles. Standard Sculpture was the result of Chris Grant and some of his colleagues pulling together in the search for work, and some of their first projects were unfinished Carlson jobs.

Like a lot of sculpture fabrication enterprises, Standard has grown progressively and iteratively from basic beginnings. Grant explains, 'When I started out, I had no technology – no

tools really. I had hand tools and wrenches, and screwdrivers, scales, and I could make moulds [and] I had a lot of studio stuff, but I didn't have [any major] equipment [that could] weld really thick metal, for example. So, we were a kind of low technology company,' he says, jokingly. But this aspect became an advantage for them, meaning they had to be 'pliable, depending on what type of project we were dealing with.'

'In one case,' Grant says, 'we were assisting Jeff Koons with a polyethylene project – so we became experts in tooling and forming polyethylene.' As a result of jobs like this, he explains, 'we're constantly trying to find ways to do stuff. Today I have projects in aluminium and stainless steel, and next week it could be anything.'

A major challenge for Grant and others in the fabrication businesses is the difficulty of finding skilled workers. One might assume, given the large numbers of students attending MFA programmes across the country, that there would be plenty of people able to do this type of work – but unfortunately, most MFA institutions do not have the technology or tools needed to train people in the cutting-edge work required at the higher end of the fabrication business, which is increasingly focused on creating three-dimensional objects through novel methods. (It almost seems sometimes that the advancement of the technology method is a primary gauge of value for collectors at the high end, who are used to buying jets and cars, which they evaluate in terms of technology.) And while there are non-artist workers who might know how to accomplish a process or use certain technologies, they tend to be more like the first type of fabricators – technicians with no specific experience of working with an artist throughout the process of making something. Grant explains, 'There certainly is a shortage of people working within our field who you know can accomplish the work and maintain a sensitivity to the artist's intention.'

Fabricators also struggle with the assumption that fabrication is an exact science. Grant says, 'Often we're explaining to

people [that] we'll do whatever you want but...we don't know that this is going to work the way that you think it's going to work. So as long as you understand that that's my position moving forward [we're fine]. [Yet] this line – of trying to meet an artist's intention and trying to provide the best and most efficient means of making something [for the client] – is a difficult line.' And then there is the issue of budget. In short, the bigger the budget, the more room there is for experimentation, and for the fabricator and artist to figure something out over time. 'Five thousand dollars or a hundred thousand dollars is [very] different....Things like bronze cost money. I think what we do really well is interface with the business side of the equation, like [asking] what is the conceptual economy of the artwork that we're making. What can we even do that makes sense?'

People work with Standard, according to Grant, for a few different reasons. They hear about a job done well for another artist and want to work with them. They're also in what Grant calls 'a kind of web of contacts' that make them a go-to, while other artists or galleries might be in another web of contacts that would send them to another place. Grant explains, 'Basically there's a landscape of sorts [for fabrication in LA]. Jack Brogan, for example...was the original fabricator of McCracken's and helped John develop finishing strategies, and he worked with people like Larry Bell. I mean, he's kind of like one of the original guys. And while we're not in competition, he's like in a different web. So, like if you're like, hey, I have this artwork and I'm trying to do this thing and I'm here in proximity to someone in that web, they're going to take you straight to Jack Brogan. So [fabrication] is definitely a kind of word of mouth situation and there are other places in LA [such as] La Paloma and Mark Rossi of Handmade, [as well as] scenic places that are on other people's radars.' All the while, according to Grant, there are increasing numbers of people who are not in any web of contacts, but who find Standard online. These seem

generally not to be the type of longer-term clients Grant would want; they are often younger people working in galleries who are trying to help younger artists, trying to get things done in a rush. 'They look up sculpture fabrication [thinking], "Can we get this done in LA?" [And then] "Oh, who is in LA who could make this thing for the Frieze Art Fair [the major international organization that holds fairs in London, New York and Los Angeles]? We got like a month."'

In the Standard studio, I see works by a number of artists I recognize – but I can't mention them here. This is typical of most high-end fabrication studios: while they have work on their premises, they are unable to discuss it or share any details. For one, Grant explains, 'If I was talking about any specific person's artwork and described the complexity [of making it in any way], this might have an impact on the retail level.' He says in particular that if they discussed any challenges they had with a work, he could see marketplace forces potentially misconstruing them as a 'mistake' in the piece that could devalue it.

Grant sees Carlson's collapse not as an anomaly, but as something likely to happen often in the fabrication industry. As a consequence, he doesn't recommend fabrication as a promising business to pursue. 'It's a horrible way to make money,' he says. 'It costs a lot of money to make things, and people don't like to spend a lot of money.' He also observes that making a connection with artists, to the extent that they trust you to do this type of work, can be extremely difficult.

—

I'm now in a similarly industrial neighbourhood – this time back on the other side of the country, in Long Island City, Queens – to speak with another well-regarded fabricator of the moment, Ted Lawson, owner of the fabrication company Prototype. Ted looks to be in his late forties, but has a young face. He has short dark hair and dark-rimmed glasses and, like Grant, he is a man – and being a man is typical of most people I meet in the world

of art fabrication. Ted leads me into the premises as his small dog, Harli, jumps up and nips at my legs to greet me. I get a quick glimpse of a workplace upstairs, and then we head down to a large basement space and settle on a couch to speak.

Prototype is a respected studio with a similar feel to Standard, but it has been around a bit longer. Since the late 1990s, Lawson has worked with artists like Koons as well as Mariko Mori, Tony Matelli, Daniel Arsham, Yoko Ono, Aaron Young and Ghada Amer. Lawson sees himself firmly in the second camp of fabricators, as a producer. He says one way you might look at it is to compare his function to that of Dr Dre, the billionaire hip-hop producer, rapper and founder of Beats. Lawson explains, 'I think of [fabrication] like…Dre produces other musicians' work. He has his own long career as an artist in his own right. He's very good at the craft. He's very good at the business. He's very good at doing a little bit of everything. But he…is like "this artist is super-talented, and I can take their brand, their music, their vision and enhance it". A really good producer has to get in the head of the artist, has to have an encyclopaedic knowledge of everything, a little bit of every-thing – they have to be able to problem-solve any problem. It's a very intimate, intense, sometimes difficult relationship between a fabricator and a client. So [the term] fabricator prob-ably should be changed to another name. Right now, fabricator sort of implies anything. It's sort of like [saying] the word *art*. It spans the whole spectrum.'

Lawson has clearly spent time thinking about what it means to be a fabricator not just from a business perspective, but from an intellectual perspective. As he describes it, he believes the main variables a fabricator contends with are 1) the concept, or the idea behind the work; 2) the process to make the work; and then 3) the materials. 'If the artist brings me two of those three [variables], I can work out the third one with them. If they give me three of the three, that's rare, because most people coming to [a] fabricator don't.' He also says if they

only bring him one of three, he's not going to work with them. It isn't his function to have such a large role in the work; if he were to take on such a case, the artist really wouldn't be creating the piece on their own. He has often encountered this issue working with younger artists.

For a while, he used to work with artists who had just received their MFAs and whose work was getting 'hot'; he did this as a way of staying plugged in to younger artists, and as a kind of 'giving back to the community thing. But I stopped that, because [young artists] can be really hard to work with. They don't fully understand the responsibility of hiring a fabricator. They want to treat it like buying something at the store. But they don't realize that it's [their] fucking work. Like, I would fabricate [it] but you have to make choices, and the choices end the second you take the work out of my studio. You made this thing; the fabricator is helping you. It's a two-way street. Ultimately that's the critical moment, that's the test. A great artist knows that. They wouldn't give up that power by ceding that responsibility.' At the end of the day, Lawson says, 'The artist is responsible for the work and the fabricator is not. That's the distinction that everyone always asks about. The artist puts their name on it, and it represents them. [In this way] art doesn't really exist as an object, it exists as an object in relation to the artist as a persona, person, reality, fantasy, whatever it is.'

Lawson says that the type of fabrication he does is typically sought out in one of two scenarios. The first involves working with mostly conceptual artists, who have an idea for a work and a gallery financially backing them, but who do not have the facilities to make the work – or simply don't know how to make it. The other scenario is when a painter is having a 'moment', and reaches a point in their career where they want to try making sculpture, in order to be seen as something more than a painter. Even with a gallery financially backing this endeavour, they need someone like Prototype to help them understand how to make something, and then eventually get it made.

Lawson was originally drawn to be a fabricator because, after going to art school, he had the idea that he needed to master the process of making things. At present, he says, 'there's no system for being Michelangelo [or someone who has the ability to be a great craftsman in a number of ways]'. So he decided to set this up for himself. '[By being a fabricator] I can be with all these different artists, deal with all of these different technologies, solve a thousand different problems. And each time [I] do it, [I] get that little extra little thing, that little [extra] idea. Maybe to do this we need to do some crazy 3D printed thing [for example]. And I maybe don't know anything specifically about that yet, but we're going to investigate it to solve it.' Like Grant, Lawson believes the most important skill for a fabricator is a talent for – and interest in – solving problems. 'The skills really aren't ever the skills. When I hire people to come work for Prototype, the first thing I tell them is you're going to learn a million new skills, but you're never going to be able to lean on a skill,' he says.

Like Grant, Lawson also has real challenges finding good people to work with. 'As more artists need fabricators,' he explains, 'the act of making things has lost inherent value – it's not somebody's skill that makes them an important artist. So, the situation is: less and less people are actually learning how to make things, there's less and less apprenticeship out there – the importance of the making – or the craft – has plummeted. But then people need more fabricators, so it's weirdly creating its own kind of like vacuum.'

Like Grant, Lawson cut his teeth making Jeff Koons' sculptures. In his case, however, this work took place not in a fabrication studio but in Koons' own studio, one of the largest studio employers in the art world. (Around 2015, in the lead up to one of Koons' exhibitions, it was employing around 100 people, but it has downsized since.[8]) It was there, Lawson explains, that he came to understand what the highest level of sculpture fabrication involved – and he has measured all of his

projects since against that experience. Koons, who has been called the Warhol of his time, is probably best known for his meticulous monumentalization of 'low-end' objects or trinkets of American life that one might find at a cheap store or a yard sale[9] – works like the highly polished *Balloon Dog* sculptures, or *Puppy*, a forty-foot-high (12.1 m) West Highland terrier covered in living, multicoloured flowers. His work is some of the most expensive contemporary artwork of the present moment.

Lawson says he started off in Koons' studio 'very young, very ambitious'. Right away, he had the opportunity to work on big projects – but he also infuriated people in the studio. The atmosphere was 'cushy' and very deferential to Jeff, but 'nothing was getting made'. For example, he recalls, 'There was a breakfast. [Jeff] was paying for breakfast. So, people would sit at breakfast for an hour. And [Jeff] had a woman who would cook the breakfast. And I was an asshole. I made a mistake. I walked in and I was like, "No, I came here to work, I want to sculpt." So I started working during the breakfast, and people would be sitting at the table and be like "Ted, sit down and eat the fucking breakfast." And of course, I ruined it. I ruined the breakfast.'

After this, Lawson kept up his provocative pace at the studio, inspired by what he says was an 'incredible budget' and the studio's interest in 'taking insane risks' – even though he says Koons was 'impossible to please'. He shares an example of what everyone thought was a 'hilarious joke in the studio back then': that Koons' iconic *Celebration* series wasn't going to be finished until 2000 because of Koons' perfectionism. 'They didn't get finished until 2006,' he says. He also tells me the story of a model for a large-scale bowl he worked on for Koons that became a kind of never-ending project and testament to Koons' processes. 'The bowl – I turned the interior in clay and then turned the exterior in plaster, popped it off, flipped it over, and there was this rim. And Jeff kept changing the rim. He wanted it curved. He wanted it square. And it's a big-ass bowl. It's twelve feet in diameter, and Jeff took the calipers out. And

if anything was off by like a millimetre on that rim, he would be like "Oh well, this looks like it's a millimetre"....And a millimetre is really small at that scale. It's not in the visible spectrum, but that's where Jeff wants to be. So, then I would do more work and then it would get to a point where I would be like, OK, the measurement is correct. You can't see it but Jeff would sort of touch it and then say, "Yeah, but can you feel that?" And then we would go back to it and get that *feeling* out, so there would be no *feeling* of it. So then we would be at a point where you can't see it, you can't feel it, you can't measure it, and Jeff would still be like, "I don't know." And you'd be like, what are we going on here? And then you'd realize, this is not about even perfection any more. This is a kind of a *thing*. Who knows what it's about for Jeff? Maybe it's sadism or holding the market back... or perfection. I don't know, something. And nobody tops Jeff, because he went past the point on the spectrum where you are like, well, he's going to *have* to finish it.'

Despite the challenges of working for someone like Koons, Lawson considers him a 'genius' and believes he set an incredible example. He mentions some of the other great artists who came out of Koons' studio while he was working there, such as Sarah Morris and Tony Matelli. Koons was fun to be with at times, too, especially when he allowed them a glimpse of the person behind his public character. 'He's funny,' Lawson explains. 'Funnier than people realize. He's got a dark, funny sense of humour. It's super dark. In the studio, he doesn't drop the affect. But he drops it. I haven't really hung with him in many, many years, but occasionally we would all go out drinking. I don't know if he drinks any more, but the crew would go out drinking, and then you'd get a different Jeff. You'd get a darkly funny, more real Jeff who would be admitting things that the character Jeff doesn't admit. I think of him as a kind of early mentor – a somewhat psychotic mentor. I still totally respect his game. Though I would never want to make art the way he does for myself, I love his work.'

Chapter 3

A Gallery Director

According to a recent estimate, there are more than 17,000 galleries dealing in contemporary art worldwide.[10] Galleries are often confused with museums (both physical spaces in which it's possible to see art), but they do have a distinct purpose, and they are one of the most important parts of the contemporary art world.

Most galleries store, show and sell the work of artists in group and one-person exhibitions. They write press releases to describe these shows, and they organize opening events to celebrate them. A relatively small group of galleries are able to do more than this: they can cultivate long-term relationships with collectors and return buyers, create a 'roster' of artists they represent, and market these artists, creating a kind of image and brand for them.

Such marketing can vary widely. Smaller galleries typically focus on creating a press release and rough angle for a show, while larger galleries are able to hire communications teams (or even sustain them in-house) to pitch shows to members of the press and create a strong presence on social media outlets. Marketing also includes events. At the lower end, these consist of the openings, perhaps with drinks provided; at the higher end, they can extend to lavish parties and exclusive dinners. Marketing is furthermore creating publications, from small brochures to beautifully illustrated and edited books and catalogues, similar to those a museum might produce.

Galleries are sometimes established by artists who have a talent for organization and take an interest in getting shows

together on behalf of their artist friends. Then there are the non-artists interested in supporting and exhibiting artists for a range of reasons, such as the cultural, social or monetary benefits. The start-up costs for a gallery are high, and people who open galleries tend to be wealthy or to come from upper-middle-class backgrounds. Those from poorer or less privileged backgrounds are less likely to have been exposed to art as a routine part of growing up, or to have had the opportunity to attend art school, so they generally would not even consider opening a gallery. Some of the best gallery owners start relatively young and immediately show a knack for what they do; Larry Gagosian, for example, got into art dealing soon after graduating from college by selling posters in a parking lot in Los Angeles. His realization that he could increase his profits by framing the posters was the beginning of a gradual progression to selling more and more valuable aesthetic objects.

Galleries' two major focuses are their artists and the people who buy their work. Galleries find artists in different ways. Smaller galleries in smaller cities are usually based on social networks; they often accept artists as walk-in visitors who show them their work, or they review email submissions from artists proposing that they exhibit them. As galleries get larger, the process becomes less about the social network or walk-ins or email submissions and starts to consist of galleries doing research on up-and-coming artists, identifying who they want to represent.

Although galleries will rarely divulge how they pick artists, they often look at MFA programmes, speak with curators, read magazines, browse social media and even keep an eye on smaller galleries in order to 'poach' their artists. Some of the primary factors they consider are the past sales of an artist's work; the level of collector interest, and who those collectors are; the cultural relevance of the work; the artist's personal charisma and 'star quality'; and critical acclaim. As galleries become more prestigious, there is less of the looking for

unrepresented artists and more of the poaching. Competition is fierce for artists whose work can command million-dollar prices and attract top-level collectors. And in the booming market that is contemporary art today, artists sometimes change dealers in order to maximize their income.

Repeat art buyers are often called collectors – although some art buyers eschew this label because it doesn't strike them as complimentary. Most collectors are private and wealthy individuals who make their money in business – the majority tend to be in finance – but they can also be museums, or corporations purchasing works for their collections.[11] Evan Beard, the National Art Services Executive at US Trust, divides collectors into a system of four categories. First, there are the 'connoisseurs', whose barrier to entry is time and knowledge and whose motivation is intellectual discovery; then there are the 'aesthetes', whose barrier to entry is taste and whose motivation is visual pleasure. Next there is the 'enterprising collector', where the barrier to entry is access and the motivation is 'defining or redefining the canon' – and then finally there is the 'trophy hunter' category, where the barrier to entry is wealth and the motivation is legacy and power. While all of these types can overlap in some ways, they show the range of connection to the academic and financial aspects of collecting. To illustrate this, Beard further organizes the four types into a four-quadrant chart, with connoisseurs and collectors on the top and aesthetes and trophy hunters on the bottom (and arrows going up the left-hand side for 'academically driven', and across the bottom and to the right for 'financially driven').[12] The biggest international collectors, many of whom can be seen in an annual list by *Artnews*, aptly called the 'Top 200 Collectors', come from all over the world, but most are from North America, Europe and Asia. The 2017 list included 113 collectors from North America, fifty-four from Europe, twenty-four from Asia, seven from South America and one each from Australia and Africa. A few collectors maintain a

public profile – one being the billionaire Japanese entrepreneur Yusaku Maezawa, who has done things like announce via Instagram that he was the winning bidder for a $110.5 million Basquiat painting at auction, which was the highest price ever paid for a post-1980 artwork or artwork by an American artist. Yet the majority of collectors, while their business interests might be well known, keep a low profile and do not publicize their art activities.

The more seasoned galleries keep detailed databases of the collectors (or clients) they have met and sold to, and do significant research and reconnaissance on those people they would like to sell to. They are secretive and discreet with regard to their relationships and, like most businesses in relation to their coveted clients, are always looking for new ways to persuade their customers to buy. The tried and true methods of getting collectors to buy art are individualized service, proven and time-sensitive investment opportunities, education about the topic, socializing and exclusive events, and opportunities to meet the artist. While galleries don't share their client lists or their sales numbers publicly, there are often situations where one or two collectors' purchases will sustain a gallery (and there are often star artists who become the focus of these collectors' consistent consumption). Galleries also create waiting lists for their artists' works; sometimes this is because there is high demand and low output, but at other times galleries might do this as a way of helping to sustain an artist's career for the long term. Just as with any other product, flooding the market and creating a market disequilibrium makes the value of the work drop.

Galleries make most of their money by selling art. There is usually a 60/40 split between what the gallery makes and what the artist makes, with 60 per cent of the sale going to the artist and 40 per cent to the gallery – or it can be just 50/50. As artists get more successful, they can command a more advantageous split, and other costs can take away from the gallery

profit depending on how they work. For example, galleries can take on significant costs to support the fabrication of works; it is also now a kind of standard practice that many galleries offer a 10 per cent discount on any purchase, and repeat clients can command even bigger discounts. The best-known contemporary art galleries are those that sell primary market works – works that come straight from the artist to the gallery and are then sold. These works don't necessarily have to be new, but 'primary' means that it's the first time they have been available to buy. However, there is also the secondary market: primary market artworks that have previously been sold to someone (or some entity) but are then put up for sale again. Secondary market works are either bought by the gallery and then resold, or placed on consignment, where the owner and the gallery agree to a certain split depending on the sales price. With few exceptions – and even though artists have historically tried to advocate to be cut into the deal – artists do not receive any money from secondary market sales.

There are also dealers who operate without galleries. Unlike gallerists, these dealers don't represent artists, and they don't usually have a network of collectors. Their focus is trading – they are purely interested in transactions. At the extreme end of this are dealers who are known as 'runners' or 'flippers' because they try to work fast, to make a profit from brokering a sale. With the growth of the art market, these runners – who focus on making deals between collectors and other private dealers as well as galleries and auction houses – have become more prevalent. But they are not well respected; it's thought they don't care much about the art, and are trading it the same way they might trade any other commodity.

Almost all galleries now have websites listing the artists they show, who they represent, and what works their artists have made. These sites vary widely in terms of how transactional they are. Most galleries prefer a site that serves as a mirror of the real-world gallery experience: a beautiful space

all about the art, with no shopping cart or checkout area. But some galleries are beginning to entertain more ways of selling their works online. One approach is to join an aggregator site like Artsy, a marketplace platform that was created to encourage enquiries into artworks and transactions. Galleries have enjoyed increasing success through such online platforms, which generate around 9 per cent of global art sales.[13]

Adam Sheffer is speaking to me in what he says is a quiet room, where he can focus. He tells me, 'It's a small room with a desk and chair in it, and I am sitting across from a large Mark Rothko painting.'[14]

Sheffer is arguably one of the world's foremost authorities on the subject of art galleries. For many years he served as president of the Art Dealers Association of America (ADAA), a professional organization that seeks to promote the highest ethical standards in the profession and counts among its members many of the country's most influential galleries. He was also a long-time director and then partner at the influential Cheim & Read Gallery; and recently he became vice president at Pace, one of the most important and powerful galleries in the world. Pace represents artists considered modern masters, such as Richard Avedon, Alexander Calder, David Hockney, Robert Irwin, Agnes Martin, Robert Rauschenberg – and Rothko.

The question most often asked about galleries from any businessperson is whether they are a good way to make money. Sheffer is on the fence about this one. 'You know, Jonathan Swift once said that a man should have money on his mind but not in his heart. And I think that anyone who approaches the art business from a purely financial point of view is misguided. So much of what you achieve in this business, financially, comes from a natural desire to deal with works of art and with artists. You need to be able to have a certain degree of sensitivity. If

you don't, then you shouldn't be in this business. It requires a lot more than salesmanship.

'So, it's quite a complicated subject to address. There are easier ways of making money. Art dealing tends to be something that people come to out of a kind of passion, which is why it has become a second career for so many people who, say, have left Wall Street for example, to become art dealers. Like Robert Mnuchin [a former Goldman Sachs executive], for example. People who leave other successful fields do so to make a life in art. It's often a business by default. I don't think that starting with the idea of making money in art is realistic, because the business is so nuanced. You can't apply macro- or micro-economic principles to it that you would learn in school. That's part of what is so unusual, and beautiful, about the art business.'

Sheffer also emphasizes the complexity of doing business as a gallery in an increasingly crowded market. He believes the most important factor in a gallery becoming successful is a distinct point of view. He explains, '[Galleries need to] have a clear sense of who they are. They need to have a real vision for their business; a real concept of the kind of things that they will do, and those they will not do. They need to have a sense of how their programme works, so you see similar themes or concerns among the works shown, so they integrate better and enhance one another. What I think is interesting about many of the best galleries out there, a place like Pace for instance, is that they're created by people who are inherently creative, and who then by some unusual life change end up in the business of art. And they can affect their business with that natural sense of creativity. Former artists, for example, often make the best art dealers, like Arne Glimcher [the founder of Pace].' Sheffer also stresses the importance of customer service and creating a special environment, which is just as or more important than the eventual commercial activity. He explains, 'As Marc Glimcher [Arne's son, and the president of the gallery] would say: we are in the

experience business, but one with a very expensive gift shop. Everything that you do at Pace is consistently of the highest quality, in that a client should have the same level of experience throughout the gallery, from the front desk, to a shipper, to a dealer, to the accounting department – across the board.'

Marketing is also key, according to Sheffer. It's not just about putting on a show and seeing what happens. 'Hope is not a strategy, put it that way.' Sheffer works closely with his marketing team, his photography department, the person writing the press release or the catalogue to tell a story about the work. 'Why are we showing it? What does it mean? How does it affect the world? How is this different than things that we've seen before? There's got to be a *message* associated with it. Otherwise you haven't quite packaged it properly,' he says. 'You know, it would be like if somebody ordered a steak and it was brought to them on a paper plate. You've got to put it on nice china with silverware, a linen napkin, and present it with some garnish and finesse. Artists are talented, remarkable people and they're sharing this tremendous gift. It's up to us to package that gift in a beautiful way, with a ribbon.'

Like many industries of today, the gallery business, in Sheffer's mind, has been somewhat negatively affected by the increasing speed of life. 'We live in an era where everything happens faster. It used to be that we lived in a world where you had *the* phone and the phone was in your home and you had an answering machine, and if you weren't there, people would leave a message, and you would return the call when you were home or even the next day. Now we are bombarded by non-stop information – and the demand to respond quickly. We are now accustomed to going to an art fair where one is expected, in the first fifteen minutes, to buy a work of art for a million dollars that they've literally never seen before. Think about our commercial lives these days – it's a point and click world.' Sheffer sees people who are buying art today not often devoting the actual time and energy they would have put into it in the past.

'We make decisions much faster. I remember when I started in the early nineties at a gallery on West Broadway, people would come into the gallery and they'd see a show. Then they'd come back for a second look during the week. Then maybe later, or even the following weekend, they'd come in again and stay for hours. We'd order lunch in for them. It was much more of a conversation, and the perception of a work of art, that took place over some time before you actually acquired it. Now it's something else. Much of this new generation of collectors is living in a different world, and they're acquiring things differently,' he says.

Sheffer tries, in his work, to buck the speed trend. As such, for him, selling art 'is not just about salesmanship'. 'It's about being articulate enough to have a meaningful conversation and begin a long-term understanding about how to look at art. Great works of art often have stories that must be told about them, and telling these stories allows people to appreciate them on a deeper level. It's our responsibility to do just that. It's a very complex thing. People don't realize that it actually takes time, not just money, to develop a collection.'

Due to this, Sheffer spends most of his days doing something most people do less and less of: just speaking with people on the phone, not corresponding with them via email, to maintain relationships. 'The entire business is based on relationships,' he explains. 'Anybody who buys a work of art can call themselves a collector, [and] that's a collector with a small "c". A collector with a capital "C" is somebody who really makes a life in art, and understands how they fit into the cultural ecosystem. Others will just never get it.'

Even though Sheffer sees the dangers of art fairs, which catapult people into quick decision-making, he understands their necessity to the current art ecosystem. 'They're actually a very important part of how we do business. They're a great way to meet new collectors, or to promote your artists' work. It's also

a very good opportunity to have yet another stage to present the good work your gallery does. The problem is that there are so many [fairs] now that they frankly become exhausting, and it's very hard and very taxing on a staff to do an exhibition programme and represent artists, and look after the interests of a collector base, and travel with artists to museum exhibitions [often two to three times a month] – and do everything at the highest quality. It takes a lot of energy, and a lot of money, and a lot of time.' This presents a dilemma for gallery staff, who have to make decisions about which fairs to put their energies towards. Sheffer says that these decisions should come 'back to the core values of the gallery – knowing who you are. You've got to decide what works for you and what does not. And you've got to make some pretty audacious decisions, [to say] "look, if this fair has not worked for us for many years – it doesn't matter if everybody else is doing it – according to our business model it's redundant." Then so be it.'

Relationships between auction houses and galleries can also be complicated. While auction houses can benefit artists by pushing up the prices of works on the primary market, galleries don't directly profit from this, and an artist makes nothing from an auction sale. Auction houses can also create inflated pricing – and driving up a young artist's pricing too quickly can lead to a sense that their success is a bubble or a flash in the pan, which doesn't work in their interest over the long term.

Sheffer sees his relationship with auction houses as being both adversarial and cooperative. For example, he says, 'it's great when a work by an immigrant, with overtly gay subject matter, sells for more at auction than a machismo, American artist' – here he is referring to the recent sale of a painting by David Hockney (who the gallery represents) for $90.3 million dollars, making him the most expensive living artist. The previous top-valued living artist had been Jeff Koons, Sheffer's 'machismo American', who has since regained his title. 'At the

same time,' Sheffer explains, 'it's a pity that there are many absolutely brilliant, innovative artists with tremendous histories who never sell well at auction because the auction houses just don't know how to promote the work. [For example,] Lucas Samaras is one of the most innovative artists of the 20th century.' (Samaras is another artist that Pace represents.) 'He doesn't have a great auction record, and it's a shame because he is every bit as important as many other artists working today. I believe that if the auction houses took the time to understand the work better – these so-called specialists – and they made an effort to present the work in a proper art-historical context, I think the results would be much better. But then again, you know, it's a revolving door of sales at auction and they probably don't have the time to actually invest in that. You know, they pack these catalogues with all kinds of so-called scholarship and it just doesn't seem authentic. It can't replace real knowledge, or first-hand experience with an artist.'

——

Pace is just one gallery, and it's a very prestigious example – not at all representative of the business as a whole. Apart from a small, elite group of comparable galleries, and a slightly lower level of so-called 'mid-size' ones that do well, most of the gallery ecosystem consists of small galleries that make minimal revenues and are only just getting by.

The writer Magnus Resch, in his book *Management of Art Galleries*, recently found that in the largest art markets – the US, UK and Germany – 55 per cent of all galleries produce revenues of $200,000 or lower, inclusive of the (generally) 50 to 60 per cent artist share. Only 16 per cent achieve revenue over $1 million, and only 7 per cent make over $5 million.[15] Resch also found that only 25 per cent of galleries employ more than four people.[16] This state of affairs is not well known because the top galleries get most of the media attention, and galleries

generally make it a point to hide the state of their business. Resch explains:

> A carefully constructed aura of success is almost certainly one of the factors obscuring gallery finances. Galleries have for decades created the impression of being high-class, elite businesses generating a decent income. Who would want to buy art from an almost bankrupt business that can't pay the caterer's invoice from last week's opening? Or from an owner whose artist is threatening him with a lawsuit because the gallerist has defaulted on the artist's share of sales from the last year? Or from someone who has employed five people for over two years, but pays them on an intern's salary?[17]

Why are most galleries doing so poorly? There are many reasons. Rent is high, and so are the costs of putting on shows. There is more and more competition from international galleries. Art fairs are increasingly the major place to sell art, but the fees you need to pay for a booth, not to mention all the overheads – the shipping costs, the management of work and personnel while there – can be exorbitant. And bigger galleries (like Pace) routinely poach smaller galleries' artists once they become successful; so often, when an artist reaches a point where they are making money and can help support a gallery, they simply move on to take advantage of the opportunities a larger operation can provide. Furthermore, auction houses are now doing what galleries do: getting involved in private sales, which cut into galleries' profits. There's also the fact – and Resch, for one, considers this one of the most significant reasons for galleries' lack of success – that galleries are not usually run by people with experience in business and management. While the people in charge might have strong instincts for choosing artists and putting on shows, they don't

necessarily have the ability to balance their aesthetic skills with the focus on profit-making that's needed to help a gallery survive. The attitude towards making money in the gallery business has often been couched in fears of 'selling out' or losing street cred – and this doesn't bode well for much of the market.[18]

Part II **Spring**

Museum Directors

Directing a major contemporary art museum is a difficult job. So many variables can dictate your success or failure.

To begin with, whoever is on your board can cause your institution to sink or swim. They can bring in incredible works to your museum (if you are a collecting museum, and some museums are not) – or their acerbic personalities or controversial business dealings can bring major controversy to everything you do. Your exhibitions can be wonderful and art-historically relevant but not catchy enough to attract the public, leading to poor attendance. Everything you try can be doomed by issues with your facilities, such as a building that is falling apart or a location that's hard to get to. You can have a great vision that happens not to align with the vision of a chief curator who might have preceded you – or even one who you hired – and this can derail the path of creating exhibitions, or just make the process torturous. You can focus on trying to reach a wide audience by eschewing avant-garde artists for those with a broader appeal, but then lose credibility and support from critically important, wealthy donors who are uncomfortable with your approach.

And there are so many other critical considerations that can define your institution and result in success or failure. Do you publish catalogues around your shows? If yes, what kind, and how do you pay for them? Do you have a website and active social media? How much do you invest in new technology? If you have a collection, how are you conserving objects, and how much do you invest in upkeep? Are you truly accessible

for all types of visitors – and if not, what are you doing about it? If you're a historical institution, are you making efforts to understand whether any works in your collection came to you through less than ethical processes? And for new historical works, how much due diligence are you willing to do to research their origins? As a non-profit, how do you approach the management of the museum, especially in the face of a board that is generally connected to (and has allegiances to and confidence in) the management practices of the business world? Furthermore, how much is your institution committed to diversity in its hiring and exhibitions; how are you marketing what you do (digitally as well as in print); and how are you planning for the museum's future and expansion? Finally, have you created a succession plan, imagining what the institution will be like when you are no longer running it – and how much thought and energy do you put into thinking about what it might be like one hundred years from now, or into responding to changes in politics, taste, technology and the climate?

–––––

One museum that has struggled with directorship in recent years because of more than a few of the variables mentioned previously is the Museum of Contemporary Art in Los Angeles, known to most of the art world as MOCA.

MOCA is relatively young in the world of museums. It opened its first exhibition space in 1983, experienced a quick ascent into influence and spent much of the 1980s and 1990s as a critically acclaimed player in the Los Angeles art scene, while also affecting how contemporary art was being shown and understood globally. It was praised both for its permanent collection of post-war art and for its groundbreaking, serious and ambitious thematic exhibitions, which questioned historical assumptions about major art movements like minimalism, exposed the darker sides of American culture and devoted significant space to genres like performance and feminist art

decades before they were embraced by other major art institutions. MOCA also hosted the first museum retrospectives for now well-known artists such as John Baldessari (1990), Jeff Wall (1997), Barbara Kruger (1999) and Takashi Murakami (2007). Because many of these exhibitions travelled across the US and the world, MOCA was praised as 'one of the greatest feeder museums in the country'.[19]

MOCA's success and critical acclaim came to a halt in 2008 when it almost collapsed financially. It was revealed that the museum's finances had been mismanaged, and that this mismanagement had been exacerbated further by the 2008 financial crisis. MOCA had operated at a deficit in six of the previous eight years, and its endowment had shrunk from $42.7 million (in 1999) to $6 million. On the basis of all of this, the museum was being investigated by the California attorney general to see if it had broken the law regarding how non-profits use their funds, primarily by spending money from its endowment.[20]

MOCA was eventually bailed out by means of a $30 million plan negotiated with the LA art patron and collector Eli Broad (which involved him matching an initial $15 million from trustees), as well as by a series of austerity measures managed by a former University of California chancellor and a fundraising campaign.[21] MOCA's leadership took a lot of the blame for its financial issues and as part of the overhaul, MOCA's director Jeremy Strick resigned.[22]

The museum tried to improve its state by hiring a new director, Jeffrey Deitch. Although Deitch had limited museum experience – he had curated museum shows and written for museum catalogues, but his only full-time role in a museum had been for a single year early in his career – his background as an art dealer, his MBA from Harvard and his record of organizing shows that brought in broad and diverse audiences were highly appealing.[23] Unfortunately, Deitch was criticized by the media from the start. Commentators homed in on his lack of

experience, and interpreted his propensity for showy exhibitions as a slap in the face to the more sophisticated legacy of the museum's previous shows.

Deitch's actions during the next few years did little to assuage these concerns. His exhibition choices – such as 'Art in the Streets', a street art exhibition that became the best-attended show ever organized at MOCA – were criticized for being overly invested in pop culture; and he controversially dismissed several significant and highly respected members of the MOCA curatorial team, principally chief curator Paul Schimmel, who was renowned worldwide for his work at MOCA. Whether the cause was Deitch's curatorial or managerial choices – or both, or neither – fundraising dropped again at the museum during his tenure. His third-year budget ($14.3 million) was comparable to budgets the museum had operated with in the late 1990s.[24] In light of all this, Deitch resigned in 2013.

Philippe Vergne was chosen to replace Deitch, and when he took up the post in March 2014, there was a lot of optimism around his hiring. Vergne was already a well-respected museum director – he had been at the Dia Art Foundation, New York, from 2008 to 2014 – and had previously been chief curator at the Walker Art Center, arguably the most influential contemporary art museum in the Midwest. He was seen to bring a seriousness that harked back to the MOCA of the past (not Deitch's aesthetic) – and he arrived just as the museum had bounced back financially, reaching a major fundraising goal of $100 million. The same year he was hired, Vergne also hired the acclaimed curator Helen Molesworth, who went on to organize important MOCA exhibitions including a particularly influential one for artist Kerry James Marshall.

Things seemed to be running smoothly from the outside – until March 2018, when the news broke that Vergne had abruptly fired Molesworth. The reasons for this decision were not made public, but there were reports of 'creative differences' between the two, and allegations that Molesworth was

'undermining the museum' internally and in her public comments. There was also a sense that she was critical of a lack of diversity in the museum's upcoming programming. This was reflected among other things in the decision to stage an exhibition of the white painter Mark Grotjahn – a market darling, but less critically acclaimed – and to honour him at the museum's yearly fundraising gala.

Molesworth's firing ignited controversy throughout the art world. Some believed she was wrongly terminated, seeing her as yet another example of a powerful woman brought down by a patriarchal structure. Others were less quick to come to conclusions, sensing there was more to the story. But the museum itself seemed to take Molesworth's side when it announced that it would not be renewing Vergne's contract in May 2018.

Klaus Biesenbach was chosen to replace Vergne in July 2018. He took up his post at the museum that October.

Biesenbach was born and grew up in Germany, and was the founder of Kunst-Werke (KW) Institute for Contemporary Art in Berlin and of the Berlin Biennale. He initially came to the US to be a curator at MoMA PS1.

I first met him in 2002, when I was working at Matthew Marks. We were introduced at a party the gallery threw to celebrate the opening of an exhibition by photographer David Armstrong. I was a bit starstruck; having followed Biesenbach's work in college and then while living in New York, I saw him (as did many others in my orbit at the time) as one of the rising international curatorial stars. We didn't speak for long, but my distinct and lasting impression of him was as intense, confident and strikingly honest about the machinations of the art world. I was intrigued enough to, from that point on, always keep track of what he was doing.

Since then, Biesenbach has become what a lot of people expected he would be: one of the best-known curators in

the world, with a perceived great sense for new art and new artists (a sense that led to his acquiring the nickname 'Herr Zeitgeist'). At PS1 and then at MoMA, he ascended the curatorial ranks and produced world-renowned exhibitions. In 2004 he was appointed curator in MoMA's Department of Film and Media and by 2010, he became director of MoMA PS1 and chief curator at large at MoMA. Among the highly successful exhibitions Biesenbach organized at MoMA were the culturally iconic 'Marina Abramović: The Artist Is Present' (2010), as well as shows of the work of Pipilotti Rist and Olafur Eliasson. Yet amidst all of this success, as Biesenbach's career at MoMA wore on, the art community began to take issue with some of his curatorial choices and behaviours. In 2015, his retrospective of the singer Björk was almost universally panned and even led some to call for him to be fired from both museum roles. He was also criticized for mixing too much with celebrities such as James Franco, Tilda Swinton and Lady Gaga, and pursuing art projects with them that were thought to have limited critical merit.

When it was announced that Biesenbach would take over MOCA, media criticism came first and fast, much as it had for Deitch. Some were afraid that, like Deitch, his curatorial decisions would flip the museum back yet again to a place too enamoured by pop culture and celebrity. Others were dismayed that yet another director had been chosen from New York, and asked why Los Angeles's major contemporary art space was not being run by an LA art expert. Still others couldn't believe that, in an environment where there are many great female and minority candidates, MOCA had hired yet another white man. Yet Biesenbach's supporters cited his deep institutional experience. While he was known mostly as a curator, he had more than twenty years of institutional management experience at MoMA and MoMA PS1 – not just as a curator, but as a museum director – in addition to his history with the KW Institute and the Berlin Biennale.

Admittedly, Biesenbach didn't do himself any favours when, in one of his first interviews about the new position – with the art critic for the *LA Times*, no less – he called LA 'the new Berlin'. This definitely ruffled some feathers on the LA art scene, where, especially in the last decade or so, many people want LA to be understood as unique and have become tired of being compared to other cities. As a result, the LA community seized on Biesenbach's 'backhanded', 'Eurocentric' compliment, and it led to immediate criticism that he just plain didn't know the city. However, this soon gave way to more constructive criticism, such as the publication of 'to-do lists' for him in his new role. People seemed open to suspending judgment until he started, and seeing what he would actually do on the job.[25]

The LA that Biesenbach entered into is a top art world destination. Since the 1960s the city has been an art centre with great art schools, but in recent years it has established a much larger community of artists, galleries and museums that collectively create something altogether different from any other city in the world. It's believed (though there are no exact numbers around it) that LA now has the largest community of young artists in the United States, with a lot of the artists who study there opting to stay rather than moving to New York. The city also has home-grown, internationally renowned galleries such as David Kordansky and Night Gallery, and a number of other critically acclaimed and growing institutions. In addition to MOCA, there are the Hammer Museum and the Los Angeles County Museum of Art (LACMA), both of which are embarking on major renovations; then there is the Broad, the museum for Eli Broad's collection, which is always packed due to the strength of its collection, two permanent Yayoi Kusama Infinity Rooms, and a schedule of important travelling exhibitions. Furthermore, there are new and influential spaces opening in Los Angeles every year; a lot of buzz has focused the past few years on the Underground Museum and the newly opened Marciano Art Foundation. And LA money is staying in

LA art institutions – for example, David Geffen recently gave LACMA $150 million towards its renovation. Finally, LA has always been lacking a major art fair, but 2019 seemed to signal a tipping point. Frieze launched a fair there, and there is confidence it will continue. (In the past, other fairs such as the New York-based Armory Show or the Paris-based FIAC have tried LA, but it didn't work out.)

In short, Klaus Biesenbach arrived at a terrific moment. Contemporary art is big and growing in Los Angeles.

───

Biesenbach has been the director of MOCA for only a few months when I have a chance to speak with him.

I catch him in transit. We're speaking as he is being driven to a meeting, and I have a sense that a lot of his life is like this – that taking an interview in a car is a regular occurrence. I'm most curious about how he defines the difference between a museum director and a curator, so I ask him to do that for me, because I assume my time will be limited.

'The priorities of a director,' he explains, 'are securing, stabilizing and growing the foundation of the museum. Building a strong board, getting your finances straight and growing; making sure you have a great staff, making sure that the buildings are serving the mission of the institution. And I think you should see yourself as being connected to a team of shareholders, which are the artists – because they are the reason you do what you do – and with the trustees; it's literally a form of teamwork. And then you start engaging and serving the larger community. So that is what a director does, whereas a curator I think has different priorities. The curator has to really focus on why he/she is doing an exhibition at this point, at this place and doesn't have to think so much about the foundation, the base work, the frameworks....I started basically with preparing the ground. My fallback position is always directorial. That is basically the difference.'

I then ask Biesenbach whether, given the history of controversies surrounding MOCA's previous directors, he has any hesitancy about taking on this particular role. He doesn't seem to, trusting that his past administrative experience, particularly in establishing and maintaining institutions, will serve him well. He explains, 'When I came to MoMA PS1 in 1995, I came more like a guest, as a guest curator, and Alanna Heiss was the director. Alanna gave me a lot of responsibilities, though, because she had seen how much I had built KW and connected it with a whole generation of artists, and what I did with the Berlin Biennale. And then when I came to MoMA in 2004, I started the Media department together with Glenn Lowry and then the Performance department. I think I'm always building structures, initiating structures and stabilizing structures, so what I am doing now in LA is actually something I have done both in Berlin and in New York.'

How people get roles like Biesenbach's is often a mystery to the larger public. It turns out he initially came into contact with the museum in a kind of consulting role to find a new director, but he did not think – or at least he says he did not think – he would be considered for the role. He explains, 'When Alanna went into retirement and the economic crash of 2008 happened, MoMA PS1 was not in a good position. Unofficially, Glenn Lowry and Kathy Halbreich and I basically looked after it for a year, and it was in a dire moment. And then I thought, well, I should focus on MoMA PS1. And with a huge joint effort we tripled the budget, built the staff and increased the attendance drastically within nearly ten years. So that was an important building process. So, then [the acclaimed photographer and MOCA board member] Cathy [Catherine] Opie called me – one of the artists on the board at MOCA – she basically said, would you help us right now? You don't say no to a question like this, and you hear Cathy out – and I didn't really immediately think it would mean I would leave New York and the institution I love and move to LA. So Cathy had called me and then I went to LA

and I basically said that I will help and perhaps I can help the whole board to figure out what they are really looking for, and I said I want to talk to everybody who was around and available from the board of trustees if that's possible. Cathy said that nobody ever asked her that, and I said, "Yes, but I would like to do that." I want to know what's at the heart of where you are right now. So, we looked at the venues; and we met more than thirty of the trustees – which is most of them; everybody who was in town, everybody who could make themselves available by phone. My marching order was basically I don't want to be invested in the outcome. I said the only outcome, my only goal, is to help this process and I will be very honest because only honesty works in such a situation that is so complex. So, I did this series of meetings and we managed to meet so many of the board members and the honesty was very refreshing, I think, for many. They were surprised, and it was a very good energy, like a constructive energy. But it wasn't surprising for me, it was more like "let's discuss what's going on and take it from there together".'

Klaus was nearing the end of his time in LA and was in the car with Opie when she turned to him and said 'There is such a great inspiring energy. If the board really wanted *you*...?' He says he was caught off guard: 'Whoa. I was like, wait, I need a break,' he recalls. 'And then we were literally in a car stopped at a traffic light and she said, "You have to tell me, if we would vote for you, would you really come?"....And then it took me some breathing in and breathing out. And I basically said yes, I'd do it. And I was as surprised myself that I'd just said that.'

I ask about Biesenbach's knowledge of the art scene in Los Angeles before he started. I wonder if he is going to bring up his Berlin/LA comment and, to my surprise, he immediately does. 'I think I outed myself as completely not knowledgeable about the city when I did funny comparisons with LA,' he explains. 'I had, over the years, been to LA but visiting basically artist studios. I would visit Doug Aitken and Andrea Zittel and Mike

Kelley. I'd go to the studio, go to one to two exhibitions, go to see the museums, and then off I went. I never understood the complexity of the city and having made these slightly provocative comments that outed me as a person who doesn't understand Los Angeles was actually a very good point of entry. Everybody then gave me advice. How I explored LA became the mission of the day. Everybody had gotten that note and responded, "Oh, we have to tell Klaus what LA is!" And then I turned it around and I asked the younger, more junior staff at MOCA – and many artists – "What are the ten places you would guess I would never find myself in LA?" And then I had a list of over fifty and then a hundred places, and I started driving around and exploring them. And I have found LA to be a very different city when you live here than when you visit it. I have done the highest peak, Mount Baldy; I have been to all the different areas of the city. I literally bought a complete map of the county and I drove around its perimeter and started visiting all these places, from Glendale to Montecito Heights to San Pedro,' he says.

This process has been important for Biesenbach, even to the point that he says he has had some epiphanies. 'I think it has been an incredibly rewarding, incredibly exciting experience,' he explains. 'It's an artist-driven exploration, and in a strange way LA feels so much about the future. Like yesterday, somebody brought me to a café on Venice Beach. And there was this big rainstorm and everybody who was on the beach suddenly came into the café. It was a very, very young crowd. Everybody was on their laptops and devices. LA feels very much like looking forward. And it's not so much constantly reflecting on its past....I think it's at a really beautiful point where it's open for new ideas and new artists. And that's actually pretty great,' he says.

I can't imagine how intense the expectations must be for Biesenbach in this first year after such dysfunction. I ask him how he will gauge success for himself and the institution. He stresses humility and moving slowly and deliberately, and

being a bit boring, which it seems – maybe with the exception of the first few years of Vergne's tenure – has not been the museum's past approach. 'I think it's important that now MOCA is humbly walking the walk, doing its work as a museum, and serving its community: the artist community and the larger audience community. I think it's important the goal is to just function as a museum and do what a museum does, not promising fireworks or other things. I think that stabilizing the institution and slowly starting to grow, being a responsible citizen among citizens, is the goal. It sounds very humble but it's actually a steep goal for an institution that was for more than ten years in such a series of monumental changes,' he says.

What does this actually consist of in day-to-day terms? I follow Biesenbach on Instagram and see him hanging out with major art world collectors and philanthropists, and I'm curious about whether attracting these people to the museum is one of his priorities. Biesenbach says it's about understanding the history of the museum; perhaps it's also about trying to instil confidence back into people who were once long-time museum supporters but drifted away because of all the 'fireworks'. Biesenbach explains, 'One priority right now is that I'm visiting artists and people who have been instrumental in the foundation of MOCA and its beginnings and who have invested their time and their creativity and sometimes their collection into building it up. So I visited the former directors, and visited many of the founding members who still live here, and it's incredible to just listen and learn. So, my first priority is this: to just understand the more complex past and hope to create an open door for these people who have invested so much over four decades. This is also still their place, and I think that's important. That is perhaps what you see on Instagram? I think it's important. I visited David Hockney and Frank Gehry this week – both of them – and that's incredible. That's one priority; and another priority is building a board that can support

a museum growing. I think that's very important. We already have a great board and I think it's one priority to align the board with our vision and slowly grow now.'

The board is central to most museums, and Biesenbach has a particular way of speaking about it to enforce and explain its functions. 'For me, the board *is* the museum,' he says. 'For me the board is the governing body, for me the board is like shareholders. It's a group of people that *are* the museum because the board makes sure the museum is stable. So, it hires the director, and then the director works with the board to make sure that the museum can follow through with its mission. So, for me that's the foundation. When I started in Berlin, I built a board there, though institutions in Germany don't necessarily have a board – and that was my first priority.'

Biesenbach sees the growth of social media as a significant factor in changing how museums operate, giving them new ways to highlight their advantages – that they are homes for great art and social experiences – vis-à-vis more market-focused experiences like those of galleries and fairs. He explains, 'I think that in a cultural way, it was very interesting when apps like Instagram or Snapchat came out, everybody realized that the phone is primarily a camera and a mirror – and remember the time when people did selfies? And now selfies look so dated and not what anybody would do, unless it's a very funny selfie way or in front of a situation that you think you want to document, which I think is charming and humorous – but the idea of the selfie is completely obsolete now. So, it's very interesting that social media and Instagram and Facebook very much have changed how people travel in a city and where people go and what people go for. I think this shift from the selfie to a picture that documents more the content of the visual quality of a work of art has happened. What is its meaning; what is its context? And I think this will also change the perception right now that the museum world is often mistaken for the auction house or art market. They are different things. The history of art is not

the history of the art market or trophy works. A library is not a bookstore. I think art is there to change our lives, at least how we look at our lives. Art is incredibly relevant and meaningful as a political, as a civic, as an intellectual, and as a social tool to address urgent matters. I think this is the shift that is happening right now, which is hugely relevant.'

He sees the museum of the future also offering one of the few experiences that *aren't* mediated by technology. 'One thing that a museum really offers,' he comments, 'is a one-on-one; a person with a work of art experience. I remember when I first hitchhiked to Amsterdam and saw the first Van Gogh I'd ever seen in person as a teenager and felt how empowering and inspiring it was actually standing in front of this work, this famous work of art. It's not about the fact that it's famous, it's famous for a *reason* – because it visualizes the truth and beauty that's eternal. So, this one-on-one, direct and not mediated, authentic contemplation is what a museum can offer. A museum also can offer the fact that you don't have to do this alone, this can be a shared experience, so a museum is one of the few places that you can't replace with your iPhone or a little Snapchat video, so you have to be there in person. I think the culture shift and social media and devices and the whole digital world has changed our lives so much, and often in a way that we haven't comprehended yet. I think the museum is a very important place to convene amidst this. Art is a very important occasion on which you can talk about some really important matters and issues in life. And I think this is getting more and more clear that we will have an even more important role in society going forward,' he says.

In ten years' time, Biesenbach wants MOCA to be known worldwide as a place where contemporary art is 'finding its form, is being anticipated, where you see the art that defines our moment and where you find the time to experience it in the context of all the other artists who create contemporary culture'. He also wants it to be a place where really meaningful,

relevant issues in society are circulated and where artists can raise questions in a very utopian way. 'I think art,' he says, 'and this is a very Joseph Beuys idea – is there not only to change how we look at the world, but by changing how we look at it, it is also changing the world for the better. So, I want to be an entity for change and for a way of shared and communal work. I think a museum is like a library. It's like a civic institution that offers itself to its residents around it. I would like MOCA to be a resident amongst residents,' he says.

Biesenbach then mentions some projects he's excited about for the future: offering free general admission to the museum in early 2020, thanks to a $10 million gift from MOCA board president Carolyn Powers; the launching of their WAREHOUSE programming of performance and various types of live, experimental events; and upcoming shows featuring artists such as Pipilotti Rist, Jennifer Packer, Tala Madani and Henry Taylor.

Then, suddenly, Biesenbach is at his next stop. We exchange regards and he politely excuses himself to go on to his meeting. I hear him greeted as he gets out of the car, on to the next conversation towards building the museum back up – and making progress.

Chapter 5

Art Fairs

It's now late March, and I am in China to attend the major contemporary art world event of the spring in Asia: Art Basel Hong Kong.

Art fairs function as the trade shows of the art world. Like other luxury trade shows for choice items like watches or cars, they are held in large convention centres or tents where galleries rent booths to exhibit and sell their works. There is an admission fee for visitors, which generally ranges from around $20 to $50.

Fairs have been a booming business in the last few years. As of 2017, there existed over 260 art fairs globally – with almost fifty of them founded in just the past decade.[26] Art Basel, which operates three fairs (Basel, Hong Kong and Miami) and works with roughly five hundred galleries a year, is currently the most influential art fair and brand; but the network of Frieze Art Fairs is on the rise, with its fairs in London, New York and now Los Angeles. These are big occasions: Art Basel in Basel typically sees almost three hundred galleries take part, while Frieze New York has close to two hundred.

Other important contemporary fairs exist, but they are usually relegated to one city and do not have the international reach or strong branding of Art Basel or Frieze. Examples are the Armory Show in New York, Zona Maco in Mexico City, ARCO in Madrid and Lisbon, 1:54 Contemporary African Art Fair (New York, London and Morocco), ADAA Art Show in New York, Independent (New York and Brussels), Art Brussels (Belgium), EXPO Chicago, FIAC in Paris and Art021 in Shanghai.

What are the smaller fairs like? They range from a kind of step down from places like Art Basel (e.g. fairs that have fewer exhibitors, a less strong brand and less valuable artworks) to quite small, curated affairs which often include influential galleries that, for reasons connected to their specific markets, don't want to be a part of larger fairs. These smaller fairs can offer something resembling the polish or cool factor of a larger fair without the price point. At the bottom end of the fair hierarchy – and this accounts for most of the art fairs that exist – there are the fairs that clearly offer a much lower price point; these are generally regarded by the art world elite as much less tasteful and maybe even a little 'cheesy' in their presentation.

An example of a small, curated fair is Independent, whose fairs in New York and Brussels have attracted galleries that would historically show at the Armory Show during its New York fair, but have stepped back from it for various reasons (such as the withdrawal of more prestigious galleries in recent years, or the desire for a cooler, more hip experience). Independent has achieved a kind of cult following, impressing visitors with its smaller scale and varied presentation of booths. People even tend to think of it as something akin to a group show or biennial experience, as opposed to a shopping experience. It's also relatively inexpensive for galleries to participate in. Exact figures about fair booth costs can be difficult to pin down, but at Independent's 2018 Brussels fair, an 82-square-foot (25 m²) stand in the Young Galleries section would have cost around $4,700 – equivalent to $188 per square metre of space.[27] By comparison, it was reported in 2018 that the Armory Show's largest booth commanded a fee of roughly $100,000 for 93 square metres ($1,075 per square metre). Then there are the booths at Art Basel in Switzerland, which range in price from $400 to $830 per square metre.[28] Importantly, this figure is the cost of the booth alone – any gallery showing at a fair will probably need to invest even more money in various special services. Art Basel offers options like nicer lighting, or stronger walls to hold particularly heavy

sculptures, for those able to pay. Then there are all the other costs that come along with doing fairs: shipping all the work back and forth to the location, providing lodging and food and entertainment for your employees, and any meals and client entertaining you might organize. The latter can range from a small dinner with a few 'choice' people to a spectacular dance party in a medieval church, such as the party the Paris gallery Perrotin has been throwing for the past couple of years at Art Basel in Basel. According to a 2018 poll, typical gallery costs for attending Art Basel are said to range from $50,000 to upwards of $400,000, depending on the gallery's size and prestige.[29]

Fairs with significantly lower price points get much less press and critical acclaim than an event like Art Basel, but many are long-established and successful. For example, there are numerous fairs held in the vicinity of Art Basel Miami Beach to cater to people who might aspire to buy things at Art Basel, but can only afford much lower-cost items. These include SCOPE, PULSE, Aqua, Art Miami, Spectrum and Red Dot, among others.

These days, the transactions galleries make at art fairs have become more significant than the business they do at their own locations – to the extent that the bulk of a gallery's revenue comes from doing fairs.[30] Why has this happened? There are various factors at play. First, there's the sheer success of the art-fair model: what could be more appealing than the creation of a one-stop shop for people to browse art from all over the world, rather than having to visit all of the galleries separately? Then there's the change in character of the 'typical' art buyer since the 1970s: as the Western economy hit a few boom moments, buyers began to include working people as well as those with inherited wealth. Working people don't always have time to travel the globe in a leisurely manner and visit galleries; they need more efficient ways to buy, and fairs make it possible for the art world to come to them.[31] Other elements are the decreasing cost of air travel, and the globalization of the art

world – people who are interested in works from other places can now go there and visit them with ease.

Another reason might be that, in the age of online access, people are attending fewer individual gallery shows but viewing much larger quantities of work online – and so, when they do decide to go and see some art in person, they expect to see a similar quantity and range in an offline context. Fairs are also major tourist attractions and social scenes (as is clear when I look right now through the various events taking place alongside Art Basel Hong Kong), and can establish and remake a city's image. ARCO Madrid historically heralded a new era of democratic Spain; Art Basel put Miami on the cultural map in a way it had never been before; and recently, Art Stage Singapore has been called the 'get-together event of the entire South-east Asian art world...the place and week where creative people from the region – artists, collectors, curators, museum directors, art lovers, etc. – come together and dialogue'.[32]

Art world people love to complain about art fairs. Artists, critics and curators often say they diminish art with their trade-show design, overwhelming size and sales-first agenda. Some collectors don't like them because they prefer to avoid the attention they get from galleries; they want to look at art uninterrupted and not be bothered by salespeople. Some galleries say the fairs are too expensive to take part in, or too exclusive (squeezing out smaller and medium-sized operations who can't afford the fairs or are not picked by the major art fair selection committees). Others argue they are killing the gallery as a site of business, making gallerists into travelling salesmen, stealing time and energy away from the creation of good art and exhibitions and strong relationships with collectors. And there's always some background grumbling about certain fairs (particularly Art Basel Miami Beach) being 'played out'. Yet the fact remains that the fair system is booming, and it seems to be here to stay.

Art Basel was founded in 1970 by a group of gallerists. In its first year – with just one fair in Basel, Switzerland – it was immediately successful. More than 16,000 visitors attended and saw artworks from ninety galleries representing ten countries. By 1975, the fair reached almost 300 exhibitors from twenty-one countries, and 37,000 visitors. In the late 1990s and early 2000s the fair started to become even more successful, and as a result sought to scale up. In 2002, Art Basel Miami Beach opened; and then, in 2013, Art Basel Hong Kong.

Hong Kong was a logical choice for Art Basel when it considered expanding to Asia. It's arguably the most business-focused centre in Asia, and it already hosted a number of international auction houses. Also, Art Basel did not have to start from scratch with a brand-new fair; instead, in 2008 it took over the art fair Art HK and began steadily increasing its capabilities.

The word on the street was that 2018 would be Art Basel Hong Kong's best year yet. A testament of this was the fact that, according to Marc Spiegler, the global director of Art Basel, they had to limit the number of Western galleries looking to be involved in order to keep their preferred balance of galleries from the East and West. Those that were admitted needed to prove they were truly worth the fair's while. As Spiegler explained: 'For an established gallery from the West, the beauty and the terror of this fair is that's it's a meritocracy....You need a strategy. In order to succeed, you will have to put time in and designate someone to show face in person, since that's important in Asia....There are galleries we'd love to have, but once we speak, we realize they have work to do before their first appearance. It's a surreal experience for a fair director to caution big galleries from entering a fair, but it's the responsible thing to do.'[33]

As ABHK has seen increasing success, its management has remained aware that there is still room to grow, and that the art world is shifting towards Asia more widely. It's true that this is the biggest moment in a massive Asian community becoming

more and more engaged with the collecting of international contemporary art. But there are new centres popping up, with many of them having already-experienced communities of buyers, throughout East Asia.

The events that are organized to capitalize on art fair visitor numbers can sometimes overshadow the excitement and interest surrounding the fairs themselves.

In the early VIP days of a fair, or even a few days after the fair, galleries (and sometimes museums) hold a slew of adjacent events. These can include openings, exclusive dinners, parties or artist talks at which galleries can promote their artists and exhibitions to collectors and important influencers (museum curators, art advisors and others). They offer an increased incentive to come out to fairs – which, as the years go by, can begin to feel a bit boring format-wise, can be seen to offer ever less exciting or unique works (owing to the growing number of fairs) and can often be criticized for the environmental impact of all the air travel they involve. As art fairs have increased in number and importance to the international art scene, budgets for these adjacent events have grown; high-end luxury brands and financial institutions have become involved in their own right, or as event sponsors. These brands understand that art fairs can be lucrative marketing opportunities for reaching high net worth individuals – after all, if a visitor can afford a piece of art, they can probably also afford a new car, a watch, or highly exclusive financial advice. At the end of the day, the competition to create the most unmissable event during the fair can be fierce, as can the efforts visitors make to get into them.

I'm here in Hong Kong to host one such event, on behalf of Artsy in collaboration with the gallery David Zwirner. It's one of the most high-profile occasions I've ever organized: a live

conversation between two art world heavyweights, Jeff Koons and Hans Ulrich Obrist.

Swiss-born Obrist is a globe-trotting curator who holds the position of artistic director of the Serpentine Gallery in London, among a host of other adjunct and advisory positions. He's been named the most powerful person in the art world by *Art Review*, which creates such a list (the 'Power 100') annually, and he is highly valued for his relationships with legions of influential contemporary artists as well as his boundless energy and ability to talk – very fast, in a 'sibilant, rapid-fire mittel-European accent' – with artists on any subject.[34] In 2014, he stated that he had made 'roughly two thousand trips in the past twenty years' to meet with established and younger artists and see all types of exhibitions. He is a super-connector of the art world.

We're in quite a grand location, in what has been dubbed 'the Sky Lounge' – a majestic, cream-coloured library-like space on the 49th and top floor of the Upper House, one of the fanciest hotels in Hong Kong. The view of skyscrapers growing out of steep, saturated-green mountainsides is breathtaking.

Koons, who is sixty-three and seems very fit, is dressed in a navy-blue suit and white shirt with no tie and is somewhat mirrored by Obrist – also a white man in a white shirt and jacket. But while younger, at forty-nine, Obrist looks a bit more road-weary (perhaps unsurprising given his incessant travel and his career, which he often says is focused on 'velocity'.[35] His hair is completely grey; he is quite bald; and he looks less fit than Koons. The two men are seated in chairs that are perfectly cushioned (not too squishy, not too firm) as well as meticulously spaced and positioned at an angle (halfway between facing each other and facing the audience), in front of a minimalist fireplace. The audience is made up of one hundred highly curated VIP guests.

As I look out into the crowd, I see a lot of what are often referred to as 'top tier' art world 'insiders': important collectors,

curators, advisors and heads of galleries and art fairs. I can pick out Norman Rosenthal, a British curator best known for his shows at the Royal Academy in London, such as a 1981 exhibition that heralded a return to painting in the 1980s, and the controversial 1997 'Sensation', which introduced the Young British Artists or YBAs (the best-known being Damien Hirst) to a wider audience. Near Rosenthal I see Lucas Zwirner, son of David Zwirner and perceived heir to the gallery, and head of their burgeoning book publishing projects. Slightly behind Zwirner I see Sabrina Buell, with whom I worked at my first job, at Matthew Marks. She has since become one of the most sought-after US art advisors, especially for young Silicon Valley entrepreneurs.[36]

People tell me afterwards how lucky they felt to be there, in such an intimate setting – usually that doesn't happen with someone like Koons or Obrist – and to hear Koons opening up about his work in a way he usually doesn't. Among other things, Koons talks about his recent works (showing at Art Basel that week), which incorporate a gazing ball. He says that one of the jumping-off points for these works were the gazing-ball lawn ornaments he saw growing up in Pennsylvania. According to Koons, these were brought over by German immigrants, but they had initially been popularized in Venice in the 1500s. (This contrast is typical of the high–low play of cultural ideas that interests Koons.) He also discusses his interest in Salvador Dalí, and how he sought out and met him once during his second year in art school. He found out from his mom (this made me wonder what her connection to the art world had been) that Dalí spent half the year at the St Regis Hotel in New York, and Koons then cold-called the hotel to ask for Dalí's room. 'They put me through. [Dalí] answered the phone, and I said that I was a young artist from Pennsylvania and I really enjoyed his work and would like to meet him. And he said, "If you can come this weekend, I'll meet you at noontime in the lobby of the hotel."'[37]

Koons continues, 'I went to the hotel and exactly at noon he came down. [Dalí] was dressed in a big buffalo fur coat and he had his diamond tie tack on, a silver cane, his moustache waxed up, really dressed to the hilt. He invited me to go see his new exhibition at the Knoedler Gallery; he said he had to meet a French journalist [there]. So, I met him there. And he's walking around with this really tall, blonde journalist with a feminine figure and I realized much later that it was probably Amanda Lear, the French journalist who was a transsexual. He walked around with her and then came over to pose for some photographs for me in front of this large painting, *The Head of the Royal Tiger*, a piece that was created in 1963.' Koons, an avid collector, finishes the story by explaining that he was happy to have bought the study for the painting twelve years ago, and that it sits in his bedroom.

Later on, Koons talks about one of his early teachers, Ed Paschke at the School of the Art Institute, and particularly how Paschke, rather than Duchamp or Warhol, showed him how 'ready-made' subject matter – something he was very much interested in – could be seen in his own life as well. He explains, 'We would work in the studio all day, we would go out and he would show me where he got his source material. Ed taught me that everything's already there; everything's already in the universe, you just have to go look for it. He would take me to clubs where he would find different lighting that he could possibly use in one of his paintings. Maybe there would be a woman who was dancing in a club who was completely tattooed. These were the first realizations of ready-mades for me. I knew about [Marcel] Duchamp, but where Ed got his source material had more meaning to me. It was more connected to everyday life.'

For the last portion of the event, Obrist shifts the conversation to Koons' unrealized projects, a favourite subject matter of Obrist's to discuss with any artist he comes across.[38] One of these projects that Koons never made was called *Lips*: he describes it as an airship 'over three times the size of the

Hindenburg' (or over 2,600 feet/800 metres long) in the shape of a pair of lips, which would hover over Paris. The idea was based on an image created by Man Ray, showing huge lips hovering in the sky, and as it would be solar-powered, Koons envisioned it travelling around the world. 'It could be outside here in Hong Kong for the art fair right now, and then it could return to Paris or go to Los Angeles.'

The best-known unrealized sculpture Koons discusses is his *Train*. The idea for *Train* was to build a full-size (70 feet/21.3 metre-long) steam engine, a replica of a 1943 Baldwin 2900 engine, that would hang in the air – pointing nose-down – from a 166-foot-tall crane, with the so-called 'cattle catcher' on the front of the train suspended about 30 feet from the ground and dangling over spectators in an 'awe-inspiring' and 'terrifying' manner.[39]

Koons explains to Obrist that 'the train would do everything that a real train does, but at a faster pace. It takes a real train eight hours to gain enough energy to be able to pull out of the station. This would be condensed into about a 30-minute time period. You would be sitting there looking at it and you may start to notice that the light is kind of flickering off the firebox, and maybe you would see a little steam coming from a valve. And then the pistons would start to fire and the wheels would start to turn and it would go "choo-choo, choo-choo", and each time that a piston fires is one puff of steam; it's breathing. The faster it goes is just a faster rate of breathing. And so, it would go until the train would reach full speed at around 80 or 85 miles per hour with a huge plume of steam coming out of the train. And it would reach this huge climax of speed in about eight and a half minutes and then you would have this climax, "woo, woo, woo, woo, woo, woo", and then on the same bell curve along which it had been speeding up, it would also de-escalate its speed to the last puff of steam.'

Although Koons does not say this at the talk, *Train* has been the subject of well-publicized discussion for the past

decade. It had originally been planned for a new museum in the early 2000s for the collector François Pinault (head of the luxury goods group LVMH and as such, Christie's), but had been deemed unfeasible when the museum's site was changed from Paris to Venice. In 2007, one million dollars was gifted by the Annenberg Foundation to the Los Angeles County Museum of Art to explore whether it would be feasible for them. The museum's director, Michael Govan, was hugely supportive of the project, envisioning the train as LA's Eiffel tower. However, the project was estimated at $25 million just to build – and it then would have required significant funds to maintain it appropriately. In the midst of discussions, the stock market crashed, no doubt making it even more difficult for the museum to justify the cost internally and externally; so the project stalled there, and the company who would have built it closed down. At around the same time, the High Line in New York started to consider it – for what better site could there be for the train than a former train track that had become a high-traffic tourist destination? But after assessing the likely costs, the High Line also passed.

After Koons takes a few questions, I step in to offer the audience a thank you and a farewell, wishing everyone a great rest of their week, and then the event is concluded. People quickly get up from their seats (or displace themselves from the section of wall they have been leaning on, because it turned out we had way more attendees than seats) to gravitate towards Koons and Ulrich, to say hello or introduce themselves or just catch a glimpse. And then – seemingly just as quickly – everyone is out the door, off to the next event.

I'm now walking around ABHK, which is based in the Hong Kong Convention Centre.

My friends who are not particularly involved with the art world sometimes ask me about the best way to walk around a

fair. There is no right way; collectors, dealers, museum directors and reporters all do it differently. A VIP collector might be joined by their art advisor for the moment the doors open, in order to take part in the most exclusive 'first choice' – opening times are usually staggered to allow for this – and only see a handful of things that the advisor has picked out. Then they might attend one dinner and just leave town. Museum directors and curators might lead a tour of their patrons that is pre-selected, aimed at persuading them to buy works that could go into the institution's collections. Writers and reporters generally go in with more openness, but they do also have a specific group of people they want to speak with so they can file their stories, which generally relate to what has sold at the fair or which were the best booths. And then there are the casual 'looking and learning' attendees, who increase in number as the fair gets less VIP-focused and heads into the weekend. These visitors don't buy art, but like to visit art fairs simply to look around or enjoy the spectacle, or to try to make sense of the whole enterprise, or just to get great photos of themselves with the most Instagram-friendly pieces.

And what is an art fair like, if you haven't been to one? Looked at objectively, they are a significant downgrade from how people may be used to looking at art in museums or at some galleries, where a great deal of effort is made to curate the viewing experience. Museums create a beautiful setting for works of art, and a certain flow and narrative and story arc for an exhibition, so that you feel, as in a good book, there is reason to go on. Art fairs use the same big-box convention centres that host the watch and car and consumer electronic trade shows – and while efforts are usually made to 'elevate' the atmosphere with pretty tents (such as at Frieze New York), minimalist and consistent booth construction or interesting places to stop and eat, being at a fair is mostly just looking at booth after booth of art, displayed on walls and on the floor. Large booths offer a bit of a respite, as they take up most of your

point of view; but the majority of booths are small enough to walk past in about fifteen seconds, row after row after row. As there are usually hundreds of booths at fairs, the process of walking from one to the next quickly transforms a sequence of potentially interesting individual displays into a mind-numbing and overwhelming stream. When you factor in the hundreds if not thousands of people at the fair with you, whom you need to avoid bumping into and might also want to watch just for interest's sake, the whole affair can be overwhelming and energy-sapping.

The experience at Art Basel Hong Kong is better than 99 per cent of what happens at most fairs, because the production of the event by Art Basel is really good. The space is grand, the design cutting-edge, the organization very intuitive – and the art is made by the most talented and critically acclaimed artists in the world, represented by the world's best galleries. Personally, what I am looking at, or for, usually depends on what project I'm working on. If I am trying to find a great artist for an art and technology commission, for example, I'll structure most of my time at the fair around that intention and not spend too much extra time looking at other things. I find having an agenda – any agenda – at an art fair a saving grace, and I always recommend this to people. If you don't have one, and this has been me in the past, fairs can be soul-crushing affairs and this works to the detriment of the art. You can find yourself with a total lack of focus, and then feel terrible for not giving time to any of the works and artists in front of you.

After about an hour and a half at the fair, I begin to tire. Then I bump into Cristobal Riestra from Galería OMR, a gallery I worked with earlier this year on an event in Mexico City with the artist Jose Dávila. Seeing my state of mind, Cristobal smiles at me and suggests I share some mezcal with him, which he has at the booth. I take a sip and then another as he tells me about the mezcal's maker and then about the works in the booth, and the friction of the fair slowly dissipates. I chat with him for a

while longer, and then take this respite and relief as a cue that I am done for the day and will come back tomorrow.

Outside the fair, in the area where visitors are being dropped off and picked up by cars, I see some commotion. A throng of people surround a young man getting into a black car. I ask who it is, and am told it's a South Korean pop star – his name is unfamiliar, and I can't quite catch it. I watch the black car pull away and look out at the city, thinking about who else might have been drawn here to see the fair and the week's adjacent events. Then I take in the sweeping view of the harbour, and try to figure out via Google Maps where I can get something quick to eat before moving on to the next art event.

Chapter 6

Artist Estates

I am now at 12 East 86th Street in Manhattan, in an expensive pre-war apartment building one block from 5th Avenue on the Upper East Side. I am sitting with a man named Stephen Koch, in his office.

Koch's office is one room of a two-bedroom apartment he shares with the art dealer Rosa Esman, and it's from this office that he does his two jobs. Koch is a writer of mostly non-fiction, and his work ranges from a seminal text on creative writing to one of his most recent, a book on Hemingway, Dos Passos and the Spanish Civil War. Copies of these books, lined up on floor-to-ceiling wooden shelves, are the first things you see when you walk in. But Koch has another significant job – as an executor. He runs the Peter Hujar Archive, which manages the estate of the late American photographer Peter Hujar (1934–87).

⸻

Artists' estates are arguably one of the least glamorous parts of the art world. They consist mainly of stored artworks, records and personal artefacts, housed in the most mundane (because mundane generally means safe) of circumstances. Yet – as modern and contemporary art has come to dominate the present era of art collecting, as foundations and estates of such artists as Rauschenberg, Haring, Warhol or Basquiat have set a precedent for making modern and contemporary artists even more valuable posthumously than in their lifetimes, and as promising or successful younger artists are passing away – estates represent a serious business opportunity. Top

galleries now regularly take on new estates to represent them, with the aim of selling undervalued historical material for top dollar, attracting new collectors and using historically revered artists to give prestige by proximity to their contemporary (living) artists.

In the US, for one, advisory services are also cropping up to help living artists and their heirs prepare for their deaths, and to help heirs manage estates and create entities such as non-profit foundations.[40] Foundations are particularly helpful for artists whose work is highly valued by the market, since, at the time of their death, all of the work in their possession converts from being valued at the cost of the materials to its actual market value – which can create a significant estate tax bill for their heirs. Establishing a non-profit foundation to which the work can be bequeathed is one way of getting around this problem. According to the Aspen Institute's Artist-Endowed Foundations Initiative (AEFI), there are now generally four types of artist foundations: grant-making foundations, which give grants to charities, organizations and other artists; study and exhibition foundations, which use assets like the artist's archive or collected works to set up a study centre, create scholarship or loan works for exhibitions; comprehensive foundations, which combine the two aforementioned functions (these are the norm today); and finally, estate distribution foundations, which dispose of the artist's assets held at their death over a certain period – typically twenty years.[41]

Managing an artist's estate is challenging, sometimes emotionally draining work for those who inherit the task. There is the sheer and seemingly endless protection, care and maintenance of the myriad materials they are left with: not just the artist's works, but also possibly their possessions, as well as their studios full of tools and equipment, preparatory studies, artist's proofs, negatives, contact sheets, casts, computers, hard drives. Then there is the exploration of what it is to manage, promote and sell the work, in a domain they might

not know the first thing about – and the sense of failure that can result when people are not interested in buying the work. Furthermore there is the fact that the person landed with all of this responsibility might never even have wanted it. Heirs often take on estates unexpectedly and reluctantly. They may have had a complicated relationship with the deceased artist, and can feel saddled and burdened with the work, depressed by having to deal with it, haunted by the responsibility of it, and troubled by the complexity of managing the remnants of a person who is no longer there. This can lead to the demise of an artist's work and reputation because there is little support for making it live onwards – which has often happened to artists who have been recognized in their lifetimes, testifying to the entirely different challenge that is maintaining an artist's work after they have passed away.

In more positive scenarios, family and friends are honoured to manage their beloved's art, to help further their work and share it with the world, and they see benefits to their families and future generations. Or sometimes, someone is hired or appointed by the family or executor of the will, and that person finds a great passion in the work of making the artist known. This can result in stories where an artist who was generally unknown during their lifetime can rise to become world-renowned. Peter Hujar is one of these artists, and the story of his rise from obscurity is one of the more positive and compelling accounts of an artist's estate in recent memory.

Hujar lived and worked in 1970s and 1980s downtown New York, and specialized in intimate black-and-white studio portraits of his bohemian community. Among his subjects were some of the most important cultural figures of the era: Susan Sontag, John Waters, Fran Lebowitz and Andy Warhol. Yet Hujar was considered an artist's artist, and during his lifetime he had little to no career and no consistent dealer. Personal trauma and probably undiagnosed psychological issues played a part in this, and the result was that a brilliantly talented artist, who

craved fame, somehow ended up doing everything possible to jeopardize his own relations with the art market.

For one, Hujar was hostile to any professional who took an interest in him. Lebowitz, with whom he was quite close, said of him at his funeral that 'Peter...hung up on every important photography dealer in the Western world.'[42] There was also an often-mentioned story about Hujar trying to smash a bar stool over the head of a French dealer who wanted to represent him.[43] As a result, between 1973 – when Hujar vowed to stop working as a commercial photographer to support his art – and his death from AIDS-related pneumonia in 1987 at the age of 53, he was constantly broke. Yet since then, the work has become progressively more commercially valuable and critically acclaimed, and in recent years it has been embraced by major international museums with solo exhibitions. In 2018, on the basis of an extensive show at the Morgan Library in Manhattan, Hujar was called by *The New Yorker* 'among the greatest of all American photographers.'[44] This story did not happen by accident, and it speaks of the labours, trials and tribulations that are often involved in managing an artist's work after their death – and rarely end so happily. I was able to see this playing out at first hand, because I had a part-time job at the Peter Hujar Archive for roughly four years, while I was working on my PhD.

So how did Peter Hujar emerge from 'almost forgotten' to the pantheon of American photographers? First of all, even with his self-destructive tendencies, Hujar had a very deep confidence in the value of his work and a sense that with himself out of the picture, he would be famous. As a result, he felt it was of the utmost importance that he find the right person to manage the work after he died. On one hand, he had influential friends in the culture world, but on the other hand, he felt – rightly – that often, your most influential friends won't have enough time to do the job well. Accordingly, in 1987, in the months before his death, Hujar decided to appoint his friend

Stephen Koch, whom he had known for over two decades, as executor of his estate. Koch, he felt, seemed to be the most stable and organized of his friends, and maybe he also sensed that Koch's affection for him could drive the – major, long-term – responsibility of having to manage his work.

At the time, Koch had achieved modest critical success with novels and non-fiction and was gainfully employed at Ivy League colleges (Princeton, then Columbia) as a professor of writing. He was also the son of a lawyer, and so – unlike a lot of people in the cultural world at the time – he had the ability to read, interpret and manage contracts and negotiations.

The process of bringing Hujar from near unrecognizability into public recognition began at the moment of his death, and it has been an arduous and intensive one for Koch – in fact, one of the hardest things he has ever embarked on in his life. He tells me, 'One thing that I'm convinced of, and I'm happy to say that Peter was also convinced of, is that when an artist dies the work is facing a whole new challenge in its existence. It can sink or swim. Major artists can be forgotten, and minor artists can be promoted with some success. But someone has to do the work. In other words, without Theo and his wife, [van Gogh's] paintings would have vanished from history. Someone might have come across them forty years later, covered with cow shit. I believe that. I'm not able to quite prove it, but I think that this is true – even with the artists with major reputations. There are, I am sure, Abstract Expressionists who were once viewed as major, major figures who have now receded very much into the background. They're not quite forgotten. But they're not household names. And that is partly because of the work. But it is also because of what somebody did with the work.'

Little fanfare accompanied the announcement of Koch as the executor of the estate. His first act was to gather Hujar's

prints and negatives and contact sheets from his home/studio. He then rented a small office. Koch readily admits that at that point, he had no idea what he was doing. 'I knew nothing about galleries, curators, museums, critics, collectors, shows, auctions, conservation, inventories, digitization, databases, art storage, or the public.'[45]

Koch initially thought he would face a big disadvantage because of Peter's lack of career success. Yet this – slowly – became an advantage. There was a lot of work available due to the lack of sales and a dealer. Hujar was also an artist's artist, a bohemian, a commercial failure who died in poverty – and this was a story that appealed to buyers who might have been less interested in someone with a middling or failed career. Then there was the fact that Hujar's bohemian, anti-establishment community, many of whom were featured in his photographs, gradually became part of the establishment.

Koch sold his first print at Peter's memorial service. It was a surprise. Robert Mapplethorpe (whose work had a lot in common with Hujar's; in fact, Hujar's work has been called a 'precursor' to it) purchased a picture of a running horse for $500.[46] Koch remembers setting this price – what he felt was a high price – to get off on the right foot. He said he wouldn't 'sell a print for anything less'. But that was a one-off, and later success came slowly. Koch also started to be haunted by dreams of Peter, which made him feel like he was failing in his role to make something of the work. Koch particularly remembers one recurring dream in which he would be at home, and then would hear that Peter was back from the dead. He would go to see him, and Peter would greet him with anger. Peter would then ask what he had been doing to promote the estate, and when Koch started to explain, he would interrupt violently. Hujar would scream, 'Wrong! Stop! Not one more word!' Koch recalls, 'Every move I'd made was stupid, incompetent. The whole enterprise was a disaster. He would never forgive me. He got angrier and angrier, and wanted me

out of his life and his work back immediately. Then I would wake up.'

In the first year of managing the estate, a few influential curators and dealers came to Koch's office. A common complaint, either stated or implied, was that Hujar's work 'could be successful with homosexuals', but not with a wider public.

Koch felt as if he was behind a brick wall for a few more years – until, out of the blue, a dealer decided to take on the work. This was prompted by a suggestion from Gary Schneider, a photographer who had been Peter's friend and studio assistant, and Annie Leibovitz, who was impressed by the work and was the partner of Susan Sontag (who was one of Peter's close friends). As the years went by, curators started to become interested. Then Koch received a call from the Stedelijk Museum in Amsterdam and the Fotomuseum Winterthur. They wanted to organize a full retrospective of the work, which would travel and include a catalogue. Their idea was, according to Stephen, to 'do a show of a great artist who was totally unknown'. This, more shows, a new dealer (Matthew Marks) and acclaim slowly followed. A breakthrough moment was a show of Peter's work at PS1, and another was his recent show at the Morgan.

During all these years, as Koch's responsibilities increased and Hujar's work became more widely recognized, variations on the old dream continued to haunt him. Yet one day, around the time of the PS1 exhibition, Koch had a different dream. He remembers, in the dream, walking into Peter's loft downtown and feeling the place to be 'as tense as a courtroom in which some criminal is about to be sentenced to death. Peter stood in the centre, radiating all the rage that I had so often managed to evade. The attack began. He condemned me. He denounced me. The tirade didn't stop, and every sentence was crueller than the last.'

But then, Koch says, he spoke up. 'Peter,' he began, 'I want to say from the bottom of my heart that I am thrilled that you are back from the dead. And I'll be returning every scrap of

your work, starting tomorrow morning. But before I do, let me say something. In the many years since you died, I have managed to pull your wonderful work out of the dank little hole where you left it. Because of its quality, and my efforts, it is now in many of the major museums of the world. Critics and journalists on three continents write respectfully about you. Curators and collectors clamour for your photographs. Your work is widely published. You have a large, enthusiastic following among the youth of not one but two new generations. And if there is something in that state of affairs that you find less than satisfactory, I suggest you go fuck yourself.' Then he 'jolted awake'. He has not had the dream since.

Koch tells me that the Archive has gone far beyond anything he'd ever imagined when he got the job thirty-one years ago. 'Peter now stands on the threshold of the pantheon. By age twenty-three, [he] felt certain that he was destined to be famous. Somehow, I was sure of it, too. Now recognition has come. My task is far from over, but as time goes by, I will matter less and less. Finally, I won't matter at all, because, as Auden said about Yeats in his elegy, Peter will have become his admirers. Peter grew up abused and in hardship, and he created his great body of work in obscurity, poverty, and against all odds, but no difficulty could stop him. He always knew exactly who he was and exactly how to turn the damaged world he saw around him into images that are whole, beautiful, and his own. He has triumphed.'

I sit here with Koch in awe of what has happened. I'm also very proud of my own small contribution to this success; yet at the same time, I have a nagging sense of fear. Koch is not a young man. He's reaching eighty years old. We talk about the future. He discusses finding someone else to manage the estate, or selling it, or leaving it to his family. I think about where we started this conversation, and the importance of having that one person who really champions the work. I wonder what will happen when Koch is no longer here (which

hopefully will not be the case for a while). Will there still be such a person? Will Hujar's work need to be resurrected again? Or is this the final push that needed to happen, and from now on it's smooth sailing, with Peter's name hard-coded into art history?

Part of me suspects that, unfortunately, the resurrection of Peter Hujar may eventually need to happen again. One thing I've come to understand in the course of my own work is that artists have to constantly be promoted, established and re-established in this world, because people forget things easily and will move quickly on to the next new, shiny thing. Who will be the next champion of Peter Hujar, and who will take up the cause of all the artists today who die without one? I'm not sure; but, in the meantime, at least there are some remarkable people like Koch, who are devoted to the work for their own reasons – whether love, fidelity, fame, financial gain or sheer interest – and, arguably more importantly, who make the time to make the effort.

1. Frieze London, UK, 2012.

2. The Broad Museum, Los Angeles, 2017.

3. Olafur Eliasson, *Your rainbow panorama*, 2006–2011. ARoS Aarhus Kunstmuseum, Denmark, 2011.

4. Taryn Simon, photographed by Rineke Dijkstra, London, 2011.

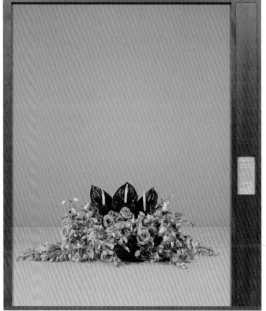

5. Taryn Simon, *A Cold Hole*, 2019. MASS MoCA, North Adams.

6. Taryn Simon, 'Memorandum of Understanding between the Royal Government of Cambodia and the Government of Australia Relating to the Settlement of Refugees in Cambodia. Ministry of Interior, Phnom Penh, Cambodia, September 26, 2014', from *Paperwork and the Will of Capital*, 2016.

7. Taryn Simon, 'Chapter XI', from *A Living Man Declared Dead and Other Chapters I–XVIII*, 2011.

8. Taryn Simon, *An Occupation of Loss*, 2016. Park Avenue Armory, New York, NY, in collaboration with Artangel, London, United Kingdom. Photo by Naho Kubota.

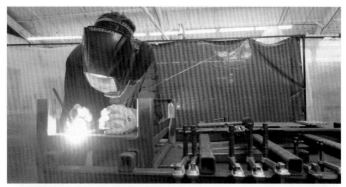

9. Welding in the fabrication space at Standard Sculpture, Los Angeles, 2019.

10. Ted Lawson with some of his own artworks in his metal fabricating studio 'Prototype', Queens, New York, 2018. Works left to right: *Effigy: Satyr With Flute*, 2017; *Nowhere Again*, 2017; *Carina Nebula*, 2013.

11. 26th Street, in the gallery neighbourhood of Chelsea, New York, USA, as seen from the High Line elevated park, 2016.

12. Pace Gallery, 540 West 25th Street, New York, 2019.

13. Philip Reese, Adam Sheffer and Tracey Reese at an art reception in New York, 2009.

14. Jeff Koons posing in front of his artwork *Bluebird Planter* during the media preview of Art Basel Hong Kong, 2018.

15. Art Basel Hong Kong, 2017.

16. Art Basel, Basel, 2019.

17. Peter Hujar, *Self-Portrait Jumping I*, 1974.
18. Stephen Koch, New York, 1969.

Art Writers

Writing about art can mean all sorts of things: art news writing, current events writing, art market writing, art-historical writing, art theory, features or profiles of individual artists or artist groups, art criticism and reviews, promotional writing. And it can end up in just as many places – magazines, newspapers, books, academic journals, brochures, press releases – all existing both online and off.

And there is a vast array of art writing styles. Art writing can be academic, informed by feminist, poststructuralist or Marxist theory; it can be creative, akin to poetry; it can be journalistic, analytical or market-focused. Often – and this is indicative of the best art writing – it's a confluence of various different types of writing. The most prestigious forms are probably art criticism and art-historical writing.

Even in the United States – the world's largest art market, where you might expect to find some good opportunities for making money through writing about art – few people make a living in this way alone. Mirroring the current trend in writing as a whole, art writers' pay has gone down and never bounced back since the recession of 2008. Almost all art writers need to supplement their income with other jobs, such as teaching or copywriting. Many of the print publications focusing on art and culture that historically offered the highest rates for freelancers have closed down, and rates of pay have declined elsewhere as a result of the cost-cutting measures at surviving print or online magazines. In keeping with many other forms of digital content, fees for online articles started out much lower

than for print and have not increased significantly, even as the print versions of many publications have been eliminated.[47]

What makes a good art writer? While that is a gigantic and impossible question, there are some base-level requirements: an understanding of art history and of research principles; a good sense of storytelling or dramatic presentation; a unique voice or perspective; a grasp of nuance and complexity; and a connection to the wider culture and sense of the times. There is also the appeal of new ideas, and the ability to pay close attention to a particular subject or work of art.

—

I'm sitting in a café down the street from my house in Brooklyn, with a man named Jarrett Earnest. He wears oversized sunglasses because of the spring sun shining into his eyes from the street-side windows. He has a dramatic way of speaking, and his long beard recalls that of the 19th-century French realist painter Gustave Courbet.

Earnest is an art writer and curator, and I am talking to him because he is the author of the recently published *What It Means to Write About Art*, a compilation of thirty interviews he has done with people who do just that. It's one of the most interesting efforts to consider (and question) the subject of art writing that I have seen in a long time.

Earnest's book, which is mainly US-focused, looks at a range of art writing from the 1960s to the present day. It includes interviews with art historians who promoted structuralist thinking about art in the 1980s and 1990s, such as Rosalind Krauss; reviewers such as Peter Schjeldahl, head art critic for *The New Yorker*; essayists who have historically pushed the boundaries of the art review, like Dave Hickey, the so-called 'bad boy of art criticism' who is beloved for what he has called his '"love songs" on art and music'; and poets such as Eileen Myles.

Earnest is on the fence about the current state of art criticism. 'I would say I feel two things about it simultaneously:

one is absolute, desolate, abject negativity,' he says, laughing. 'A lot of times I ask myself if art criticism even exists – if we currently have a culture in which anyone wants it to exist? But at the same time, I'm hopeful about what it has been and could be – and all those feelings overlap.'[48]

Earnest feels negative about the state of criticism because he says he sees authority structures that confer value within the culture completely breaking down. As an example, he cites an exhibition that MoMA did on Charles White that they would 'never have been able to...even ten years ago'. This, I infer, is because White is an artist of colour and someone who has not been historically integrated into MoMA's story of modern and contemporary art. Earnest also observes that *Artforum*, for so long a 'signifier of authority', is in an identity crisis about its role in our culture. (Part of this crisis, even though Earnest does not say it, was brought on by the controversy that surrounded the magazine after its publisher, art world fixture Knight Landesman, was accused of sexual harassment, which led to his leaving the magazine. There was a significant backlash against *Artforum* for fostering an environment where something like this could happen, and its editor-in-chief, Michelle Kuo, resigned in protest.)

On one hand, I agree with Earnest. Since I started working in the art world there has been a decentring of many of its power structures, just as in the larger world of culture, and I have found it destabilizing to an extent. I think we're all struggling to understand the reasons behind this. Maybe it's the rise of the internet; maybe it's the post-9/11 climate, in which America has had to really digest the fact that it is one part of a wider world, rather than being 'superior' and a 'superpower'. Maybe it is the growth of the art world into a global phenomenon, with many structures of power – not just ones in New York City. Or maybe it's just about getting older, and realizing that the structures of authority and power you were educated about and revered so much when you were younger were being

viewed through a prism of youth and naivety – and the more time you spend in the world, the more malleable you realize its structures are. But on the other hand, I would never label the phenomenon of decentring and its resulting destabilization as negative; I believe that these changes to long-standing structures of power resulting from a consciousness of the diversity of the world are incredibly necessary and positive.

So I ask him, 'Hasn't this been a kind of goal of progressives in art for so long? To create a kind of crisis that would dislocate or disperse centres of power?'

Earnest agrees, but he believes it is important to create something in its aftermath. He points out that a similar thing happened in the 1970s in the work of Rosalind Krauss. 'When I was talking to her for my book,' he says, 'one of the things she said that she was trying to do in her criticism of the 1970s was "torpedo pluralism", so that everything could not be admissible at the same time. If you look at her students, and the people around her at the influential magazine *October*, they say something similar. "How do we make sense of this world in which everything seems to be collapsed and equally viable?" That idea is challenging because it means that there isn't any hierarchy of importance, and thus the critic isn't needed to make those kinds of distinctions, which traditionally was their domain. So, on the one hand, you could say that it was the ambition of a certain kind of politics to collapse these structures – but in American art history and criticism, there were no intellectual structures that were articulated to serve in their absence.'

Earnest believes this has created a problem for art writing because 'The critic's job is to help make intelligible some aspect of the culture to itself, and if that is no longer necessary – because "everything's okay" no matter what it is – then you have to ask, "well, what is the purpose of this?"' In the place of intellectual structures, he says, the default driver of discussion and debate has become the art market.

At the same time, he professes optimism about the field. He explains that in the process of writing his book and speaking with so many people, he realized that everyone seemed to have their own way of going about being an art writer and 'because the cultural expectations for criticism are so low, critics get to decide what is interesting to them. One way that happens is by challenging themselves intellectually and artistically as writers, and the other is to cultivate a community of writers, artists and people with whom they're in conversation.'

For Earnest, this stands against what he sees as a 'misguided' vision of a globalized art world where people can speak to millions or billions, because he feels it's becoming clear that art 'is for anyone but not for everyone. The audience for serious art writing has always been small, and part of the problem is trying to imagine otherwise. The more diffused the picture of who you think you're talking to, the less meaningful it will be as criticism....That's what people have been trying to do for the past fifteen years online, and I don't think we've seen that create a meaningful context for discourse.'

Instead, Earnest wants to see 'a reversion down to a kind of immediate micro-culture, a circle of friends, which is what culture always was. What happened in the 1990s and 2000s, with the globalism of the art world, is that there was this illusion that something is supposed to be meaningful across the entire world. The same artists in all the biennials all over the place. That is not authentic culture. You cannot gain traction or have a conversation across the entire surface of the globe. That's part of the inherent problematics that we're experiencing right now in the art world. People are having to redefine what is it they're trying to do as artists, or what is it they're trying to do as writers, in the wreckage of global capitalism. From there, we have an opportunity to revitalize the culture and revitalize what criticism even is and can be – there's really no gatekeeper that can stop you, as far as I can see. You know, there's no powerful critical voice that could shut down a new

mode of art or criticism from emerging. And we're really ripe for it.'

According to Earnest, this is why the criticism that seems to be getting the most traction right now is coming from people who are not functioning as traditional art critics: Eileen Myles or Chris Kraus writing in a kind of performative autobiographical mode, or art historians like Douglas Crimp publishing critical memoirs.

Importantly, even within the art world, art criticism seems to be going through a crisis. It doesn't seem paid attention to. I ask Earnest to put a percentage on the number of people in the art world he thinks care about art writing. He first responds, half-jokingly, 'I guess it depends if it's writing about them,' but then with the following:

'Well, what percentage of people in the art world are paying attention to any writing at all? Very little....That's back to the depressing part of it...which is why art criticism seems kind of doomed. Most people in the art world are not reading. They are not reading literature. They're not reading poetry. They're not reading. Or if they are, it's very narrow, a by-product of professionalization....I couldn't even begin to measure my own little slice of the art world against even the whole of the New York art world. I mean if you consider how many galleries there are, how many people work in them, the art handlers, the artists...'

One of the things I was told in my first college art history courses on modern art (and have come to accept) was that there was a time in post-war American art history when the critic was said to be driving what people paid attention to in terms of art – but then, as time passed, the collector started to rise in terms of influence. 'I'm sure you have heard that story – and do you believe in that?' I ask him.

Earnest says he has heard that story, but he's never experienced it while he has worked in the art world.

'To me...the greatest power of criticism is it's a constant around which you can organize a little mini-reality, a

community of people who have engaged with this object and had feelings and thoughts about it. You see something and have a thought about it, and then you can read a work of criticism that will connect it to much more. It's like the famous image of crystallization Stendhal uses in his treatise "On Love", of the bough dropped into a salt mine. The naked branch begins to accumulate salt crystals, and it becomes ever more refracted and beautiful. That's what criticism does. Artwork is the bough, and criticism is one activity through which it becomes encrusted with human life and thought and meaning – made into an ever-splendouring thing, an ever more beautiful thing, as it moves through time. Sometimes you have to brush away the layers that have encrusted a great work of art over centuries, but that becomes part of their story – the way that people responded to a painting in the 18th century, the way that it was loved by so-and-so in the 19th century. And here it is before you, in the Frick or in the Met or in the MoMA, and you get to have your own authentic, direct experience that is in conversation with thousands of other people in the world. And in a way you then enter a community of minds, you enter into a conversation that goes through time and space, not just with the artist but with other people who are engaging with the same artwork that you are.'

'In the next five to ten years, what would you like to see in terms of art writing, and what are some things that you actually think will happen?' I ask.

'I would like to see a bunch of younger writers coalesce around a new platform,' Earnest says. 'I live in New York. I can really only speak for New York, but I would like to see a certain kind of energy take the form of a magazine or a couple new magazines or websites or whatever, that have a real opinion and a stake in the conversation but that aren't intent on executing the other people who do not agree, but instead understand that having disagreements makes everything better. It makes thinking better, it makes writing better – and makes it more

fun. It's pleasurable. Right now, my fear within the culture is that people are not talking to those who they don't agree with. Even within the art world. My hope, and what I think will have to happen, is we have to break down those barriers that exist between different factions of the art world, or different kinds of writing, and really look for a magazine or a publication of some sort that could be a place in which that could really foment – and I think that you cannot have it only in one place. There needs to be a couple. You need a critical mass of publications. We have so many smart people who are writing in New York right now. We have such good art and there's so many good people. All the elements are there. It's just waiting to congeal....I think what's happening around the magazines *Triple Canopy* and *4Columns* is very interesting, but I think that we still really need something else that could be stronger, more provocative, a catalyst. I mean with a kind of *Team of Rivals*-like level rigour...So I think that's going to happen, because I would probably kill myself if I didn't think it was going to happen,' he says.

We both laugh. 'That's a really sad way to end this conversation,' I say, still smiling.

'Yeah,' he says. 'Well, I told you that that's kind of where I'm coming from with this. As I said at the beginning, I think the potential of art writing is so awesome and exciting. I also think its reality is so impossibly bleak you can't go on. And both of those things can be true at the same time.'

Part III **Summer**

Curators

I'm in Manhattan, at a building that appears from the outside to be a series of unevenly stacked light grey blocks. This building is the New Museum. Its slogan is 'New art, new ideas', and it has become world-renowned for its exhibitions of international artists. In many ways this is due to a curator named Massimiliano Gioni.

The word curator (in Latin, literally 'one who takes care') has historically meant different things. In ancient Rome, curators were people who looked after citizens deemed unfit to manage their own property or minors (under twenty-five) when there was no family left; the term was also used as a title for some of the people who administered public departments. Although in certain contexts this former meaning is still used, in modern understanding the term curator has come to mean keepers of museums, art collections and public galleries.

Even this meaning has evolved significantly during the late 20th and 21st centuries. Because museums are looked to more and more to exhibit and collect new art, the best-known curators are those who work with contemporary art and put on exhibitions of current work, both in monographic shows of individual artists – which at major institutions, often take several years to secure and develop – or group shows exhibiting what are deemed major trends. All of this requires funding, which curators are expected (in some places more than others) to help locate. Curators have thus become prominent

gatekeepers for art of the now – deciding, through inclusion in shows or acquisition of works, which artists are taken seriously and are considered part of art history, and which are not. These activities result in an endless trickle-down effect that influences the buying habits and attention of collectors, critics, museum patrons and the general public. (At the same time, and to back up: collectors can actually be the catalyst behind curators' decisions. Their purchases and place on museum boards can influence what shows a curator decides to do, although this is a fact not often discussed.)

As a result, curating contemporary art has become one of the fastest-growing and most intriguing professions in the art world. Curators are now bona fide stars who ensure their institutions' critical and commercial success. It is partly because of this stardom – but probably more because there is a need for people to be able to sort and navigate the internet's endless flood of information – that curating has infiltrated the wider culture. As most of us have seen, restaurant menus, Facebook pages, and even the flavours of air fresheners are now 'curated'.

Curators come in a range of types. Those who have full-time jobs at museums do various things: some might work carefully on exhibitions over a number of years, and do little else; some primarily manage departments of other curators, functioning more as managers than creative decision-makers; and younger curators sometimes take on smaller projects, but most often their work involves assisting with the projects of more senior colleagues. Outside of institutions, there are freelance curators who are paid per job (and the pay can be quite minimal). They can curate at museums for one-off projects, but they mostly curate for non-museum, non-profit spaces or galleries, or organize large temporary group exhibitions such as biennials or triennials.

Curators generally want to produce exhibitions that are challenging, where they can test out ideas and artists and provoke audiences in a good way – and which eventually stand

the test of time. And they want to do shows that add something
to the wider conversation, whether by featuring artists who
are exhibiting their work for the first time, or by presenting
better-known artists from a new angle or in greater depth. The
success of a show is usually measured by attendance, positive
reviews, word of mouth, and, for independent curators, further
invitations to curate other exhibitions.

———

Italian-born, forty-four-year-old Gioni, who is officially the New
Museum's artistic director, is widely considered one of the most
important curators in the world, and I am here today to try to
pick his brain about that role. We are seated in a conference
room on a floor devoted to offices at the museum. The space
is cramped, as are the offices. This is by no means unusual for
the art world, and especially for museums, where the magnifi-
cent spaces are devoted to artworks while people are (with a
few exceptions) almost an afterthought, often crammed into
claustrophobic, bullpen-like 'open office' spaces featuring out-
dated technologies.

The story of Gioni's career thus far reflects the emergence
of the curator as a pivotal art world role, parallels the career
paths of many curators of the last decade and gives voice to a
number of the challenges such a career involves. Handsome,
charismatic, well-spoken and humorous, Gioni became at age
thirty-nine the youngest ever artistic director of the Venice
Biennale. This was in 2013, when he was dubbed 'The Crown
Prince of the Art World' by *The Wall Street Journal*. By that time,
he already had an impressive track record of curating major
biennials including the Berlin Biennale (2006); Manifesta 5
(2004); and the Gwangju Biennale (2010). His first professional
role in the art world was as an editor for the Italian/US maga-
zine *Flash Art*, initially in Italy and then in the United States. In
his time at the New Museum since 2006, he has been involved
with almost all of their exhibitions in some fashion. Between

2002 and 2005, Gioni also ran a highly acclaimed, one-metre-square exhibition space in Chelsea called The Wrong Gallery, along with curator Ali Subotnick and artist/art world jokester Maurizio Cattelan. One of their exhibitions consisted of a sign reading 'FUCK OFF, WE'RE CLOSED', by the artist Adam McEwen.

Gioni grew up in a small town in Busto Arsizio, Italy, outside Milan, in a family with no connection to the art world. He got into art in his teen years, and realized at university that he wanted to be 'close to art' in some way – or, as he says, 'with art'. This led him to start writing about art, and he founded an internet art magazine.[49] Then, at a certain point in the early 1990s, he started to become more conscious of the growing status of curators in the art world – it seemed curating was becoming more public, almost an industry in itself. He mentions a few things that made this apparent, including the fact that the 1993 Venice Biennale was curated by multiple people; and that the publication by Phaidon of an exhibition-as-book, *CREAM*, featured 100 'rising art stars' chosen by ten curators from around the world – and he knew many of them. There was also a series of talks at the ARCO Madrid art fair that focused on the subject of curating, something that would be very normal today but was rare then.

Around the same time, Gioni came to a few other realizations. For one, he wasn't going to be able to make much of a living as an art writer. ('Sadly, writing is the profession that has profited least from the expansion of the art world,' he says.) He'd come to New York as an editor working in English, which was not his mother tongue, and found this to be a difficult shift, so he gravitated towards opportunities where language was less central. He also increasingly found that the critic was out of the loop of the art world – left to deal with the art once a lot of what he found exciting was over. 'Even with the greatest critic, they come into action once the artwork is done,' he explains. Curators, by contrast, he found to be 'much more

in the mix', almost in the role of producers. He continues, 'I started thinking, oh wow, that's interesting. And I started realizing that there was a way to be a *companion* to the artist. And I [realized] there were people who were the spokesperson... ones that vocalized what the artists were doing. I don't want to suggest that the curator is an artist, but they are closer to the source of the artwork and...more of an accomplice.'

As a result, Gioni shifted his focus away from writing and editing and began looking for work as a curator. Between 1999 and 2003, even though he always had editorial and translating side gigs to support himself, this resulted in him assisting the acclaimed curator Francesco Bonami for most of Bonami's shows. 'That's how I learned the ropes,' he explains – adding with a smile that for most of this period, if he ever began to feel a little self-important, he would remind himself that when you typed the word 'curator' into Microsoft Word, it would be highlighted as a typo.

Gioni's first major show was in 2003, when he curated a young Italian pavilion at the Venice Biennale. Since then, he has curated countless shows, most of them critically acclaimed. 'And so, I think I can celebrate fifteen years of more or less sloppy behaviour,' he jokes again.

Gioni is less critical than some others of the societal expansion of the term 'curating' to embrace things like salad. He explains, 'I think we can all make fun of the kind of hypertrophy of curating...but I think this is a result of the art world growing in size and influence...and I would be lying if I were not to recognize that this increase has also created more spaces for a lot of people who I love and respect. You know, I don't think a museum like this could exist in a different moment.' On the other hand, he fears for the future of curators and museums as a whole due to the emergence of curated platforms, such as Spotify and YouTube and museum-like Instagram-fodder entertainment experiences such as the Museum of Ice Cream and Refinery 29's '29 Rooms', which take

on the authority of curating and often get far greater attend-
ance than art exhibitions. 'They are clearly taking a few pages
from the contemporary museum, from the avant-garde...the
kind of experiential, immersive presentations that have defined
contemporary art in the past few decades. You know, we joke
here at the New Museum that we have imposed a moratorium
on the word "immersive". It's gone from being some sort of
critical or avant-garde position to being the ultimate form of
consumerism. I live in an anxiety of what museums will be like
in ten or fifteen years,' he says. 'In my life I never thought that
I would see the end of the music industry, or the dissolution
of ideas of underground or alternative versus mainstream. I've
seen the end of cinemas, and I may be living long enough to
see the end of museums as we know it.' According to Gioni,
to survive, museums need to remain true to their values, as
places that are generally more difficult than something like
the Museum of Ice Cream. He says that he often creates shows
with too much text – or more text than people generally expect
– because he wants people at the museum because they made
a conscious choice.

Even though curating has gained significant societal
prestige, Gioni warns that it shouldn't be seen as glamorous.
He mentions this specifically in the context of his work with
artists. 'It's not necessarily always a friendship,' he counsels.
'Some of these relationships can be awful. A great part of exhi-
bition-making is the mating dance with the artist, but also
the trauma of that relationship, which can be quite confronta-
tional. I enjoy spending time with artists, but at the same time
they are a source of both joy and anxiety! When you work with
artists there should be something like the equivalent of belts in
karate. For example, if you are a black belt in curating, you can
go into a room with an artist and he or she gets it. But it doesn't
work that way. You know, you can be a black belt or you could
have done the Venice Biennale and a dozen of major shows, but
once you sit down with the artist, he or she thinks they know

a lot about their work – and it's true – and you're going to have to work it out as though you were a white belt, a novice. Yes, it's frustrating, but this also keeps you in check, because your ego cannot get inflated, because the next artist could tell you to "fuck off" as much as the one that told you to twenty years ago! I'm sure for the artist too it's annoying to have somebody like me try and say, hey, have you thought of *this*?'

Museums are always trying to figure out how to measure the success of their exhibitions, and increasingly, as more businesspeople get involved in museum work and management, there are efforts to find and create more data (within or aside from attendance and press coverage) to mark wins and areas for improvement. Gioni pushes back against this type of approach. He explains, 'One thing that makes the New Museum very special – and of course, this is to Lisa Phillips', our director's credit – is that I think we strive for excellence, whatever that means, but there isn't a lot of space for business talk. There is a clear understanding – maybe because Lisa was a curator, and *is* a curator – that we shouldn't just simply model our discipline on a business model. So, we do strive for success, but we don't really...have a matrix.' He points out that they have never scheduled a show at the New Museum because it was going to bring people in; and they have never cancelled a show, even when they were conscious that the money was going to be tight. Gioni also says that the museum's future success is in many ways based on their track record: he believes people are confident that what they are going to see there will be top-quality. 'This sounds maybe obnoxious of me, but I think we can go and knock on the door of any artist tomorrow and have a fair chance that they will do a show here; I think we can play in the same league as much bigger museums, and that maybe is a sign of success.' He also thinks it's important to reinforce the idea that some shows may not have high attendance, but will still be culturally significant. 'I always say "This Is Tomorrow", the exhibition [at the Whitechapel Gallery in 1956] that gave the

name to Pop Art and became a legend in and of itself, opened at the beginning of August and ran for four weeks – a slot you'd never give to a half-decent show. I don't know how many people saw it. Maybe it was a resounding success, but probably no one even knows the actual numbers of visitors, and that's okay: we know the show, not how many people saw it.'

Curating the Biennale at such a young age can be hard for a curator; Gioni is conscious of a certain narrative of decline regarding his career. He jokes, 'I have a bright future behind me,' or, as Jesus said on the cross, 'I'm at the pinnacle of my career.' But then he explains, more seriously, that he would like to do another large show. He observes that the trajectory of people's careers moving from the small time to the big time, to ever greater achievements and goals, is not the only way it has to be; it may not even be well suited to the time in which we live. 'You know, the 21st century is asymmetrical by definition. It opened with 2001 in asymmetrical war. Suddenly the biggest world power had to come to terms with the fact that people with literally no weapons could inflict a major blow – with basically a box cutter. Not that this comparison is particularly delicate or smart, but maybe the 21st century is not about a clear trajectory of growth?' He also points out that curating Venice at such a young age may even have been better for him: he had less to lose and didn't have to defend a career or an agenda, all of which meant he had a little more freedom.

Curating Venice so young also led to a lot of job speculation for Gioni, and this was quite normal, as many curators work their way up to more and more prestigious positions in museums or exhibitions – and then the expectation is that they will direct a museum. Yet Gioni has preferred to stay put and keep doing his job. This, he says, is because being a museum director is a different type of role, and one not necessarily suited to all curatorial interests and skill sets. 'A lot of interest came from many institutions after I did the Biennale,' he says. 'And I keep getting approached for different jobs. But

I had second thoughts about a couple of things. I wouldn't have been allowed the freedom to do projects outside of the museum [he cites an exhibition he is currently working on, on Jeff Koons and Marcel Duchamp, at the Jumex Collection in Mexico City]; and my bosses would be trustees. And while I love trustees, I felt like my impact on the future of an artwork or an artist would actually be thinner if I were a director. Maybe it's just that I still consider myself a player, not just a coach, and I want artists and artworks to be my bosses and my clients. But the question is still – how long can you postpone that transition to being a director? Because the way the system is built, particularly in America, is that it happens sooner or later, and otherwise you find these situations in which somebody else will come in and be your boss, someone you don't know. I can think of many examples,' he concludes. 'And I am thinking these are not such positive examples.'

———

The number of curators working in the art world today is increasing quickly, particularly because of the success and growth of curator training degrees. As curating has grown as a field, and the art world has slowly begun to make an effort to become less Amero- and Eurocentric, curators from a wider range of geographical regions have come to the West. Some of these curators have served almost as ambassadors, opening doors to artists, art tendencies and bodies of knowledge that have not previously been explored – or at least, not in such depth.

One curator who has received a good deal of critical acclaim in the art world in recent years, and who has become one of these looked-to voices for non-American or European regions, is Omar Kholeif. Kholeif is known for his expertise in the art of the Middle East and South Asia (his other focus is, more broadly, 'artists of the post-digital condition'). Born in Cairo, he has worked in London at the Whitechapel Gallery, and then at the Museum of Contemporary Art, Chicago, where

he occupied Francesco Bonami's former position of Manilow Senior Curator. He then spent some time working on independent projects before taking on the new role of Director of Collections and Senior Curator of the Sharjah Art Foundation.

Kholeif is a peripatetic curator recognized not just for his exhibitions but for his accessible, engaging writing, which has appeared in publications including the *Guardian*, *Frieze* and *Wired*. He has also written or edited over thirty books, including *You Are Here: Art after the Internet*, an influential title on post-internet artistic practice.

At the time we talk, Kholeif's next big curatorial project is the 14th Sharjah Biennial, which explores themes of time, acceleration and exhaustion. That will quickly be followed by an exhibition made up of entirely new work about speed, resistance and slowness at the Palazzo del Zaatere at the upcoming Venice Biennale, called 'Time, Forward!' – which is the V-A-C Foundation's participation in the Biennale. He's also teaching at Oxford's Ruskin School of Art, and writing two new books: a book of poetry, and a monograph called *Encounters with Contemporary Art*. In addition to all this, he is preparing a major retrospective of David Lynch's paintings for the Manchester International Festival, a group show on poetry and mythology for the Modern Art Museum of Fort Worth and another group show called 'Art in the Age of Anxiety'. Clearly, Kholeif is in significant demand right now.[50]

Kholeif believes there have been some major changes in the art world since he started working in it. For one, he says, he sees curating becoming more 'subjective'. He explains that he finds it more common for curators to bring a sense of authorship to curating rather than simply acting as what he calls editors-in-chief. 'The term "editor" was described to me repeatedly as being part and parcel of the role of a curator during my studies; I don't find this to be the case. I see curating as a discursive field of practice where I get to explore my interests – that's why I curate, not because of some moralistic reason,

i.e. those who might say that they do it to simply present the best view or version of X artist or X movement. That's not to say that this isn't worthy practice, but I see curating as very much a space that is determined by the subjectivity of the person pulling the thing together.'

Kholeif mentions some unremarked-upon aspects of what curators do now. He highlights that they can be informal art advisors (sometimes formal ones) – generally, they are people who others go to in the hope of discerning the quality of their taste. They can also be friends to artists, offering non-judgmental feedback on their work – and 'they read, write and above all, look!' More broadly, he thinks curators should be appreciated for creating 'discourse around how, why and what we should be looking at in the realm of contemporary art'. Additionally, he remarks on the fact that commercial galleries have been increasingly 'poaching' curators to organize shows for them (rather than for museums or non-profits). These opportunities offer the advantages of better pay than typical non-profit positions; more contemporaneity, because they don't have to plan as far in advance as museums; and more scope for risk-taking, because the subject matter or cost (for the wealthier galleries) might be well beyond what a larger not-for-profit could support.

Independent curating is a different animal. He emphasizes the many roadblocks for exhibition-making independent curators have to consider. Even for someone at his level, it is a 'huge challenge' to simply get your idea 'on the roster somewhere', he says. 'There are dozens of shows that I want to stage, but finding the right venue, the right time, etc. is the biggest thing standing in the way of these dreams coming true. I can get invitations all the time to stage shows, but there will be someone's specific remit in mind: but what about what I really want to do?' And then if the show is accepted, there is the major challenge of fundraising. 'I do believe that as curators we have to show artists and their work in the best possible light, and to

offer them a chance to do something different. But the costs of exhibitions have grown ever more expensive with the professionalization of the art world, and so the curator is now expected to be the one hunting for the money (as she or he) has the most intimate knowledge of the project, the artist, etc.'

Regarding the way the term 'curator' has moved into mainstream usage, Kholeif expresses a belief that cultural attitudes actually haven't 'changed much'. 'The average person,' he says, 'and I include my parents in this category, have no idea what a curator is or does....But it has become the norm now that if something isn't "curated", that it isn't worth seeing or engaging with – which perhaps is rightly so!' Regarding other major art world changes, Kholeif lists the following: 'What was once dubbed "new media" is no longer in a pure silo or ghetto; there are more art fairs than before; people feel they need to go to more art fairs; there are more boring panel discussions and talks than before, and everyone has become more obsessed with [fundraising] in the age of austerity brought about by cuts in government funding.'

———

Koyo Kouoh is another curator who, in recent years, has been looked to to speak on behalf of a non-American or European region of the art world. In her case, it is African art.

The story of African art's position in the global art world is a long and complex – and racist – one; but in recent years, African art has come to occupy a much bigger place in the international consciousness. This has been spurred on by, among other things, the 1990s and 2000s work of powerful curatorial voices such as the late Okwui Enwezor, one of the few people to have curated both Documenta and the Venice Biennale – and the only African curator to have done so. The profile of African art has also been raised by the growing US focus on African American art and the significant galleries, art fairs (such as 1:54), other curators and collectors promoting African art. Koyo

Kouoh founded Raw Material Company in Dakar, Senegal, and has recently been named the executive director of the Zeitz Museum of Contemporary Art Africa (Zeitz MoCAA).

Like many African curators – or, Kouoh notes half-jokingly, 'the very good ones' – but unlike the recent generations of American and European curators, she did not grow up with a sense that she would become a curator. She grew up in Cameroon, in 'modest conditions' and in terms of career paths, families where she lived pushed kids into what she refers to as 'the Holy Trinity: economics, law or medicine. I had absolutely no idea in my youth about artistic practice.'[51] And when she eventually did discover an interest in modern and contemporary art, when she moved to Switzerland as a young girl, she realized how little information there was available on the subject. Any art books she came across focused on American or European artists – 'Picasso and so on' – and there was very little information on 'classical' African works. This ignorance was a symptom of the greater ignorance Kouoh came into contact with in Switzerland about Africa in general, especially regarding what was happening there in recent years and in the present. She says she was shocked by the almost complete lack of knowledge Europeans had about Africa and Africans. 'In Africa,' she says, 'when you have more or less a decent background, you are taught almost everything about Europe and the US. But I realized [then] that this is absolutely not the case [in Europe and the US regarding Africa]. That was a shock for me, and that was something that really bothered me deeply – and continues to bother me today.'

While Kouoh believed classical African art was 'unrivalled and unmatched in terms of its radicality and quality', as her interest in art increased, she determined that she didn't want to be caught in the usual cliché of studying this type of work, and continued to wonder 'what African artists were doing now'. Then she started searching out materials on the subject – mostly magazines, as there were few books – and in the

process became basically self-taught, though she mentions Simon Njami and Enwezor as major influences on her work. In the 1990s and 2000s, Njami and Enwezor curated many of the first major exhibitions to bring African artists to an international audience. 'Without Okwui's work,' she says 'and [his] constant feeding [and mentoring], I would not have become a curator. Both have immensely *fed* me into thinking through art and artists, and also getting a sense of place. A sense of place means a sense of location, a sense of where you stand – what is your ground?'

Kouoh's biggest career challenge has been battling against the ignorance of African art, an ignorance she says is constant and has fed so many stigmatizing clichés – but in recent years she has decided to move on from this approach. 'I used to have to [feel like I needed to explain everything to everyone],' she says, 'but I refuse to do it now. It's been ten years that I don't do it any more. I'm not here to educate ignorance. Nowadays, you want to know something – Google it, find out...a lot of things are on a *click*. I'm not here to educate people who are lazy.' She now tries to focus on 'producing that material and that knowledge that needs to get out there. And fine for anyone who wants to pick [that effort] up.' She also explains, 'The ignorance of non-Africans about Africa is shameful, so to speak. But the ignorance of Africans about Africa itself is a *tragedy* – and I try to work against that tragedy, particularly in the context of art. So my immediate interlocutor is the Dakar environment, is Senegal, is West Africa and is the continent – and by the way, I am one of those who will always speak about the continent as a whole because I think that the more they have [established] so many divisions, [the more there has] been so much divisive rhetoric. [So] for me [it is] very important to speak from a whole perspective because as a whole, I feel supported by the massive continent with so much diversity; with so much to give. Of course, that doesn't mean that I don't acknowledge particularities and specificities and diversities and all of that,'

she adds. 'I really also want to have a conversation with my immediate surroundings – be it Dakar, be it West Africa, be it Africa as a whole, you know, to escape this postcolonial condition of constantly speaking to your former power and saying "look at me. I'm really good. You said so many times that I'm not good."'

Dakar is a centre for the visual arts arguably unmatched by any other city in Africa, other than those in South Africa. It's historically been, according to Kouoh, 'a mythical city in the imagination of lots of Africa, at least from West Africa and Central Africa, because of [Léopold Sédar] Senghor [Senegalese politician, poet and theorist who helped found the idea of *Négritude* or black consciousness in French colonies in the 1930s and 1940s] and his utopias and his imagination; his cultural influence and his theorization. It's also been economically stable and cosmopolitan, and had the most important university in West Africa, so it's always been this centre for multiple generations of Africans who come from Cameroon, Mali, Côte d'Ivoire and the Congo, among other places, to study. Finally, Dakar had the only biennial in the entire continent for the longest time – years before Johannesburg and Cairo and any other city.'

Kouoh decided to open Raw because she saw a gap in the structures the country had for art. She explains, 'Dakar had all the structures for presenting and promoting arts and culture – a national gallery, a museum of art, a biennial, a ministry of culture – and even some galleries and cultural centres. [But] a lot was always focused on *display*; on exhibition-making, not necessarily on the analytical. It was lacking a space to discuss the process of artistic practice; the process of curatorial practice; a space where one goes beyond the exhibition-making, where one engages with what feeds into every art work one might be exposed to in an exhibition context. Practically, the city was lacking a space for art research, where you could have a good art library and access to material that might not be

readily available elsewhere – because Dakar University doesn't have an art history department.' Raw's first space was a library, and then they grew from there to develop residencies, publications and exhibitions. 'But really the root of it was to deal [with this issue that we were] surrounded by exhibition-making practice that in the context of Dakar becomes a social kind of event – people go to openings, go to see shows, but most of the time they don't necessarily have access to what is behind the work that they are seeing, and what generated the works that they are seeing,' Kouoh says.

Like Kholeif, she emphasizes that one of the biggest challenges to her work is money. 'Why do I say money? People are full of ideas. You don't need money for that. You need money to implement them. And one of the biggest challenges is that there is this general expectation from society, from people in general, that creative people – so-called artists, curators and writers – can just provide, you know, ideas and content for free. And this is something that nobody talks about. Apply this to non-affluent societies, places where the system of arts and culture is not so elaborated in a way, where there are channels and pipelines of exchanging support and money and commerce and whatever, it becomes extremely difficult.' Kouoh admits that these issues can really push her over the edge. 'I can get very aggressive on those topics when I'm confronted with it,' she says. At Raw, for instance, she makes a point of ensuring that whenever someone reaches out for collaboration to work with a professional, they always say under what financial conditions it will be.

Kouoh believes that at the end of the day, past presenting 'the best art possible in the best way possible and...from all possible angles of entry and understanding', she wants people 'to be able to really live more through art, in a sense, to really understand the object, to understand each time, because it changes all the time. To understand what kind of knowledge artists are putting out there through their works.' She believes

one thing that is underappreciated is the sense that 'art has its own thinking system that is very difficult to grasp, as opposed to any other social science or other field'. She feels that curators borrow too much from other social sciences, such as politics and economics, to explain art. 'As much as all those borrowings are helpful...to understand the practice of art and the works of art,' she says, 'I think that there is another step that a lot of us have not done to get into the really interesting thinking system that art provides. I would love to see a text about art or an artist's practice that, from the first word to the last word, is knowledge and material that came out of the work – that is not referencing Deleuze; that is not referencing I don't know who or whatever.'

Chapter 9

Biennials

The art world is flooded with biennials. Since the 1980s, when there were only a handful of these exhibitions – large-scale, non-commercial biennial group shows, highlighting the work of a particular city or a region for an international audience – their number has increased all over the world. It has ballooned especially fast during the past decade: between 2008 and 2018, the number of biennials increased fivefold. There are now roughly 250 biennials in cities around the world: some of the best known are in Venice, São Paulo, Berlin, Sharjah, Istanbul, Shanghai, Johannesburg, Lyon, Moscow, Sydney and Oslo, but there are biennials organized in virtually every country, including Andorra, Bangladesh, Benin, Columbia, Slovenia – even Antarctica.[52]

Biennials can be an effective way for cities that may have been overlooked by the world art market or art tourism to present themselves as new art destinations. In the process, they have also become a way for cities to create so-called 'calls to action' to visit at certain times. They can attract tourism, press and revenue, and can help to boost regional and national pride.

The value of biennials should also be recognized in comparison with art fairs, which serve a different, commercial purpose but increasingly do include curated sections. In short, the best biennials blow art fairs away in this respect, because the focus of a biennial is so plainly on curating the work and the experience. There isn't a rush to buy, or the focus on financials and booth-to-booth experience that, in the end, downgrades the art at a fair. As Klaus Biesenbach has pointed out, 'Going to an art fair…is nothing in comparison to going to a [biennial]

curated exhibition where organizers and artists really cared for the form and the content of the exhibition, not its sell-ability [or the fact that] visitors can take small or medium-sized colourful pieces home and place them behind their couches and hope they quintuple their value in two years.'[53]

Biennials usually have a head curator, or a small two-to-three-person curatorial team – and almost all the world's recognized curators (including Gioni, Kholeif and Kouoh) have curated at least one. They also usually have a curatorial statement, which allows the event to say something about the state of art, culture and/or society. A great deal of thought is put into how the works are arranged and what spaces they are placed in, in order to connect back to this statement.

The Venice Biennale, which has been dubbed 'the World Series of curating' and the 'Art Olympics', is considered the world's most prestigious biennial. Its historical longevity and increasing size and success have been a primary catalyst for the growth of biennials worldwide. 'Venice', as it's simply known in art world conversations, is on view in two areas of the historic and majestic canal-filled Italian port – the Arsenale and the Giardini – from May through November every two years, and it has been a longstanding art world institution since 1895. For much of its history, Venice has been seen as one of the best places to figure out what is happening in the world of contemporary art; and, because of its influence on the critical and collecting audience, what will happen next.

In terms of format, Venice is like the United Nations of art exhibitions. Although in its first year the exhibition was limited to Italian artists, it soon became open to foreign artists to show – and since then, countries around the world have set up individual exhibitions in permanent spaces that are called the national pavilions. In 1914, there were seven pavilions; today there are thirty. In addition to these pavilions, there is the main exhibition – the 'International Art Exhibition' – which is organized by an artistic director, who is appointed every two years. Alongside

these there are also a large number of unofficial special pro-
jects and collateral events organized by galleries, museums,
non-profits and collectors during the run of the exhibition, to
capitalize on the prestige and audience of the moment. Finally,
there is an award for the best artist of the exhibition: the pres-
tigious Golden Lion. A significant moment in the history of
American art was Robert Rauschenberg's Golden Lion win in
1964. He was the first American artist to win it (and, at thirty-
nine, the youngest ever to win at that point), and his triumph
was taken as a strong signal of the international acclaim and
embrace of American artists in the post-war period.

Despite the fact that Venice is not a selling exhibition,
the reality is that a lot of deals happen there. When artists
are chosen to show there, their galleries naturally attend and
use the moment to market their artists to collectors. It was
rumoured a few years ago that the mega-collector François
Pinault, who owns a magnificent two-part museum in Venice
(the Palazzo Grassi and the Punta della Dogana) had pur-
chased eight Georg Baselitz paintings on the spot during the
Biennale.[54] Galleries also help to fund some of the artist inclu-
sions, and they set up collateral events around the Biennale
to show them too. Additionally, it's very convenient that every
other year the art fair of all art fairs, Art Basel, follows Venice;
many collectors go from the opening of Venice to Basel, and at
Basel they are conveniently shown new works by some of the
galleries' artists who have exhibited at Venice.

The announcement of a new Biennale artistic director is a
major moment in the art world calendar. As Venice is one of the
most prestigious large-scale exhibitions to take place outside of
a museum, it represents one of the top honours in a curator's
career. It's hard to think what could be more significant for a
contemporary curator, other than becoming the director or
chief curator of one of the world's major museums.

For 2019, Ralph Rugoff has been chosen to be the Biennale's
artistic director. Right now, I am sitting across from him in the

Hayward Gallery, the contemporary art museum he directs in London. We're squeezed into a futuristic-looking glassed-in porch in a small hallway space, behind a room where people are looking at pieces of video art with headphones on. It's a public space, but Rugoff has set up two chairs for us there because it's a spot where we can have some quiet, and he is overwhelmingly busy. I'm thus ready to gather as efficiently as possible what I can about what it takes to curate the Venice Biennale.

Rugoff is an Ivy League-educated (Brown University), sixty-one-year-old white American man with a long face and a greying beard. For the last twelve years he has lived in London, where he moved for the Hayward position. He came there from San Francisco and the Wattis Institute – a small, progressive and critically acclaimed contemporary art institution con-nected to the California College of the Arts – which he directed from 2000 to 2006. Prior to that, Rugoff worked as a freelance curator, but mostly as a writer and critic. Writing is still central to what he does, to the extent that he claims he doesn't person-ally understand an exhibition until he has written his curator's essay about it. He believes writing makes one a better curator, and has said that 'the process of writing – and the thinking it requires – helps one to better understand the issues in each exhibition and to discover lines of connection between works you might not otherwise have noticed'.[55]

Rugoff is well spoken and thoughtful. He is also slightly stooped in his jacket and button-down shirt, and his hair is a bit messed up. I'm curious about what effect being the Biennale artistic director has on one's energy, and how many other meetings and events and phone calls he has had to attend to before this moment. The Biennale won't open for several more months, but the work it takes – to create such a large show, and put forward one of the most important statements on what is happening in the world of art – usually begins as soon as you're selected. In recent years, the director has been selected after

the current Biennale closes, leaving a window of only eighteen months to make it all happen.

Interestingly, even Rugoff can offer little insight, outside of his own history as a respected curator, into why people get chosen as artistic directors. There's no application process or election-type scenario, no hat to put your name into. 'It's all a mystery,' he says.[56] 'You'd have to talk to the president of the Biennale, Paolo Baratta. I don't know how I was chosen....I just got a phone call at home one Saturday asking me if I would like to have lunch in Rome, but no discussion of what it was about, though [Paolo] did identify himself. Lunch in Rome sounded good, so I was happy to go; and after we had a very nice lunch, he asked me if I would be the artistic director.' Rugoff suspects that the choice wasn't made until after the lunch, and that the lunch was a necessary opportunity for Baratta to 'check him out'.

Rugoff's appointment is historically significant. There have been plenty of other white men appointed to the position – recent years have seen efforts to push back against this tendency – but Rugoff thinks that he may be the first artistic director to ever be based in the UK. (This is a bit complicated because Rugoff considers himself, at this point, American and British, with two passports, and he says he is 'immersed in both cultures'.) 'I had to wonder, when I got the appointment, if it was in some ways a response to Brexit. This was going to be the first Biennale after the UK had left the EU – of course, that scheduled departure remains up in the air. But Paolo has never said anything to me. If it wasn't intentional, it just seems like a funny coincidence.'

There are many challenges in front of Rugoff right now. The short timeframe is one big one. Another, according to Rugoff, is keeping conversations going with eighty different artists, while also trying to keep re-adjusting your mental picture of an exhibition that will encompass close to 1,000 individual artworks. Then there is the challenge 'of presenting each artist's work in the best possible manner while also trying to highlight

the relationships between them, so that the exhibition as a whole makes sense', he explains. Rugoff has reached out to past Biennale curators since he was appointed, but he says, 'I probably need more advice than I have gotten. It sort of is what it is, though; there are no secret recipes. It's a complex beast with certain challenges, and there is no one way to make good on it.'

The travel schedule for people in the art world – expected to be experts in the world of contemporary art, which means attending countless fairs and biennials and major exhibitions – can be unrelenting. For a person who is curating an exhibition that purports to represent the entire world and is considered one of the crowning moments of a curator's career, it is doubly unrelenting (if that is even possible). Rugoff says that already, at this point, he is 'travelling almost every week', and that he will eventually go around the world – 'visiting five continents' – due to all of his travel. 'This doesn't mean I get to see much of the world,' he clarifies. Most of his travel consists of arriving in cities only to take a car to a studio, gallery or other space to look at art – and then immediately moving on. This gets paid for through a mix of backers. 'I have a travel budget,' Rugoff explains, but he says that the Biennale also seeks out relationships with governments and other national organizations who are interested enough to fund his visit based on the prestige of being included in the show.

Rugoff is not a one-man show. He has several assistant curators, and divides the work among them. He explains specifically he has chosen them '[based] on an ability to handle thirty artist projects at the same time' and that, in addition to this, there is a group of people in the office in Venice who 'do much of the heavy lifting' – i.e. they take on a lot of the logistical efforts to get all the work to Venice and install it.

Is it really possible to have the confidence to make a statement about the entire world of art – especially given the state of the world today, so disassociated, so infinitely complex, so filled with a myriad of identities, themes and interests that one

person can hardly begin to understand it? Rugoff explains his approach to the question. 'I don't think [for this exhibition] you have to make a monolithic statement about the entire world....I'm trying to do something that will be more specific, and will highlight art's capacity for open-ended thinking and juggling alternative perspectives, and contradictions – the exact opposite of the kind of thinking that informs most of our polarized political discourse today. To me, art's great value is to provide an arena in our culture where you can encounter more complex ways of thinking and feeling, where questioning and curiosity take priority over knowing the right answer. Unfortunately, education is becoming more and more geared towards producing people who will be useful workers in one way or another, while most pop media tends to be formula-driven. It seems like art is one of the few places in our culture where there is this room for this kind of type of thinking which seeks to find connections between things we don't normally connect.'

It seems like every major art institution, to some extent, is subject to protest nowadays – protests they are sometimes prepared for, and sometimes are taken entirely off guard by. This reflects a larger political environment (particularly in the US and Western Europe) in which questions of representation and sources of cultural funding are increasingly at issue, and where (luckily) there is freedom to publicly debate those issues. Just to name a few examples of the many art world protests of the past few years: in the US, the Metropolitan Museum of Art was protested because of its funding by the Sackler Family, members of which own Purdue Pharmaceuticals, blamed for fuelling opioid addiction. The Brooklyn Museum was protested by the group Decolonize This Place for a lack of diversity in its curatorial staff, board and programming after a white woman was hired as a consulting curator in its African Art department. The Whitney was protested by the New York chapter of the historically influential activist group ACT UP (which stands for AIDS Coalition to Unleash Power) because they felt its David

Wojnarowicz retrospective at the museum misrepresented the AIDS epidemic and made it look like it was no longer an issue; and in London, the Tate and the British Museum have been protested for the controversial behaviours of exhibition sponsors Ernst & Young and BP.[57]

So the Biennale has the potential to be open to a lot of criticism, because of the significant stage it occupies. But Rugoff seems to have prepped for this – at least regarding the content of the show and not the Biennale as an institution – and believes it's worth it for him. He says, 'If you agree to do something like this, you can't be too thin-skinned.' He then proceeds to list all of the challenges for curating what is inherently an 'impossible' and 'brutal' exhibition: its overwhelming scale and number of artists, and its imperative to include artists from all across the globe in a meaningful manner. At the end of the day, he explains, since you can't avoid controversy and the idea is to 'take chances' and 'not to play it safe', you need to just go for it. He adds, 'I received some early criticism about the title of the exhibition, which in the West was falsely believed to be an ancient Chinese curse. The critics lashed out without realizing that the "fake news" status of this counterfeit proverb was precisely the point of using it. And that's the world we live in now. Denunciations on social media drive traffic. So, you know you're going to get some criticism, no matter what moves you make.' He continues, 'If you're doing exhibitions for a period of time, you're not always going to get good reviews. And sometimes you're going to get mixed reviews. Initially it's no fun getting a bad review when you're starting off, because it's printed in a public forum and you have no recourse to address it, to write back, and say, "Hey, wait a second, I think you misunderstood something important here." But ultimately, I think it's about getting used to the idea that it's the nature of things that people interpret the same thing really differently. That's one of the interesting things about art. People have really different reactions to

it. They read it differently, they have different experiences of it. And, in a way, that's what makes the art world interesting. It's always a discussion, because there's no definitive way of looking at any of this work.'

While none of the information about the exhibition is public yet, Rugoff does reveal that one of his main interests is playing with the format of the show. He explains, 'I'm not so interested in having a theme, because it could close down the way visitors read the works of art, and my point is to focus on the open-ended character of contemporary art. So, I decided to divide the Biennale into two parts, or propositions, with the same artists showing very different types of works in each of these parallel shows. In a way, they will both be alternative versions of the same Biennale.'

Rugoff is honest with himself about the status of Venice in the face of the proliferation of biennials around the world, and this has affected his approach. 'The whole exercise seems pretty redundant,' he explains. 'That's why I think it's more interesting to experiment with the format. There seems to be, not for everybody, but in general, a strong tendency among biennial curators to want to make sweeping statements about world politics, injustices across the globe – to treat it like it's a United Nations platform. I often feel there is too much overtly tendentious work in biennals that doesn't really serve the purpose that I think it wants to serve. There are many things we need to change in the world, but I don't think the revolution is going to start in an art gallery. For me, the problem with a certain kind of political art is that it is very wedded to one particular position: it can't represent the kind of open-ended thinking that I think is art's great strength as part of our culture, because it's locked into one particular perspective. I have very strong feelings about the state of the world at this moment and it seems quite precarious in terms of the health of democracies around the world (and also in the West), [and] the acceleration of climate change. We seem to be at a moment

where we could really descend into a very dark period, but I also don't think that making anti-Trump art is necessarily going to make things better. We all need to do work as engaged citizens, but we don't have to do that job in an art gallery.'

At the end of the day, Rugoff is hoping for people to take away from his show 'a joy in complex experience and thinking'. He explains, 'Art to me always has to be challenging – it challenges all of our habitual ways of looking and thinking – but it should also provide pleasure. Pleasure is the fuel that keeps us involved enough to think through what we're grappling with, and not just to stop at superficial responses. Really good art is enlivening in every way. You're feeling more, you're thinking more, you're paying attention in different ways, and you realize suddenly that there is some other room in your head that you've never entered before, and now you can go in that room and look out the window and get a different perspective.'

———

A week after meeting with Rugoff, I am back in New York, walking west along 14th Street towards The Whitney Museum of American Art. The Whitney, designed by superstar architect Renzo Piano and opened to the public in 2015, sits on the waterfront next the Hudson River and capitalizes on the immense popularity of the High Line. It is still one of the newest and most exciting spaces for contemporary art in New York.

I'm heading to The Whitney to meet with two other curators of a major 2019 biennial – Jane Panetta and Rujeko Hockley, co-curators of the next Whitney Biennial. This is the most anticipated biennial exhibition of contemporary art in America, regarded (as Venice is in relation to the world) as the major statement of what is happening in American art. Other museums in the US have biennials and triennials, but they are not solely focused on American art, and because of its history and connection to a major museum, the Whitney Biennial is regarded as one of the most important biennial exhibitions

in the world.[58] Hundreds of artists have gotten their breaks thanks to the Biennial, which was first held in 1932. It's a safe bet that again this year the artist list will be hotly anticipated and acted upon by the art market and the art press – which, as with Venice, loves to use it to engage collectors.

Alongside the excitement of the show, the Whitney Biennial is notorious for attracting criticism – maybe because its unusual domestic focus, and its inherent aim to encapsulate what American art is right now, provide commentators with a ripe opportunity for making analogies about what is wrong with the country. (This has led it to be characterized by past curators as an 'imperfect mirror'.) The Biennial also frequently becomes an occasion for reflection on the unequal demographics of the American art world; the choice of artists in terms of race, gender and representation of any kind is always pored over and subjected to debate, discussion and sometimes protest. In 1987, the Guerrilla Girls protested the show's sexism – only 24 per cent of that year's artists were women – as well as its racism. The 2015 biennial was criticized for the fact that out of 118 participants there were only thirty-eight women, only nine of whom were black. In 2017, an open letter addressed to the museum asking that the painting *Open Casket* by Dana Schutz be destroyed spurred anger and protest on both sides. The painting depicted Emmett Till, the African American teenager whose lynching in 1955 galvanized civil rights activism of the era; the incident had come back into the news in recent years because of the wrongful deaths of other young African Americans including Trayvon Martin, Alton Sterling and Philando Castile. On one side, critics of Schutz (a white woman) challenged her right to appropriate such a freighted historical image; on the other side, supporters viewed the painting in the context of Schutz's work and defended her right to free speech.

Observers regard the Biennial as an opportunity to see how the museum, and perhaps by extension the wider cultural

establishment, identifies *who* qualifies as American. Although in its early years The Whitney's identity as a museum of 'American art' was meant to be anti-establishment – a call to arms in the face of a Eurocentric art world – today, such a label is open to accusations of xenophobia. Accordingly, in recent years the museum has used a working definition of American artists as those who 'live and work in the territory', allowing for the inclusion of individuals who are only temporarily in the United States or who identify more strongly with another country.[59]

⸻

I take the elevator up to The Whitney's light-filled offices, which have beautiful double-height windows that evoke an elaborate cruise ship or a spacecraft, and am led into a glass-walled conference room to speak with Panetta and Hockley.

Both curators came to The Whitney from quite different places and have quite different public profiles. Hockley, who goes by 'Ru', was born in Zimbabwe to a Zimbabwean mother and English father and spent her childhood living internationally, primarily because her mother worked for the UN, in places such as Somalia, Barbados and Malawi. Hockley is thus an interesting choice for the Biennial, as even though she and her family have spent a great deal of time in the United States, none of them are American citizens.[60] Hockley has also been the subject of various magazine articles, maintains a popular social media presence and is married to an artist – Hank Willis Thomas, who has one of the largest social media followings in contemporary art, and is constantly involved in new activities that often involve some mention of Hockley.

By contrast, information about Panetta is quite hard to find online, and it seems like she prefers to keep a much lower profile. There is barely a web biography of her, outside of the announcement that she is curating the 2018 Biennial and various credits for shows she has curated (which just list her name, and little else).

The process of being picked to curate the Whitney Biennial sounds similar to that of Venice. There's generally no application process, and like Rugoff, Hockley and Panetta learned the news out of the blue directly from the person in power (in this case, chief curator Scott Rothkopf), who announced that he wanted to meet with them. They were both initially confused by the urgency of this request and thought it implied bad news rather than good. The subject line was 'just, like, *meeting*', Hockley recalls.

At the same time, both Hockley and Panetta believe they were practical choices for the museum. Panetta believes she and Hockley already had kind of a 'jump start' on the biennial. 'Both Ru and I have been working as part of this emerging artists working group at the museum,' she says. She had also done a lot of programming with emerging artists since the museum opened and had worked on acquisitions and done studio visits, as had Hockley.

Preparing for the Whitney Biennial is arguably harder than for Venice. (Hockley jokes that one of the first pieces of advice she got was to make sure to keep her health, in readiness for what was in store.) Venice generally goes to a curator who has done a show on a similar scale before, working with a large number of artists and dealing with all of the logistics, timeframes and schedules. By contrast, the Whitney Biennial is typically undertaken by people earlier in their careers who work at The Whitney in-house and have either (due to the priorities of a museum) focused on smaller group shows or monographic exhibitions that deal with only one artist. This is not to say that those shows with fewer artists are less challenging; but it's quite daunting to go into an exhibition where you are given the responsibility of taking the temperature of American art, of an entire country, and figuring out how to go about that, when you haven't even worked with that type of exhibition model before.

Hockley and Panetta emphasize, though, that they are

not alone in the endeavour. They have a small team of people working to support their project at the museum, and they are also supported in various ways by the rest of The Whitney staff. They went on a 'listening tour' before formally beginning their work, to speak with people who had curated the biennial previously – 'There is no biennial handbook!' they say – and they stress that the biennial has a sizeable budget. They won't say what this budget is, but Panetta offers that it is a 'significant chunk of the [museum's] annual exhibition budget'.

Panetta and Hockley also want to emphasize how they went about approaching the show from the beginning: not with an overarching idea, but with a desire to be led by what they saw. This is similar to Rugoff's approach, though Panetta and Hockley might end up leading with a more strict theme than his by the time their show goes up. Panetta explains, 'How we started our process...feels essential to understanding where we ended up. We very deliberately approached our research without too many pre-set ideas, forcing ourselves to head out with an open mind and to ultimately be led by what we found and saw in terms of both artists and works. This wasn't a situation – as is often the case with exhibitions – where we had a predetermined thesis we wanted to support, and went out seeking the appropriate examples to support our ideas.'

Hockley and Panetta are conscious of the power of the Biennial, which they call a 'lightning rod' at the institution and which they see as having the potential to make an artist's career or change its trajectory. But they also clearly see this power, and the focus it brings on creating an expression of American art right now, as what it has been in the past: a kind of 'impossible mandate', something that can be difficult to manage once the show is up. Hockley says, 'I am a little hesitant to kind of go fully down [that] road [of creating a show that encapsulates America]....I do think that was something that could be

true when it was a much smaller art world – like even in the nineties...but in 2019, no.'

What's not often discussed is the nature of the art world stardom that being picked for something like Venice or the Whitney Biennial can bring to curators. Being out in public as the known Biennial curators has changed Hockley and Panetta. They express anxiety about being out at major art events, such as art fairs, owing to their newly acquired power and influence. They made a point last year, for example, of not having their names announced as the curators until after Art Basel in Miami Beach; they thought they would be watched for the entire fair, at one of the major events for American art. Even outside the context of fairs, Hockley says, her new title can make things complicated. 'It's intense. It does change how we interact. We are now in this position where we are inherently saying no to a lot of things – by virtue of saying yes to a few things, you say no to a lot of things – and it does make it sometimes a little less appealing to go to a fair, or even go to galleries, to walk around, just as you would normally, on a Saturday, because it's slower – there's a lot more talking, and...'

'People are pitching stuff,' Panetta adds.

They've both noticed that a few weird things now regularly happen to them. For example, according to Panetta, 'You'll sign the [signature] book [at a gallery] somewhere and then twenty minutes later you'll get an email,' and someone will want to come talk to them, mentioning that they 'just happened' to notice they had been there, and can they help them with anything? In general, she explains, 'People are just paying attention to what we're doing a little bit more than before.' She adds, 'It feels...hard for us personally to be in a position where we're, like, picking people for something.'

And Hockley says, 'Everything is significant in a situation where there's a lot of discretion...Especially because we both have had relationships with artists, and that's been really important to both of us throughout our career, both in our

work, but also socially...I'm married to an artist. I think that part has been, and is, really, really hard – it kind of sucks, honestly, especially having to be perceived as tastemakers, like it's this objective thing. I mean, I say this all the time: the work that we do is deeply subjective, because it is about our own [taste]. Jane and I are doing a biennial – two other people who would do also a super great biennial, i.e. other people looking at the same artist, the same cities, the same historical period, would [curate something that would] look different. So I just really try to push back against the tastemaker thing and against th[is perception of] objectivity.'

Hockley and Panetta have a smaller area to travel than Rugoff, but they have made a point of going to cities in the US that people might not expect them to visit, to enable the geographic diversity that they believe is essential to presenting a show on American art and to avoid the sense (notable in past Biennials) that most of the artists come from New York or Los Angeles. Counting on their fingers and looking up at the ceiling to remember them all, they list the places: Boston, New York (and upstate New York), LA, San Francisco, Houston, Austin, Portland, Detroit, Miami, Puerto Rico, Birmingham, New Haven, New Orleans, Cleveland, Chicago and Berlin. The longest trips have been five days – filled with non-stop studio visits and meetings – and they have been (and plan to go) to a number of these places more than once. Hockley says from the winter through the summer of this year, the plan has been to 'travel during the week and try to be home on the weekends – to try and just be people in our lives'. They've also made a point of visiting other biennials, both to see artists and, probably, for the sake of comparison. They say they have been to 'Made in LA', which is held at the Hammer Museum in Los Angeles; the new FRONT Triennial in Cleveland; the Berlin Biennale; the Venice architecture biennial; Prospect New Orleans; and the Carnegie International.

Yet their approach to travel has never been about spending

time on a plane every day. They are aware that there is a point at which quantity would not equate to quality, even if they had all the money in the world. While there are some influential curators (the most well-known being Hans Ulrich Obrist) who popularize the idea of a successful curator being everywhere at once and travelling in perpetuity, Panetta explains that she and Hockley decided they were 'going to do this, we're going to travel, we're going to make a real effort to travel nationally... but we're not going to...this is not going to be about visiting eighty-five locations in the United States'. She is alluding to a 2014–15 project undertaken by the Crystal Bridges Museum in Bentonville, Arkansas (famous for being founded by Walmart heir Alice Walton), in which the curators took 'the ultimate road trip, a thousand destinations...to investigate what's happening in American art today'. They travelled more than 100,000 miles, 'crisscrossing the United States to visit nearly 1,000 artists'.[61]

Hockley adds, 'I think there's often a lot of travelling and a lot of hype about the travelling and all this pounding the pavement, flights every day, and I don't know that when you go to see the shows, you think the show is good or compelling or moving because people went to eighty-five locations...You don't see the residue of those locations necessarily in the shows...[So we have always been thinking,] what's the kind of "have your cake and eat it too" version of that?' They admit, though, that they won't ever be able to represent everything or show the work of everyone they want to. They acknowledge that there are artists in cities they have visited whose work they haven't seen, and cities and regions to which they haven't paid enough attention. One way they have tried to fill the gaps in their travel and research is by using digital tools. Hockley comments, 'Living in this technological moment that we're in, we...Skype with a lot of people.'

They hope their show will be seen as a way to push back against some of the dominant forces that make it hard to be an artist, to be part of the effort to see through the money

and influence and power at the top of the market and allow a broader statement of American art. Hockley explains, 'At the end of the day, one of the really important things for us, about the biennial and about doing the biennial, especially in this time in 2019, is that this be a platform for as many people as possible. It's really hard to be an artist in New York right now, but also in other places: [with the cost of] studio space, MFA debt, the art market, the gallery system, small galleries closing – there's just so many pressures that we kind of felt like this moment is an opportunity we have to kind of spread the love and really give a platform to people we really believe in and [try] to do our small part to be a bulwark against all of these really, really intense and sometimes seemingly insurmountable obstacles to being a creative person in the world. So, it just felt like when we think about how we're spending our money [for the show], that has always been really top of mind. That's what we're trying to do here. You need money to do that, and more money lets you do that for more people.'

While, like Rugoff, they can't speak about the details of the show, they say they are aiming to organize an exhibition that has certain thematic groupings, that functions like a historical exhibition with contemporary art and allows for artists to be in dialogue with each other. They describe this as a response to recent tendencies to create monographic rooms for artists – which is common now at art fairs – or to just bring together a massive collection of works that aren't given much thematic shape. It's also been inspired by the work they both do at the museum on similar types of shows, which they characterize as 'successful': Panetta's work on the museum's re-opening exhibition, 'America Is Hard to See', and Hockley's 'Incomplete History of Protest', which looked at how artists since the 1940s engaged with political and social issues of their historical moments. Hockley cautions that their thematic groupings won't be too heavy-handed. 'There [will be] like nodes that you're hitting or thematic constellations that make up [a] big

idea. But it's not like everything you see perfectly hits that thesis on the nose – that doesn't make for an interesting [show].'

When I ask about models and inspirations for the show, Panetta and Hockley cite past biennials, which they have taken the time to research in the museum's archives. The records include installation shots of past exhibitions, going back decades. A major inspiration for Hockley has been the 1993 biennial, which has come to be seen as one of the most influential Whitney Biennials. Highly criticized at the time, it specifically focused for the first time on one major theme: politically and socially engaged art from marginalized groups. Hockley also mentions Okwui Enwezor's highly political 2015 Venice Biennale, 'All the World's Futures', about which she says, 'Okwui, throughout his career...really modelled a lot of things we're talking about, really working with artists, high-lighting artists, really putting work[s] in dialogue with each other [and] thinking deeply about what work is doing, but also what history is doing [and] how these things kind of interpo-late with each other, but that show I just felt, walking through it, it was like, wow, this whole thing has been thought of, this floor plan, this immense space of the whole Venice Biennale had been so clearly considered from a curatorial perspective from a "what is an exhibition?" [perspective] – making an argu-ment in space, with objects. And I said to myself, wow, [he] did that, on the biggest kind of scale possible and it never – for me, at least – fell apart.'

I bring up the controversy from the last biennial, and ask them if this is something they have thought about. Both obvi-ously have, and both take a deep breath and consider their responses. They say it's really a 'little bit the luck of the draw'. Even at The Whitney – even though it does its due diligence and thinks in advance about how any exhibition will resonate with the public – unexpected things do happen, and the museum was caught off guard last year by the controversy. Hockley says, 'I think so much of what happened in the last biennial was

connected to the historical moment. I mean, we know that that painting was shown in Germany and nobody said "boo", so context is deeply important, but I also think the timing is important and we can't predict the future. Obviously, we have no idea what's going to be happening in May...'

They are already sensitive about not being all-inclusive, though. Panetta explains, 'We're going to put more emphasis on certain things, and certain locations maybe and certain mediums, and with that is going to come criticism.' She explains that the show is, importantly, a show – not a book or 'an essay, and so I think it's going to leave things out, and that just provokes people.'

But they're also very aware that any choice they make to include anything that might be considered controversial has to be something they both feel fully on board with. Hockley explains, 'I think obviously our intention is not and would never be to court controversy, and this is one of the really important kinds of big-picture feedback notes we got from previous biennial curators: especially in the wake of the last biennial, be sensitive to who [is] making work that may be controversial but has a deep underpinning and is important, versus artists who are courting controversy themselves. And think about that, because now you're in this position where people are going to be looking at you in a very particular way because of the last biennial. And so, I think we've been thinking about that, but still knowing that, approaching it that way, we still are doing our due diligence, doing all these things. We still kind of can't predict what may or may not happen.'

Chapter 10

Art Schools

It's now a few weeks later, and I'm a bit uptown from The Whitney, sitting on a hard, light-grey couch in a room containing little more than a minimalist coffee table and a floor-to-ceiling wall of bookshelves. The view, as at The Whitney, is very nice – but now it is a southern view of Manhattan, as we are on the tenth floor of a building in Chelsea. This floor is the headquarters of the School of Visual Arts' Curatorial Practice programme.

The School of Visual Arts (SVA) is one of the major art schools in New York City – if not the country – and it has been educating artists, designers and creative professionals since the late 1940s. With more than 6,000 students at its Manhattan campus and nearly 37,000 alumni in seventy-five countries, SVA could be considered one of the most influential artistic communities in the world. Among the school's famous art alumni are Sol LeWitt, Joseph Kosuth, Elizabeth Peyton, Sarah Sze and Keith Haring; though Haring is an interesting case. He didn't graduate, but was expelled after he was caught creating a graffiti project inside an SVA building – with none other than Jean-Michel Basquiat.

SVA's Curatorial Practice programme is a two-year master's degree that provides training through direct exposure to established curators already working in the field. Most of the coursework consists of case study seminars that focus on different types of curating (performance, digital media, interdisciplinary programming) and practicums in exhibition-making, as well as writing workshops. The programme also

secures internships and establishes a means for constant networking through its weekly speaker series of notable curators, artists, conservators, writers, critics and theorists who, according to the programme's website, 'stream into our space on 21st Street from around the world to talk about their exhibitions, programmes, projects and events'.[62]

The room I am in is in just one section of the programme's floor-through space, and it bears little resemblance to how one might traditionally envision a school. There is only one traditional-looking classroom that I can see; other than that, just a series of floor-to-ceiling white rectangular moveable walls on wheels, which can be arranged at will and make up any size of room that's needed. This structure can accommodate intimate discussions as well as large-scale exhibitions – which makes perfect sense for a curatorial programme proposing to unite ideas with the nuts and bolts of putting up shows.

———

This particular space at SVA represents just one dot on a worldwide map of thousands of art graduate programmes currently on offer. When most people think of graduate schools for art, they don't usually think of a school like this. They characteristically think of studio art schools, or maybe graduate programmes in art history. Yet this understanding is drastically outdated. In the last forty years – particularly in the art centres of the United States and Western Europe, but also in China – as staggering amounts of money has fuelled the art world and the art market has expanded into myriad new forms including biennials, art fairs and private and corporate collections, more and more art world roles have become specialized and streamlined into professions. Accordingly, training has been (in many respects) invented for these professions, so now 'art school' can mean many, many different things.

Art schools are now set up to train people for careers as artists and art historians, but also as art journalists, curators,

auction house specialists, conservators, advisors, gallery owners, art educators (for pre-higher education schools), art publicists, collection managers, social media experts, and founders of online art ventures – in short, for most of the professions discussed in this book. These graduate programmes (as the specialized programmes are mostly at the graduate level) have names like Curatorial Practice, but also Curatorial Studies, Art Business, Museum Studies, Art Education, Visual Arts Education, Art and Education, Art Education and Community Arts Practices, Arts Administration, and Critical and Visual Studies.[63] While most of these new programmes exist in the art centres of the United States and Western Europe, they field international populations. They are also usually a part of colleges and universities, with some programmes – that focus more directly on the art market – having more of a partnership relationship with higher education institutions.

Reflecting the broader trend in higher education towards gaining more vocational skills, and owing to the existence of art history and studio schools, these newer programmes tend towards the practical, with less emphasis on theory and what seems to have been deemed the less applicable approach of an art history degree with hands-on skills. Also, the predominant focus is on working in the field of contemporary art – which has seen a major boom in interest in the last few decades, especially in relation to other fields and time periods. A lot of programmes – because the focus is on art of the present – market the fact that they do trips, site visits and field work, which makes it advantageous for them to exist in major art world spots such as New York or London and allows students to participate directly in the world they are studying.

Most of these programmes are marketed as a means of accelerating one's progress in the art world. For example, in an art business programme like the one at Sotheby's Institute of Art, the proposal is that instead of spending five years 'learning the ropes' by working your way up in a gallery or auction house,

you can acquire comparable industry knowledge in a single year. Accordingly, their courses, like 'Navigating the Art World', 'Introduction to Valuation', 'Art Law', 'Principles of Business 1', 'Collection Building' and 'Art Advisory' are presented as equipping you with skills you might normally develop on the job – but chances are, not in such a concentrated and systematic way. Recent years have seen some of these programmes also introduce online courses, which can function in a variety of ways: as a means for students to test out coursework before enrolling in the fuller programme; as a way for them to take an individual course because they are interested in the subject, without the expectation that they might progress further; or as a way for enrolled students to take some of their courses. Some (but not many) of the schools even offer fully online degrees.

———

Amidst all of this expansion, most of these new art graduate programmes – especially those more directly connected to the art market – are uncontroversial. While their strategies differ and they might be expensive, most of them are seen to offer concrete skills that can be applied to certain growing, profitable professions – and they are not difficult for students or their families to rationalize.

This is not the case with MFA Studio Art programmes, which are what most people think of when anyone mentions graduate school for art (though the MFA is no longer generally regarded as the terminal degree for fine arts; increasingly, at least in Western Europe, this is the PhD). Especially in the United States, where there is little to no government support for arts education, questions have been raised about the usefulness of MFA studio programmes in recent years – primarily because of their very high cost, and the very low chance of artists making any money from their artistic success afterwards. The cost for the most esteemed two-year MFA programmes in the

United States, such as those at Yale, Rhode Island School of Design, School of Visual Arts or Columbia University, can be over $100,000, and this doesn't include the funds needed for room and board and materials.[64] So the current sad reality is that a large number of the roughly 30,000 MFA graduates per year studying studio art (I clarify here, since the MFA is offered also for things like filmmaking, animation, interactive design, graphic design, product design and illustration) in the United States will end up as unsuccessful artists saddled with significant loans they will never be able to pay back.

Yet artists still want MFA programmes – so how, in this day and age, do you make an educated decision and evaluate whether a programme is a good fit for you? Traditionally, you would have focused on the reputation of the institution and the faculty and their ability to feed into the art world, but just as important would be the crafts and techniques related to different forms such as painting, sculpture, printmaking, etc. These might include drawing and painting from life and nature; casting, welding, carving; an understanding of the properties of materials and the interaction of colours – and since the advent of photography, camera and darkroom techniques. Judging the quality of the programme, in essence, meant assessing the students' knowledge and practice of these techniques. Yet, as is well-known, since the 1960s, these methods – many of which were passed down from medieval guilds to the Renaissance apprenticeship system, and 19th-century beaux arts academies – have, to a large extent, stopped informing how artists make work and what types of work they make. Mostly due to the influence of artists like Marcel Duchamp – who proposed that any object could be understood as art, and suggested the idea of a work was just as important as the object – artists and the art world have eschewed traditional definitions of craft and dispensed with many historical notions of quality. And since the 1960s, art has been progressively allowed by its makers and the rest of the field to be virtually anything:

a painting or a sculpture, but also a meal, a discussion, or an installation consisting of whatever materials the artist sees fit to include.

———

I'm at SVA today to ask Steven Henry Madoff about how to make choices about MFA programmes. He's the chair of the Curatorial Practice programme, but more importantly he is the author of the book *Art School (Propositions for the 21st Century)*, which collected writings from over thirty leading artists and educators to consider the state of studio art education.[65]

In *Art School*, Madoff calls the art school a 'factory of ideas, objects, practices, and pedagogies', and labels the field as 'particularly restless, wanting more porosity, irritated by bureaucratic weight, impatient for new shapes, even for an ephemeral life'.[66] Yet based on the opinions given within, there seems to be some consensus on what makes a good art programme at the moment. To begin with, most people in the book stress the importance of artists having adequate space to make work, and how a school needs to, in a sense, remain separate from the world to allow the artist the freedom to think and create, and really make an unencumbered statement. But there is some debate about how separate to make such schools. Some opt for an ivory tower approach, insulating artists from the influence of the art market, while others focus more on placement services, such as offering more professional development and encouraging exposure to the business of art and galleries and to subjects like branding as well as strategies for enabling a long-term career. Most agree that students should have interaction with working artists – and some faculty members believe there should be a *lot* of interaction, as much as possible, with them. Leaders of these programmes also mention the importance of creating relationships between students and a space for criticism and debate (which they facilitate through structures such as one-on-one interaction with teachers), more

group critiques (which bring classes or the whole student and faculty population together to discuss an individual student's work), and bringing different types of students into one programme, to stir things up. Some of the professors stressed the importance of writing – particularly working to find or create a writing voice suited to the kind of work that they make.

One of the big issues for MFA programmes is that they struggle with finding the right balance of faculty members, and this struggle affects their identity, their appeal to students and the quality of what they offer. In an environment where a sense of what is good or in style is constantly changing and up for debate, there is little consensus about how long an art educator should remain in their post. The upside to long careers and tenure is historical perspective and knowledge, but the downside is a risk for schools that the teacher's work will not be influential, and their opinions and allegiances will become ossified.

'Superstar' faculty can also be an issue; they attract attention and students, but often cannot devote enough time to teaching or being with students (or even physically just being present on campus) because they are too focused on their careers. This puts pressure on their teaching assistants to handle the responsibilities of teaching their classes, leading to a poor departmental dynamic in which certain faculty are allowed more leeway than others. It can also be a problem if such faculty members hire students to be their assistants, perhaps giving those students a false sense of success by catapulting them into situations where they are able to network with the top brass before they're really ready to do so. A different set of issues arises with teachers who have no experience in the field – they may come cheaply, be enthusiastic and have new ideas, but these tend to be academia-approved ideas without much grounding in the real world.

Madoff believes we may be approaching a tipping point for the MFA in the 21st century in terms of economics, politics and even the paradigm for the art school itself.

When I ask why, he explains that in the most practical way, there has been real flux recently. He says, 'For major art schools in the US, there was apparently a one-year drop around the time of Trump's election, when there was an international sense of not knowing what the future would hold. There were consequently less applications for a year, but a year later things bounced back and, in fact, applications have increased.

'But if anything, the crisis is cost for students and their subsequent level of debt, which is an issue for all American schools. And there's the hanging question concerning Chinese students in particular – as once again the situation for all American schools, and European art schools as well, is that it may not always be the case that great numbers of Chinese students will come, as they have been for several years. If for political or economic reasons that changes, this will have a powerful impact on the revenue and staffing of our art schools. That hasn't happened yet, but it's a matter of real concern. And in the meantime, our degree at SVA is more than $70,000, where you can get a degree of quality in Zurich or Frankfurt or London for considerably less, even if it's a very different kind of experience.

'But it's also a moment of change. The model of the Bauhaus, which remains the standard model for art schools, is one hundred years old. There are new ways to think what an art school is and can be,' Madoff says. He proposes that one way out of the present conundrum could be the digital realm. 'At SVA, David Ross – the former director of SFMOMA and The Whitney – founded a programme in 2011 which is an online low-residency programme, meaning you take more theoretical and art-historical courses online and then you come to the school during the summer...for three years for three summers, and work with a different faculty for studio work.' He also wonders

whether advances in VR and haptic feedback could allow for an advanced type of experience learning studio, when a student could be working on their own work and the professor could virtually visit the student's studio and comment in real time. They might even be able to observe more in this situation than in a classroom.

Madoff thinks art school buildings, which usually try to house everything that goes on in a department, might be reconsidered as the sole model in the future. 'In the world that we live in now, when specific forms of expertise, of course, are all over – they're linked by knowledge production through the internet and apps and so forth – should we think about a kind of disintermediation, and dis-integration – not collapse, but separating out these different components, where a school could be a network and it exists in different places simultaneously?' he asks. He also thinks a focus on ethics could prove to make art schools more relevant. 'If you have studied what I studied, in terms of looking at the curricula of art schools all over the world, ethics does not play a role in what is called foundation. I think now more than ever, as we see the rise of authoritarian governments, [this] is something that artists need to understand and discuss and integrate into their practices,' he says.

There is definitely a possibility that the MFA programmes around us now simply will not last. Some cultures still rely on a more traditional, one-on-one apprenticeship model (as opposed to a student attending a particular school) – and maybe the skyrocketing costs of degrees will drive the field back to a model like this. Or maybe, as Madoff suggests, social networking or virtual reality software will yield new opportunities for connection and training entirely outside the university model.

I've been particularly intrigued by such attempts to create alternative MFAs in recent years, primarily due to the money

issue – which I have been quite close to and shocked by, as I work with many artists and have a number of friends who are MFA grads. Alternative programmes are characterized by their often small, nomadic and user-focused nature, which allows them to react to state or national regulations such as the Bologna Process in the European Union or to standards for MFA education in the United States. One example that received a lot of attention in recent years in New York was the oddly named and now defunct Bruce High Quality Foundation University. What is that?

In brief, Bruce High Quality Foundation is an artists' collective created by a group of art students from Cooper Union, and the University was an art school that became an offshoot of it. The school started in 2009 and lasted until 2017, but in its time it became a buzzy, in-the-know kind of place for an elevated type of dialogue about contemporary art. It was one of the few independent, free and relatively long-lasting efforts to remake the art school in New York City.

Today I am sitting with Seth Cameron, one of its founders, because I want to hear the story of BHQFU. Over the years I've talked about the school with many people and read various articles about it, including one by Cameron about the closing down of the school. I thought it was valuable to be able to track what had led to the rise and fall of this notable effort to change the format of the MFA.[67]

BHQFU's initial motivation came directly from the experience of being a student at Cooper Union and having an intellectual coming-of-age experience there about the design of the education system they were part of, Cameron tells me. 'On the one hand,' he explains, 'we were immersed in the spirit of Institutional Critique, that art can be an examination of its own political context, simply by the fact of who the faculty were at [Cooper at] the time. Hans Haacke, Doug Ashford of Group Material and Walid Raad were around, and while I'd credit all of them for not engendering a master-apprentice approach to

teaching, the arguments their public practices were making were definitely a big part of the conversation among students. So, in that spirit we looked at our own context, art school in the early aughts: how it came to be and what ideologies were at play. Now, Cooper Union at the time, despite its accreditation, was notable for what made it so different from other schools. No one paid tuition, and it had, and still has, a drastically lower admissions rate. At the time I believe it was five or six per cent, with the next "top" schools accepting forty per cent and higher. And Cooper's history as a crucible for radical politics, from its role in promoting the abolition of slavery, advocacy for feminism and women's suffrage, and critiques of capitalism writ large, underpinned an ideology within the school that art had a role to play in the world that was either actively resistant to, or at least "other than" the market.' At the same time, Cameron was seeing graduate schools function more like feeders for commercial galleries. He was hearing stories about dealers doing studio visits to Columbia and Yale, which is common practice now, but at the time struck him and his community as a horrifying corruption of the sacred space of the academy. 'So, when you combine a scepticism towards the art market, a belief in the ideological value of free education, and the egotistical sense that our own education was far outpacing that of other schools, it made for a lot of resistance to the idea of pursuing an MFA. In fact, it was a point of pride for my graduating class that very few people were going directly to graduate school,' he explains.

BHQF then started to get some attention from the art press, which in turn brought the attention of dealers and collectors, and at the same time Cameron's artist friends were starting to think again about graduate school to get them back into the studio and provide a credential to allow them to teach and possibly make a living doing so. 'So once again we look at our own context,' Cameron says. 'We've got some public momentum, some money coming in, access to space, and a

network of young artists. What do you do with that? And we thought, we grow it into a school. So, we started inviting different artists and educators to dinner to try to suss out what an art school should be, an educational philosophy.'

This philosophy foregrounded a few things. First, it should be tuition-free. Second, they wanted to make 'freedom itself the organizing principle'. Cameron explains, 'We took inspiration from Joseph Beuys, who famously got fired from the Kunstakademie Düsseldorf because he'd refused to honour the school's entry requirements and let anyone in who'd wanted to come. And we looked at the free school movement and read A. S. Neil, the founder of Summerhill, the first free school, and decided that we would not presuppose any particular curriculum. Rather we would hold open meetings and anyone who showed up could propose courses and vote on whether or not they would be implemented,' he says.

'Wow. That sounds ambitious and complicated and a bit of an organizational nightmare. How did that work out?' I ask.

'Summerhill had the helpful constraint of being a boarding school for youth education. But our students were adults in an urban setting with their own lives to lead,' he explains. 'There was no sense of a boundary that might keep people motivated to work toward the larger promise of the school beyond their own private motivation. Rarely, if ever, was a group of self-selected participants in those open meetings going to shoot down someone else's idea of a class. This meant we were spending resources and energy on things that didn't really have communal demand. And the classes that did garner interest were fairly isolated from one another – they didn't connect to anything we might call a curriculum. So, despite our intentions, in practice we felt a real gulf between how students were involved in the school and the mission of what we were creating. So, the question became do we care more about an absolute anarcho-democratic model, results be damned, or do we want to make a great art school?'

After a few semesters of what Cameron calls 'absolute openness', BHQFU re-emerged as a non-profit. Originally the Foundation was selling work and putting that capital into the school. When BHQFU became a non-profit, it raised money from donors who were also the people collecting the work of BHQF. And while they made efforts to solicit and incorporate student feedback, decision-making ultimately became more centralized. Cameron explains, 'We started hiring our faculty instead of taking all comers. And in making those hiring decisions we had one eye toward an overarching curricular vision, and the other toward diversifying the student body. In its last few years, we selected a small group of resident artists through a rigorous admissions process who were then responsible for leading open-admission courses of their own design. This allowed us to guide the general shape of the curriculum, while still providing a way for anyone who wanted to, to be involved. In one sense, this solved the problem of how to be open and rigorous at the same time. But it didn't answer the question, at least not for me, of how to engender an educational environment where all the students feel that the school itself is what is at stake in their involvement. That would be the gold standard for any school, as far as I'm concerned – that education is an end in itself.'

In terms of classes, BHQFU looked all over for ideas, not just from art schools. 'A lot of our faculty over the years had taught in other places and saw BHQFU as an opportunity to try things that would be a bigger lift at a more staid institution. Just one example, but an early class we did in Philosophy of Film was co-taught by an analytic philosopher and a continental philosopher, while most of the students were filmmakers. Trying to make something like that happen within the bureaucracy of a major academic institution would be a real challenge. But for us, it was quite simple. Because we understood that that sort of inventiveness was the thing we could do really well, we couldn't really look to accredited schools for answers

as to how we would survive as an institution. So, we looked primarily at educational models that in some way leeched off of bigger institutions. That was in some sense what we were doing, after all, by describing BHQFU as an extension of the collective's practice.' One of the central programmes BHQFU looked to 'on a survival/institutional level' was The Whitney Independent Study Program. It's inexpensive to attend, and the strong reputation it has built over the course of its life is in some ways, according to Cameron, 'a de facto form of accreditation without it needing to answer to a governing body outside itself. If I were hiring teaching faculty today, I would certainly look at a candidate coming out of that programme with the same or more weight than I would a graduate from any MFA programme. Of course [though], The Bruce High Quality Foundation was never going to have the same support mechanism as The Whitney. And for a long time, we were pretty reticent about working with other institutions, whether they be museum education departments, accredited schools, or residency programmes, because we really wanted to see if we could make our model sustainable on its own,' he says.

What really bothered Cameron about the MFA was the fact that, by and large, it accepted a structure that put the financial burden on the artist or her family. He explains, 'The two obvious results of this are, one, that the MFA promotes the idea that artists come exclusively from backgrounds of financial means; and two, that making art should be a financially viable career. The first option is terrible because a robust artistic culture needs voices from a lot of different walks of life. And the second option is terrible because it absorbs art entirely into capitalism. I'm not suggesting that people born into wealth shouldn't be artists. And I'm not suggesting that great art can't be made from within the competition-based ideological parameters of capitalism. There is evidence from the Renaissance to Hollywood to prove the contrary. But I can't in good conscience advocate for an art world with such a limited

scope. As contemporary art has come into its own as a financial instrument accessible only to the wealthiest tier of society, it becomes more pressing than ever to protect and defend art on its own terms. And that requires people who are not invested in it for any other reason.'

'But what about financial aid? Schools market this as a way for students without money to be able to attend. Did this not make much of a difference, in your experience?' I ask.

'Selective financial aid is not a solution. Being completely tuition free is not enough [either]. I've taught at Cooper off and on for over a decade, and I've been involved in that school's admission process as well. Recruiting a diverse student body was a big enough challenge even when there was a guarantee of a full-tuition scholarship. The fact is, higher education is largely understood as a means to an end, a requirement on the path toward a viable career. But I don't believe that should be the goal of liberal arts education, much less fine arts education. Especially in the fine arts, I believe education is an end in itself, and that formal education is about helping artists hone the tools of criticality that they can call upon for the rest of their lives, both individually and socially. Financial aid does a disservice to this social aspect of learning because it creates a class division within the student body that makes students question their own merit. A student should have confidence that she is accepted into a school because her particular history and talent is of value to the community of learners she is being invited to participate with. She should not have to ask herself if she is there just to help the school get funding in some way, whether through financial aid or her parents,' he says.

The biggest challenge for BHQFU was funding. On one hand, they wanted the school to have as wide a reach as possible. And at its peak, they had a thousand students coming through in a year and were subsisting on between $300,000 to $400,000 annually. So, at most that's $200 spent per student per semester in the most expensive city in the country. 'For

comparison's sake,' Cameron explains, 'a three-credit course at a college without subsidies is going to cost $3,000 on average nationwide. It's an imperfect comparison for a lot of reasons, but it makes the point: we were trying to do way more than anyone else seemed to believe was possible. And it was this sense of a shared mission that made it possible. It made our students care, it made our faculty care, it made me care – so we could make up for our lack of financial resources with sheer motivation. So definitely the biggest challenge for me, and one I never solved, was creating a sustainable funding model that didn't compromise our mission.'

Cameron says the other challenges were 'the fun part. How do we diversify the student body? How do we get students who aren't paying anything to care about showing up? Those were problems that were energizing to answer, and we were very good at answering them. From my point of view as the director of the programme, I was really challenged by wanting to resolve a desire to make a very rigorous programme that could also answer the obvious need for community among a wide group of artists,' he says.

When I ask Cameron about what he is most proud of at the school, he hesitates. 'It's a hard question because there's a lot of stuff that happened that I think was really special in the way that, if you think about your own educational experience, the best moments are these seemingly small, fleeting things – like a great conversation that stays with you and comes back to affect your work years later. So, I think every student, every faculty member would have a different answer to that question. So perhaps for me, I'd have to locate a point of pride in a structural invention – like when we implemented a programme of resident artists that served as faculty for open admission courses. And then on a more macro and completely unverifiable level, I'm proud that the school has contributed in some way to greater self-reflection on the part of faculty, students and administrators in other programmes. One example, in our

second year of existence, we went on a road trip visiting art schools around the country, meeting with students and faculty and asking them to imagine making their own schools from the ground up. We visited Portland, Oregon toward the end of the tour and we met this artist, Sean Carney, who got inspired to make his own school with a group of friends. He later moved to New York and became an important part of BHQFU, but that was always an important realization to me – that just the idea of the school was enough of a spark to get groups of artists taking matters into their own hands.'

BHQFU's structure, by design, changed almost every semester. They thought of each term as an experiment, and would try fourteen-week courses, split semesters, ten-weeks, and then try to look at what worked better. Consistently, classes were held at night or on the weekends to accommodate the fact that people have jobs. In their first location, a space in Tribeca, they were only a classroom and an office. 'This of course meant a heavy emphasis on dialogical learning, since we couldn't accommodate direct studio-based learning,' Cameron says. In the second iteration, they split the school between two spaces in the East Village. In the fall and spring, one space was dedicated to classes, while the other was used as a combination classroom and public gallery. In the summers, both sites were turned into studio spaces for a residency pro-gramme. In its final iteration, they moved the whole school out to the Bruce High Quality Foundation studio in Industry City, where the collective has a very large space. They'd hesitated to move out to Brooklyn for fear of a big drop-off in attend-ance, so their initial programme was a series of one-off lectures meant to get students comfortable with the commute. Then they were able to accommodate studios for resident artists, a classroom space and an exhibition and events programme. The last iteration replicated this studio/resident faculty model in Miami, with an exchange component between the two cities. This kind of exchange programme was something

19. Koenig Books, Frieze Art Fair, 2011.

20. Jarrett Earnest with artworks by Christy Gast in Amenia, New York, 2019. (Works left to right: *Alpine Butterfly*, 2018; *Sappho Arboretum Grid*, 2018)

21. Massimiliano Gioni (right of group, with hand extended) at an art exhibition in Milan, 2017.

22. Omar Kholeif at the opening of the exhibition 'Subversion' at Cornerhouse, Manchester, 2012.

23. Koyo Kouoh at the closing ceremony of the 69th Berlin International Film Festival, Berlinale Palace, 2019.

24. Ralph Rugoff, Venice, 2019.

25. Historic palaces along the Grand Canal, Venice, during the Biennale, 2019.

26. Rujeko Hockley and Jane Panetta at the Whitney Museum of American Art, New York, 2017.

27. Whitney Museum of American Art, New York, view from Gansevoort Street, 2015.

28. Marta Gnyp in her Berlin office, 2019.

29. Sabrina Buell and Mary Zlot, 2015.

30. Woman engaging with *Lunatick*, 2019, a virtual reality artwork by Antony Gormley and Dr. Priyamvada Natarajan.

31. Steven Henry Madoff in the curatorial space of the School of Visual Arts, New York, 2017.

32. Students and guest speakers at Bruce High Quality Foundation University, New York, 2016.

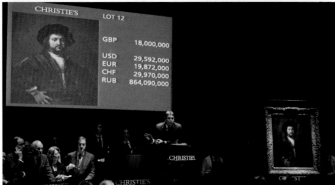

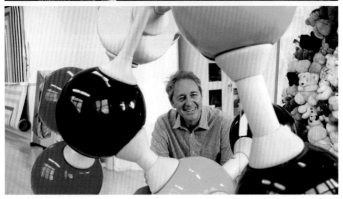

33. Sara Friedlander at Christie's, New York, 2017.

34. Christie's auctioneer James Bruce-Gardyne running the bidding during the sale of Rembrandt's *Portrait of a Man with Arms Akimbo*, King Street showroom, London, 2009.

35. Christian Scheidemann, 2015.

36. Michele Marincola and M.A. student Zhuxi Wang conducting XRF analysis to characterize the pigments of the Portrait of Charles VII by Jean Perréal in the collection of the Conservation Center of the Institute of Fine Arts, New York University, 2016.

37. Crozier Fine Arts, New York, 2017.

38. UOVO flagship storage facility, Long Island City, New York, 2017.

39. Art handlers holding Amedeo Modigliani's *Jeune femme à la rose* at Christie's, London, during a press preview for Christie's Impressionist & Modern Art Evening Sale, New York, 2016.

they were looking to do in other cities as well, before they decided to close.

One thing Cameron hasn't really mentioned is the lack of studio instruction and studios themselves, around which an art school generally revolves. I wonder how they managed this aspect. 'As I mentioned, for most of our history we didn't have a studio component,' he says. 'But it was something we felt strongly about doing and we were able to do in a limited way in the last few years of the school. Beginning while we were in the East Village, we had a summer programme for five to eight people that provided studio space. And then in Industry City we redesigned the programme around five artists who each had a studio space on site. So, they were producing work and having critiques with each other while also developing courses for a few hundred other artists who would just come for class.'

'OK. But I guess from my point of view, it seems like if you ever really wanted to be taken as a serious alternative to MFA programmes, you would need the studio aspect, right?' I ask.

'Yes,' he says. 'The growth plan was very much focused on studios, but also intra-city exchange. That was where we saw real potential for a new model. But it was highly contingent on finding partnerships. To pull it off was going to require a much more significant restructuring of how we worked and a lot of advanced groundwork we hadn't done. That fact, combined with the realization that our fundraising model wasn't reliable year-to-year, were among the practical reasons for shutting down. By this point we'd moved far away from the anarchic clubhouse model of its earliest days, and it seemed ultimately better to bracket the school's history there and let something new emerge.'

'So BHQFU closed. I assume you would have encouraged people to go there instead of an MFA while it was open. But now that it is no longer an option, what do you say to them?' I ask.

'Even while it was open, I didn't necessarily discourage artists from pursuing MFAs on a case-by-case basis,' Cameron

says. 'I did then, and still do, write recommendations for people on occasion. BHQFU was proposing a possible future, but we certainly never became a complete answer. So, I ask students what they can afford and what they hope to get from the experience. And if, for example, the student isn't going to go into debt and just really wants to study with this or that professor, then I encourage them to go for it. But if an artist is going to take on tremendous debt in the hopes that an MFA will launch a market career or get them a full-time teaching job, then I tell them not to do it. That much is simple math. And for artists who are just looking for a critical community and can afford to not work consistently, I recommend various residency programmes. For everyone else, which is most everybody, I tell them exactly what I told them when BHQFU existed: that they're going to have to make it for themselves.'

Art Online

Since the late 1990s, in parallel with so many aspects of the modern world moving online, there has been a consistent and well-funded effort to bring the art world in all its aspects – museums, galleries, auction houses, artists, buying and selling and education – there as well. Today, after a little more than two decades, the internet offers a plethora of ways to engage with art in the virtual world.

For example, you are now able to see images of millions of the world's most famous – and most niche – artworks on sites like the Google Art Project, which includes digital images from the collections of over 1,600 museums. Or just load up Instagram, where you will find an up-to-the-minute stream of the most-discussed works in the world of contemporary art. You can buy and sell artworks online through international gallery or auction house websites such as those of Gagosian Gallery, Christie's or eBay. There are endless ways for people to learn online about art, from scholarly or fact-checked resources, such as museum websites or art magazines, to user-generated content on social media apps like Facebook or, again, Instagram. The art world's increasingly online nature in the last ten years and this growth of adoption has been spurred by a number of factors, principal among them the mass use of smartphones, the birth and rise of social media, the ubiquity of mobile data plans and Wi-Fi, and the increased wealth of the highest echelons of the world economy who are interested in and buy art.

Yet amidst all of this development of the online art world, some aspects of art are still not online – and may never be. For

one, not all art can be bought online. Above a certain price point, galleries often do not feel comfortable offering works online or selling them. Their most coveted works frequently have waiting lists, and they want to thoroughly vet collectors to make sure a piece is going to the right collection (ideally, en route to a museum collection). Secondly, for some great contemporary artworks or iconic historical works there are only low-resolution images available online – not useful for sharing or reposting or studying – due to copyright concerns, and also debatable concerns that if a high-resolution image were to be put online then the artwork itself could be copied. Furthermore, scholars cannot undertake all of their research online. Many art books are not available online due to image copyright restrictions, art book formats (as art books are usually not pocket paperback size) and the fact of the content and age of the books; old art books have not been the top priorities for digital scanning projects such as Google Books.

Most importantly, as purists and conservatives love to note – and have noted since the birth of photography – viewing art digitally does not capture the physical experience of seeing a work in person. Some advances have been made in this area; Google took its Street View technology into museums to try to recreate the experience of being in a museum's galleries and seeing artworks in their actual contexts – rather than as squares and rectangles floating in space – online. The increased resolution of photography and accessibility of video to anyone with a smartphone has made it possible to create highly 'zoomable' artworks that show details even the human eye cannot see, or to provide video experiences of three-dimensional works such as sculptures and installations, limited only by the time someone wants to spend filming all the angles. New augmented reality applications generate images of two-dimensional artworks scaled down or up to any environment you find yourself in, to help you envision what artworks will look like installed in real life. (This is something Artsy introduced recently.)

At present, virtual reality companies offer some of the most promising projects aimed at bringing more qualities of art to a digital space.

———

My view of art online has been strongly shaped and influenced by the fact that I spent over eight years working at Artsy, which is considered one of the art world's most influential online platforms. Artsy is both a website (artsy.net) and an iPhone app used for collecting and discovering art. Its stated mission is 'to expand the art market to support more artists and art in the world'.

In the tradition of other American start-up origin stories like that of Facebook, where an enterprising and ambitious young person identifies a need for something and then builds it in their dorm room, Artsy started out as an idea in the head (and then the dorm room) of Princeton University student Carter Cleveland. Born and raised in New York City, Washington, DC and London, Cleveland was a computer science major with an interest in art history (his father was an art writer and collector). He wanted to put original art on his dorm room walls rather than posters, but he couldn't find a place on the web to connect with younger artists to buy their work in order to make this a reality. So Cleveland built a website called Exhibytes, which he intended as a social platform for young artists. He thought artists would post their work there and use the site to socially network (as the creative community uses Facebook and Instagram today), and in doing so provide an opportunity for people to buy their work online. It would be a great replacement for the posters he didn't want to have, and would serve as an accessible way to connect with young artists.

Unfortunately, Exhibytes didn't work out so well. The upside was that the idea was good enough for Cleveland to win some business grant award money from Princeton to develop it, but the downside was that artists didn't use the site. Most

importantly, it seemed artists didn't want to socially network there as they had on Facebook and other platforms.

Like any talented entrepreneur, Cleveland digested this feedback and data and then pivoted. He became interested in the idea of developing a 'genome' for art, based on what the music website (and now app) Pandora had done with its Music Genome Project. His thinking was that this could be an exciting and new way for people to engage with art: users would be able to, as on Pandora's site, key in the name of an artist they knew, and get tailored recommendations. In so doing they would expand their knowledge of art, and eventually they might even buy something. It had the potential to be an ideal combination of art education and collecting, and it promised something that really didn't exist in the art world – because at the time, searching online for art and getting intelligent recommendations was quite difficult. Google searches could only bring up artists' names and movements; quality control was poor, and the images were not consistently good. Museum websites offered only limited search capabilities. And there was no one-stop shop for the world's art – art existed all over the internet, on gallery and museum websites, but nothing knitted them together. The existing resources for aggregating art worked only on historical art or contemporary art, never bringing the two into one space.

With this idea of an art genome in mind, Cleveland reached out to Pandora's CEO, Joe Kennedy (who was also a Princeton computer science alum), and asked if there was any issue with him pursuing it. Kennedy gave his blessing, and so Cleveland began developing what would eventually become Artsy. He tried to buy the domain Artsy.com, but the price was too high, so instead he picked Art.sy. At that time, site names divided by dots were in vogue; more importantly, it gave the site the shortest possible domain name with 'art' in it. Art.sy, like Pandora, was 'powered by The Art Genome Project' (from now on, for clarity's sake, I'll refer to the site as Artsy or Artsy.net, as the period was dropped and the .net extension secured in 2012).[68]

I came to Artsy serendipitously at the beginning of 2011, about a year before the site had launched. At that stage, it was just a splash page showing the name 'Artsy' and a stock photograph of a bowl with blue paint in it. I was in the process of looking for a full-time academic position teaching contemporary art (as I had just completed my PhD), and in the meantime I was working whatever part-time jobs I could get. Most of them were based on past positions I had held before and during my PhD. One was writing press releases for Gagosian Gallery; another was working on a chronology for an Ellsworth Kelly book that was being organized by Matthew Marks Gallery; yet another was working on various catalogue essays.

Someone at Gagosian had told me about seeing a job listing for 'Director of The Art Genome Project' at Artsy on the New York Foundation for the Arts (NYFA) website, a popular place for people to look for jobs in the New York art world. It had sounded intriguing and strange enough to prompt me to send in my resume, but I'd heard nothing back. Then, a few days later, Cristin Tierney, an art consultant and gallerist with whom I'd had my first teaching assistant position during graduate school, emailed me to ask if I would be interested in the position – with no knowledge that I already seen it or applied for it. She told me she had been working in a part-time capacity as a kind of art-historical backboard for Artsy and for the Genome Project, but could no longer manage it alongside her growing gallery commitments. When I said I was interested Tierney e-introduced me to Cleveland as well as to Sebastian Cwilich, who had become the COO. After a five-hour interview and a few other conversations, I was taken on as a two-day-a-week director.

I was attracted by Cleveland's charisma and passion and Cwilich's experience and vision. Cwilich had graduated from Columbia, where he majored in literature and math; he had then worked at Bell Labs, and later built up the private sales division at Christie's – after creating his own start-up and

selling it during the late 1990s tech boom. Both Cleveland and Cwilich saw Artsy as becoming the major online platform for art, in a landscape where they believed it would be a winner-take-all-scenario. They stressed the fact that Gagosian and Pace, two of the largest and most influential galleries in the world, had just decided to partner with them to upload their works to the site, and Artsy listed among its investors and advisors people like Peter Thiel, Jack Dorsey, Eric Schmidt, Alexis Ohanian, Dasha Zhukova, Wendi Murdoch, Thrive Capital (led by Josh Kushner, brother of Jared), and Larry Gagosian. Cwilich made the point that even if for some reason this all didn't work out, or I wanted to try something else, Artsy would probably not be the worst network to have joined.

For the next four years, as director of The Art Genome Project, I led a team of people to create a genome for art. The project (we internally referred to it as TAGP) was initially inspired by Pandora's processes. These were to create a list of possible attributes for pieces of music – such as genre, beats per minute, vocals; basically anything you could think of to describe music – and then go through musical pieces and rate them for these attributes, so when you were done you would be creating a list of attributes ('genes') for each piece of music that would comprise something like its 'genome'. There would also be genomes created for each musician, apart from their individual songs, since a general search for The Beatles should bring up the diversity of what they produced, an aggregate sense of who they are; but each song could be given quite different genomes to account for their differences. Also, for Pandora, genes were importantly not tags, or things that are binary (you are either tagged in a photo or not; you are either tagging a location or not) but could be given strengths from 0 to 100, to rate the strength of the connection of the gene to the musical piece. This range allowed for a significant amount of nuance and a much more detailed way to connect musical pieces with each other, which was important over time, especially as their

database got bigger. What this data set worked out to for the user was that through an algorithm on the back end of the site that located similar genomes, they were able to (on the front end) be recommended an artist or a piece of music based on whatever they input into Pandora's website, and learn about new music even if what they knew themselves was quite limited.

At Artsy, we took an approach similar to Pandora's.[69] We created a list of all the attributes that you could apply to art (for *all* art, but in practice it was much more tilted to contemporary art, reflecting the focus of the site); and then we spent a great deal of time applying these terms to the site's artists and artworks, whose numbers started to rapidly increase as we established relationships with galleries, museums and image rights societies. (Importantly, all of the images we posted to the site were used with permission, not 'scraped' from the web.) As with Pandora's technology, we were able to provide nuance to the genes and not just tag artworks. This allowed for simultaneous similarities to happen – something could have many connections at once. When you searched for an artist, you were given a list of multiple artists – not just one; the same thing happened with artworks, and these lists presented a range of ways in which art and artists might be similar, from formal characteristics to more conceptual qualities.

Because we personally were creating recommendations for potentially millions of people around the world, we consistently acknowledged the subjectivity of the project. We knew that another group working in the same way might have created an altogether different genome; and we knew that the project might have been undertaken in a different way a few years earlier or later. But we had confidence in our art-historical and art world expertise. The overriding concept was that this would be a jumping-off point for learning about art, aimed more at the wider public than at experts (who might have taken issue with our user-friendly presentation of quite sophisticated art-historical connections).

When I started at Artsy, the number of genes was in the twenties and there were people with somewhat limited art-historical knowledge running the project. After I started, the numbers grew quickly into hundreds of terms encompassing things like art-historical movements, formal qualities, concepts, places an artist had lived or worked – and what we decided to call 'contemporary tendencies', or soft groupings in contemporary art that we were hesitant to define as more formal movements. We also brought more and more people onto the team who had the breadth of knowledge and the skill set to do the hard work of genoming day in and day out, making the endless edits that needed to be made to the genomes as we invented new genes, decided others were not working so well, and critiqued our own genoming through a review process.

At first, I asked Cwilich (to whom I reported) not to tell anyone in the art world I was working at Artsy. Because I was set on an academic career, I was worried about being perceived as a sell-out, or being labelled 'too commercial' for an academic role. At the same time, I was enjoying growing our terminology list and creating what would be the first large-scale search recommendation technology for art. I felt it was more exciting than any academic art project I was aware of – and much more collaborative than anything I had experienced in a highly individualistic academic environment. Before Artsy, the search capabilities for art online were quite limited. On most art websites (primarily those of museums), you could only search for things like artist, medium, technique, date, subject matter and tags; Artsy would change all of this drastically. (At the time of writing, it still remains the only dynamic search system for art in existence: the basic search fields mentioned above are still the only ways to navigate most museum websites with tens of thousands of works.) I sensed that the other people I was able to work with at the company – who had studied art history and worked in galleries, or were from art graduate schools, and who

saw Artsy as a rare opportunity to break free of academia and the museum and build something that potentially millions of people would use – were just as excited as I was.

The Art Genome Project is now just one part of the expansive online platform that Artsy has become; but I, not very objectively, still see it as one of the most fascinating art and technology projects created in the past decade. In addition to my work leading the development of the project, I functioned as an ambassador for Artsy as an educational platform, delivering talks around the country at museum conferences focused on art and technology, as well as arts education conferences. I took part in countless discussions about art online – its past, present and future. After four years, as company projects grew beyond the genome, I was given the opportunity to take on a new role at Artsy, exploring how the company might exist offline. I became curator at large and subsequently head curator, leading and expanding Artsy's real-life programming. This began with conversations with artists – in galleries and museums – before growing to include art exhibitions and installations around the world.

When I started at Artsy, we were about eleven people, crammed into a few tables in a start-up incubator in the Flatiron district. Between 2011 and 2019, the company grew to employ over 200 people, with headquarters in New York and offices in Los Angeles, London, Berlin and Hong Kong. Artsy eventually partnered with galleries to promote and sell work online, with art fairs to list their galleries and artworks, with museums to promote exhibitions and with auction houses to promote and run auctions. It also has its own highly popular magazine and millions of social media followers. One wonders, over the next decade, whether any other online art venture will match Artsy's growth, influence and ambition – and how and in what form Artsy will sustain its place in the art world ecosystem.

I'm falling.

I've been in this state for about fifteen minutes, but it feels like five. I've fallen into an endless hole, and I am slowly descending down into it through a series of dark-red, labyrinthine tunnels. At times they feel like caves. At other times, I feel like I am inside someone's body. There are bright lights surrounding me and at certain moments I see fluttering marks to the left and right of me. There is also music accompanying this descent. Then, suddenly, it ends. I feel bodies moving around me. 'Is this done?' I ask.

I hear 'Yes,' and then I am helped with the process of taking off the device attached to my face: an HTC Vive headset, used for VR films. My eyes refocus on the carpeted floor, which has barriers indicated on it, showing where I should move and not move. I look at the computer rig in front of me. It looks complicated; not really something that could be set up in someone's home.

And then I look up. I see the staff of the London-based organization Acute Art looking back at me with somewhat inquisitive faces. They seem to be half interested in my reaction and half preoccupied with their other responsibilities of the day. The artwork I've just experienced is called *Into Yourself, Fall* and it was created with Acute Art in 2018 by Anish Kapoor, the British artist internationally known for his monumental sculptural works.

Acute Art is, as I write this, the most notable thing happening in VR for the art world, and it represents a sizeable shift in how the art world relates to VR and AR technologies. It is a company that doesn't look to these technologies to better represent artworks that have already been created in real life, but instead seeks to produce digitally immersive works which, most of the time, have no real-life component.

Acute Art was founded by the Swedish art collector Gerard De Geer and his son, Jacob De Geer. It is housed in a sparsely decorated, cream-coloured office in Somerset House, home of the Courtauld Institute and museum, and it overlooks Waterloo

Bridge.[70] The company recently caught my attention because it had attracted a significant art world talent: Daniel Birnbaum. Birnbaum is one of the art world's most respected curators, and he left a prestigious post as the director of Stockholm's Moderna Museet to take on the role of director at Acute Art. The move was quite unexpected, as online projects – even if progressive – are still not considered elite in the art world, and Birnbaum has an impressive pedigree. He was head of the German art academy Städelschule and its associated exhibition space, Portikus, before taking on his role at the Moderna Museet; he was also the curator of the Venice Biennale in 2009, and is a contributing editor for *Artforum*.

While Acute Art is only a few years old and currently consists of an eight-person team supplemented by various freelancers, it has already undertaken projects with major artists: Anish Kapoor, Jeff Koons, Christo, Olafur Eliasson, Marina Abramović, Nathalie Djurberg and Hans Berg, and Antony Gormley. Birnbaum joined the team primarily to lead Acute Art's efforts to lure in other talented artists to work with. Thus far he has found the opportunity to be liberating, particularly in comparison to his past administrative and fundraising work in a museum. He recently explained in an interview, 'For me, it's a move back to where I once began, which is being close to artists.' He is excited to focus on questions like 'What will artists do with these technologies? What can they do? What are their dreams?' He's also interested in what such technologies might mean for making art more accessible. He explains, 'Ideally, digital works will be accessible in the suburbs of Lagos or outside of Zagreb. You won't have to go to Paris to see them. It's not about mass distribution, it's about omnipresence. This could really be art for all.'[71]

While Acute Art is a for-profit company, they seem to have the funding and investment right now to not have to turn a profit anytime soon. Irene Due, their Head of Communications, explains that their focus is not on revenue but on outreach,

attracting new artists and creating great 'content'. And not just any artist will work. Due explains that they focus on artists who can create a VR or AR experience which will only work in VR or AR; if the artist can do it in any other medium, then probably that is best – though she mentions how great she felt Marina Abramović's recent performance work with them was, so it's important to also say that 'there is no set "right" artist for VR projects'.

With time, Due suggests that Acute Art will eventually create a platform for VR they can charge for. She explains, 'We're going to see the technology be easier for people to have and therefore distribution might change. So, for example, something akin to Spotify, which was really a game-changer for music where you have free music online and all the access of music that you wanted. And now there are enough people on Spotify so they can actually charge a premium for you to listen. So, I think that's kind of the way that things are going to move forward for the arts as well.'

Acute Art doesn't have much competition at the moment, so their opportunity appears significant – if they can get people interested in watching VR films made by contemporary artists, whose work (in relation to the wider ecosystem of people producing VR films) is usually rather inaccessible. One competitor in the space is Khora Contemporary, which was also started by a collector. But Khora is more of an online gallery, with an emphasis on sales and dealing art, less of a runway to develop artists, and less well-known artists and curators affiliated with it.

Due agrees that an appropriate comparison with the company might be something like a fabricator, though she also adds that Acute Art see themselves as a research lab, experimental studio or 'technical partner'. She explains their process a bit more. 'The way it works is that we have an initial conversation with the artist. The artist sort of describes what they want to do and then we find ways of creatively producing the work. And we are creative in the technologies we use, so we work

with developers, riggers and 3D animators, who traditionally work to develop games and in the cinema industry. So, we take professionals from those areas and build the teams that will follow the artist projects from beginning to end to support it.'

Proponents of AR and VR projects for the art world see major possibilities in the technology. For one, Eliasson has said such projects are still in their 'Stone Age' period, and there is a huge leap to be made for the technology's capabilities.[72] People also see VR as democratizing art, and Due echoes this. 'Yeah, I think it [is]. Whereas I think a painting, you know, can be a little bit elitist – maybe sometimes you have to understand certain things or certain techniques – I think VR is an experience. It's your experience. It's comparable to a physical experience.'

One issue with VR is that it is, ironically, perceived by some as democratic, even though the costs of the technology are still quite high. Due counters that the technology will get better and cheaper very quickly. She explains, 'For example, HTC is coming out with a new headset in two months that's going to be cordless. Technology moves pretty fast, and it's a matter of, I think, a couple of years maybe – it will be a lot more accessible. It's already a lot more accessible with the Oculus Go. That was an amazing move from Facebook, to have a headset that anyone can buy for two hundred pounds; it's cheaper than a phone.' She also says we can get fixated on this idea of a headset – but soon, VR might not be typically experienced via a headset. Very soon, with the way technology is moving, it may just be glasses.

Due sees VR possibly playing an increasingly important part of our daily lives. 'Maybe that's the route we're going to take,' she says. 'You know, maybe there is going to be this world and then sort of a virtual world and we will just hop from one to the other.' In the face of criticisms of such a world being antisocial – where everyone is in their headsets – she uses the example of Olafur Eliasson's work. 'He has thought of this;

how to make his experience an experience that you can share with everyone. So, within his VR, which is called *Rainbow*, you can be up to thirteen people, so someone in China can be in the same experience as someone in New York.' She explains that other artists are starting to think about this idea of shared experiences in general, and that we will see more ideas like this coming out as VR and AR projects.

Art and technology projects can date very quickly. If they are not made with the latest and most impressive technologies, people tend to stick their noses up at them; and sometimes it seems these projects have much shorter shelf lives than more traditional forms of art such as paintings or sculpture. Yet Due says Acute Art constantly updates their works, so that they keep pace with new technology. The company has also been playing with the idea that the work gets updated like software does. In this scenario, she explains, the first work 'becomes a version one – a little bit how there is Windows Version 94 – and then Windows 97. It still doesn't mean that it's not interesting to see the previous versions, though.'

Maybe Acute Art, or someone else making VR works, will make the form more commonplace in the art world and engage more artists to create what will be considered virtual masterpieces. VR has already been shown to have major potential for use in the military, defence, aeronautics and real estate industries, owing to its ability to create an environment where someone can create and interact with a complex prototype. (Think complex modelling, remote operation, hands-on experiences (such as assembly) and interaction, or realistically conceptualizing complex changes to a physical space without doing it.) Why shouldn't it do the same for the art world?

Yet in the art world, there seem to be so many forces that will get in its way. First, even if the larger culture adopts major new technologies, the art world doesn't always adopt or value them

particularly highly. Film and video have been around since the turn of the century and the 1960s respectively. And other new media, primarily computer-generated, have been created and employed by artists in the past few decades, but all are basically non-existent when it comes to the most valued works in the art world: paintings and sculpture. In other words, for all the talk about 'art for all' and the viability of new mediums, the art market, for value's sake, continually gravitates towards unique paintings and sculptures – and even converts other, supposedly more democratic forms into unique versions. Witness the historical editioning of an unlimited medium – photography – to make it more valuable, just to cite one example.

Secondly, a lot of people (including myself) simply don't like wearing or using VR headsets. You become quite vulnerable in a headset; you are unaware of what's happening around you, and you can't see whether people are nearby or looking at you. It can leave you feeling unsafe; and sometimes you just look plain weird, and become easy fodder for people to poke fun at. At public art fairs, it's been noted that people in their Oculus Rift headsets can end up becoming 'an unwitting spectacle for other fairgoers'.[73]

Some organizations have tried to solve this problem by creating fully darkened one-person experiences for VR projects. There have also often been complaints of nausea or sickness from using the technology, because it is almost too good, too real. Maybe this will change when the technology becomes glasses (as Due suggests), but I feel that with the advancement in size will come an advancement in the sensation of reality, so I wonder if the nausea issues will actually cease or get worse.

And then there is the expense of the technology. Maybe it will get cheaper – but maybe it won't, as we have seen with the development of smartphones. Oculus Rift headsets still cost around $400, and I wonder what Oculus's motivation would be in bringing the price down. This does not include the cost of a PC, which you need to be able to create the experience

and handle the processing power of the device; and then there is the additional cost of displaying VR, which necessitates laying the appropriate wiring, installing a third-person viewing screen and hiring someone to guide visitors in operating the work. Because these things tend to have technical issues, you typically need to hire a dedicated on-site technician to trouble-shoot. (And because all this would just be for one work, there is the related problem that these works can't easily service large crowds.) Finally, to generate graphics or a user experience that come anywhere close to what people are used to from their experiences playing video games takes a lot of time, effort, expertise and money. Video game makers, with their massive followings, might not have much of a problem with this; but it is hard to see art experiences having the same opportunities for investment.

Part IV **Fall**

Art Advisors

Art advisors make a living by helping collectors decide what art they should buy.

Though there are exceptions, advisors are generally not gallerists, showing their own artists; nor are they building up their own collections. They work with collectors only, and privilege their purchases. At the high end of the market, advisors are very important, and few collectors who buy consistently and seek to build collections work without advisors. This is because of the immense complexity of today's art market.

For one, finding the works they want, negotiating the deals they want on them and figuring out variables like shipping, insurance and installation can be complicated for collectors. Because of the pace of gallery shows, fairs and new artists coming to the fore, and the fact that they usually have full-time jobs, collectors increasingly find it impossible to get around the world quickly enough to keep on top of all this – so advisors often travel to artist's studios, exhibitions and fairs on their behalf, becoming their filters, their receivers, their receptors for all the information collectors cannot manage to gather themselves. Advisors may also, depending on the prestige of their collectors, get advance information from galleries about artist availability or upcoming major exhibitions, so they can be the first to buy new work or capitalize on the fact that an artist's value will go up (as it invariably does in the wake of a prestigious museum exhibition). Collectors also need support in dealing with museums that want to show their work in exhibitions.

The most applauded art advisors exhibit a genuine interest in art and its long-term survival. They face the same criticisms as any buyer: they are watched so they do not flip works; and the most respected (and those who tend to be offered first choice of works from galleries) are the ones who help to build significant collections that confirm an artist's place within art history. Such collections are not sold off to auction but, ideally, go to museums. The top advisors usually earn their reputations and build their networks through working with no more than a few important clients, and they are judged on their ability to pick 'winners' – artists who have great potential, both art-historically and financially. Advisors are normally paid either through commissions on sold works, or through retainer fees.

———

I'm now in Paris, at a hotel in the Marais, in a small, intimate courtyard, facing a brown-haired woman wearing a red sweater. Her name is Marta Gnyp. Gnyp, who is Dutch, was born in Poland and is now based in Berlin. She is a highly respected art advisor.

I was drawn to Gnyp initially through *The New York Times*; I kept seeing her quoted about the various machinations of the art world. The media likes Gnyp because of her insights and many talents; she's unusual in that she is not just an advisor but a PhD art historian and an art collector, and in recent years she has become a gallerist. She also has a background in business, which was her first career before getting involved in the art world. Apart from all this she has written a number of books about artists, art and the market, including *The Shift: Art and the Rise to Power of Contemporary Collectors*.

Gnyp feels there are too many art advisors working in the market today. 'I think everybody who has really nothing to say and nothing to offer is an art advisor,' she says, rather bluntly.[74] 'If you want to start into art and you really don't know what to do, you just say, I'm an art advisor. This is how it works today.

So, you have an army of art advisors and from that army of art advisors, probably ten per cent are people who really have something to add. This growth is a very recent phenomenon, and it has to do with the expansion of the art world itself, and the rise of new types of collectors, especially in America. Art advisors are much more common in America than they are in Europe.'

At the same time, Gnyp believes that for people spending large sums of money on art, which she refers to (somewhat pretentiously, I feel) as 'a private investigation of identity', an advisor is essential to help them understand the art, artists and the market. For this level of collector, making such large purchases that have long-term effects on their financial well-being, it is highly advisable to have someone to confer with. When I suggest this is like having a second opinion from a doctor on a diagnosis, she responds by saying it's more like a 'first opinion'.

Gnyp feels this phenomenon of ever-present advisors has been much more noticeable in America than in Europe – the two regions she works in the most. She explains, '[It] has to do with a different idea of collecting in Europe. The idea is still that collecting is something you do yourself. It's your subjective choice, it's your personal taste, and having an art advisor is almost like you are not able to do it yourself. In America it is the opposite. I think having an art advisor is a part of a healthy prestigious domestic wealth environment.' For major old-style European collectors, the idea of art advisors 'is almost hideous because why would someone else bring works to your attention? [The assumption is] why can you not do it yourself?' But with the expansion of the art world, with some 'hundreds of thousands of new and rediscovered artists, which is fierce', she says, 'it's become very important to not do it yourself...So, the art advisor, especially if you have an ambitious collection, makes sense.'

Because of the nature of the advisory business and the potential profits involved, set against the lack of substantial

salaries in the museum world, there has been a recent tendency for museum professionals to advise. In some places this is illegal – such as in the US, because non-profit institutions have rules about doing any type of for-profit service or partnership, and more broadly, what they do is generally considered to be outside of the art market. Yet this type of advising is regularly happening now in Europe, with museums informally incorporating it into their operations. Gnyp explains, 'It is problematic, but museums are solving this problem by saying, okay, whatever I earn as an art advisor, I'm giving it to the museum,' she says. She mentions the Van Gogh museum as a place where this is happening, for one, and that this type of advising is often in the service of museum trustees. 'You will see this very often at art fairs: a museum director with trustees, going through the fair and pointing at works and commenting, this is a good work, this is a good artist. I mean...is [that] not an art advisor?'

Gnyp sees particular advisors in the industry as inspirations for her own work. She mentions Thea Westreich, who was one of the first well-known art advisors and 'has built her company around the classic concept of profound interest in art and long-term relationships with collectors'. She also mentions Simone de Pury, whose name I am surprised to hear because he is an auctioneer. But, she says, he also functions as an art advisor of a different kind. 'If there is an unusual country looking for a high-end art-related event, de Pury would jump on it. He organized, for example, a show of George Condo in Azerbaijan. He mediated a deal between a Swiss collector and Qatar. So, you could say, this is a kind of art advisor who advises without being involved in building collections. Yeah, it's all such a grey area.'

Gnyp began calling herself an art advisor eight years ago, before she had finished her PhD in art history, and says the most difficult thing for her was to actually just admit that she was doing it and be comfortable with the label. She believed

that being a successful art advisor required a reputation and established networks, and she wasn't sure she had either yet. But it was around this time that she began picking artists for people to collect – and then the artists (such as Joan Mitchell, Jack Whitten and Rose Wylie) became increasingly significant – and then people came back to her for more recommendations, so she felt more comfortable with it.

At present, Gnyp works with only a few collectors, mostly in Europe and the USA (naturally, she won't say who they are). She sporadically deals with others internationally. She gets paid by commissions from sold works – typically for advisors, this means 5 to 10 per cent of the sale price. She likes this setup because she finds it more interesting and 'because there is an element of risk and also gambling, and I like that'. She started off getting paid via commission, and it has stuck; but she sees advantages to the retainer model, and notes that she often does things for her clients that she doesn't get paid for.

At the core of any advisor's role is the picking of artist 'winners', and Gnyp dismisses the belief that something like this cannot be explained and analysed. 'There's this idea that art is something you can't grasp, which is, by the way, partially true. But there is also savviness.' For example, she says that there recently had to be some market correction regarding the fact that Abstract Expressionist painters Joan Mitchell and Lee Krasner (Jackson Pollock's wife) were so good but so undervalued, coupled with the rise in collecting of overlooked women artists and the lack of remaining Ab Ex works to collect. 'I bought a fantastic Lee Krasner four years ago for a client and the price is now at least twice as high,' she says. '[Again] it just can't be that Lee Krasner's prices are 1/50 of Jackson Pollock's. I mean, it had to be corrected.' She says that advising is a combination of this kind of analysis of art history and the art market. Yet after all of this, there is then 'a kind of intuition in relation to specific artists and specific works and the art world at large. And there's something which is extremely vague

too, like zeitgeist. I know how cheesy it sounds, but sometimes if you feel that a work responds to the zeitgeist in a very broad sense, then maybe you can also use it to make good decisions.'

We discuss the importance of getting advance information as an advisor. Gnyp says she has to 'listen to all the rumours; the myth of trusting your eyes only – that's completely crap'. Most of these rumours come out of galleries, and she stays close to the galleries, who, she says, are among the art world's most powerful entities. 'Talent and skills are the basic requirements,' she explains. 'But building a career is a complex process; specific galleries, let's say the gatekeepers of the current system, can make a good artist a great artist because they have access to the networks that define the quality of art...You have to be a part of this network, to know who could potentially turn out to be a master.'

Gnyp sees how dependent the flow of information she gets – and then, the access to works – is on the calibre of collector she works with. 'If you really have a top client that is interesting for the gallery, they will be interested to *feed* you; they will treat you well, give you inside information. And for this, you have to be a part of their programme [of events], but you don't have to be at every party,' she says. Discretion is incredibly important for this information. She emphasizes how important it is that, once 'you have the PDFs with prices that are for you, you are not spreading it around or...giving it to anybody else'.

Some people might compare the process of getting information early to insider trading, but Gnyp, as she is familiar with the business world, dismisses that. 'It is not the same as financial markets. We're not in the stock exchange. Art is principally heterogeneous, taste-related and unpredictable. There's always a promise, there is always a potential, but there is never a one hundred per cent guarantee that something will happen with that artist.' We talk about how quickly an artist's prices can jump when they get taken on by one of the top galleries, such as Hauser & Wirth, David Zwirner or Gagosian; but

she says it's important to remember that these galleries 'also have artists in their programmes without stunning careers. So [such representation] has a value, but it is not immediately translatable as with the financial markets.'

Gnyp judges her expertise as an art advisor to be based on her knowledge of art history and the fact that she makes a point of speaking with a lot of people – especially artists. She mentions in particular the importance of speaking with artists who are not trendy and not fashionable, because, she says, in those discussions sometimes lies the root of what is to come. She mentions speaking the previous week with an artist who is following the example of symbolist Arnold Böcklin and Giorgio de Chirico, a forerunner of surrealism; both of whom are currently, in her words, 'completely unfashionable'.

Gnyp is, she acknowledges, 'permanently travelling' for her job. Sometimes she visits multiple places in one week. But she likes it. She says she doesn't have children, and travelling is very easy in Europe, and she sees the plane journeys as a time to read, think and write. Her antidote to the lonely road is to do only three days max, even when she goes to New York or Hong Kong. 'If you travel for a week it's horrible,' she says. 'You have this loneliness of your hotel room.'

Evidence of her busy schedule is this week for her in Paris. She is here for FIAC, but also Paris Internationale, a smaller fair for more emerging artists and galleries, though she says 'my clients are not that keen on emerging artists'. And overall she is trying to see as much as possible. She will stop in at galleries and a few museum shows, including the Franz West and cubism shows at the Centre Pompidou. She will also visit Christie's to see a preview of works which will go up at auction; the auction houses arrange such previews to coincide with the fair. Finally, there are events and dinners for artists and galleries she is close to. She notably does all this alone, without her clients. 'I'm very happy to say my main collectors, they never go to fairs. So, I'm the lucky one. I don't need to go with them

and show the fairs.' She says she finds it good to speak regularly with her clients, to propose works and have 'arguments' about them, but she is relieved not to have to deal with them at fairs.

In advance of this trip – and any trip – Gnyp does a significant amount of preparation, so when she gets to her destination she knows exactly what she is going to see. 'You get all the PDFs [from the galleries] three weeks before [a fair] and you make a selection of what you want to see.' While she uses two assistants to go through all of the information, she has to do a lot of it herself. 'When you're an advisor, a lot is done by you, as clients want to talk to you directly. And there is generally not a lot of volume of work, but significant and specific transactions.' It might sound glamorous that she gets invited to dinners and parties, but she warns that 'after a certain amount of time, you don't really want to go. The paradoxical problem with the dinners or with the parties is, if you are not invited, you wonder whether something is wrong; but if you are invited, you think, geez, what am I doing here, I could do something more constructive with my time. It is definitely part of your job. There are some fantastic dinners, but you are surrounded by many big egos, and especially if you're an art advisor, you're not the biggest ego in the room, which means that you have to manoeuvre between the other people there.' She finds most art events difficult because they have 'nothing to do with content, only social relations. I'm not saying that the art world is appalling – not at all – [but] I think that there is a lot of these, let's say, "encounters", that very much surf on the waves of the art world, that don't really *dive*.'

One of the changes Gnyp sees in the current art world is the rise of a new group of young collectors who 'bring an enormous amount of money and speed into the market'. She mentions Japanese collector Yusaku Maezawa as an example of this new type of collector – and she is particularly struck by his presence on social media. 'He is a role model to the young collectors like Peggy Guggenheim [was] in the past,' she observes, making

the comparison because Guggenheim, a major patron to contemporary avant-garde artists in the mid-20th century, offered a departure from what art patrons, especially in America, had done historically. 'But,' she continues, 'there are plenty of collectors who think what he does is tacky. Why would you photograph yourself with the work that you just bought? But this kind of enthusiasm, the speed of it and the joy of it and this speculative aspect of it, this is very common for a lot of [new] collectors.'

Yet the biggest change she remarks upon is 'the extremely quick trendiness' of the art world today – a phenomenon driven by many factors, but mainly the quantity of art, the number of collectors and the rise of the internet and social media. She comments that artists can now become 'central' to art history more suddenly than ever before: 'Three years ago, people couldn't care less about Kerry James Marshall, and now everybody wants to have Kerry James Marshall.'

As for the future, Gnyp sees the art world moving out of an antiquated sense of itself and its structure, into a realm where the divisions are much more fluid. 'Our current ideology of the art system comes from the 19th century, when art liberated itself from the system of commissions and became principally autonomous. The free artist was from the beginning anti-bourgeois, so there has been a tension between the idea of true art related to culture and the ugly necessity of the art market,' she explains. 'The system was easily structured: the artist makes the work, the gallery that is only interested in culture sells the work to collectors and museums. I think we still prefer to think about the art system using this ideology, even though in reality, the situation has changed completely.' Artists are now professionalized and no longer as loyal as they used to be to galleries, and she finds 'the galleries are no longer interested in art as such, but art as a product around which they build their businesses'. Gnyp predicts that in the future, the galleries' focus on art as product will result in the consolidation of power

of the mega-galleries (such as Gagosian, David Zwirner and Hauser & Wirth) that are now seemingly taking on every aspect of art production, promotion and distribution. Currently they primarily show, market and sell the work, but she sees galleries taking more and more of a role in the production of work, managing contacts with institutions, even organizing curatorial courses and non-profit organizations to support art projects. She sees galleries bolstering even more their already substantial publishing houses, and advising collectors on artists outside of their gallery programmes – which she thinks will probably get formalized at some point too. 'The only thing these big galleries are not doing right now is producing the art themselves.'

———

It's now a few weeks later and I am speaking with two other influential art advisors: Mary Zlot and Sabrina Buell, who are based in San Francisco. Their experiences also offer some insight into the rise and influence of art advising, but just as much into the character of the San Francisco contemporary art collecting community and its challenges and pitfalls. I've known Buell for many years – we worked together at Matthew Marks – while Zlot I have known of for just as long, but do not know well personally.

Zlot is in many ways the go-to art advisor in the Bay Area, a legend in the art community there. She came to art advising accidentally, though, in 1978. She had three young children at the time and was not working, or even planning to work, when a friend got in touch and asked her if she would take on a role at his architectural design studio to help their clients with art. She said that she was interested, as she'd studied art in college and at MA level, but she didn't have any experience with helping people find art – and she didn't even have a resume. But her friend didn't seem to mind and, with regard to the resume, basically said, 'Write one.'[75] Zlot then went to work.

At the studio, Zlot built an art advising service, choosing art for major corporate clients such as IBM for the next ten years. She remembers a few steps she needed to take at that point, including becoming a member of the Association of Professional Art Advisors. 'I applied for membership [and] in those days you had to submit slides of things you'd placed [in art collections] and then they sent somebody out from New York to make sure that [you were] legit.' Zlot says this was the start of the moment when US corporations were building nice offices on a national scale and wanted to acquire art to benefit their employees, as a way to show their value and create a more 'elevated' working environment in a competitive market.

Then the design firm suddenly shut down. 'But everybody left, including me, with all the business,' Zlot explains. That business – particularly Zlot's work with the eminent investment firm KKR, cofounded by Henry Kravis and George Roberts – then became the basis for her to set up her own advisory firm, which she did in 1983. The new firm had two tracks: as well as working with corporate clients, Zlot began to work with individuals. At this point, she says, she felt like she was defining what kind of consultant she wanted to be.

Akin to the way Marta Gnyp has established herself years later, Zlot explains that she 'never worked in a way [where my role would be to pair] the purple painting over the purple couch. Now, people would do that, and they [would] do that really well. But my background was art history and I had done graduate work. I just wasn't the person to work in that way. I really wanted to [support artists], develop collections, [educate] collectors, [and support the community]. And at that same time San Francisco changed because they hired Jack Lane to be the director of [SFMOMA]. He brought in John Caldwell as the curator, [and as a result] this community became internationally recognized.'

Buell, who grew up in San Francisco, knew she wanted to work in the business of art from the time she was fifteen. In

high school, she had to visit a local gallery and write about a work of art for an English free-writing essay, and that experience changed her life. She went to see Stephen Wirtz at his gallery – she remembers walking in and picking a 'random work of art on the wall' and Stephen spending three hours with her, taking every book off the shelf, opening up all the flat files in the gallery 'and just educating' her about this artist. 'He knew I wasn't going to spend any money with him, and it made such a deep impression on me. I thought what a cool job this guy had. That he got to have his own business. That he got to work with artists and be creative and that he also got to be an educator and work with other people to share his passion. And basically, from that day forward, it was like tunnel vision that I wanted to work on the business side of art,' she says.

Buell majored in art history and economics at Stanford and when she left, she wanted to stay in the Bay Area because it felt like an exciting time, with the rise of start-up culture. She quickly homed in on Zlot, who came heavily recommended, as a way to work in the art business. 'I asked if I could be her intern and she said no because she didn't take any interns (due to the high discretion of her business). And so, I just kind of begged, I think, on my hands and knees,' she says. 'She eventually hired me – and it was amazing, because for the first time ever I was just opened up to the enormous international world of galleries and artists, and Mary was just so connected everywhere.' Buell worked with Zlot for a few years, then went to New York to work at Matthew Marks, and eventually returned to San Francisco, first still working for the gallery on the West Coast before formally returning to Zlot as a partner in 2012.

As well as being the most prominent art advisory film in San Francisco, if not on the West Coast, the pair are known for their success in getting tech people to collect art. This has been a real but tough goal for the art world, as Silicon Valley contains millionaires and billionaires with the expendable wealth that makes art collecting on an ambitious scale

possible, but historically there hasn't been much of a value placed on art among this set. While Zlot works with major collectors who are leaders in finance, such as Charles Schwab and George Roberts, Buell works with Kaitlyn and Mike Krieger (the founder of Instagram), Alison and Mark Pincus (the founder of Zynga) and, reportedly, Lucy and Larry Page of Google.

Buell sees her work with this generally younger set – many of whom she knew from Stanford – as they started to have 'their own companies and make their own money but were not so connected to arts and culture' – as a kind of 'civic responsibility'. She explains, 'I saw that this community [I'd grown up in] really needed my generation to get it [i.e., art] if it was going to continue to be [an] important cultural centre in the world'.

Like Gnyp's operation, Zlot Buell is not very big – just eight people. In addition to themselves, they employ three other advisors, an office manager, a registrar who tracks the movement of the many works of art that they are dealing with, and a writer, who helps with their 'public projects and their work with museums'. They notably have no marketing arm – no website, no brochures, no social media – as they never approach clients. People come to them, and it's usually through word of mouth. Their discretion and polish are what has made them really popular and prestigious, driving some of the most influential and important people in the California art world to collect with them.

Zlot and Buell see their work as highly educational. They talk about emphasizing transparency and consistency in the way that they and their clients operate in the art world, which they believe will help the clients establish stronger relationships with the art world's gatekeepers. For example, if their collectors want to sell a work they have purchased, they advise them to make the move of giving the gallerist or dealer they bought it from a right of first refusal. They also push to think about the long term for their clients, and prefer to steer clear of hype or speculative bubbles when it comes to buying or selling work. As such, they encourage clients to buy on the primary

market and try to encourage them – when they are fixated on a 'big brand artist' – to think about someone who is comparable but may be undervalued and lower priced. Additionally, they have never bought work and sold it, they have no inventory and they never directly take money from galleries (as many art advisors do) through discounts while charging their clients full price. All discounts are passed on to clients, so that the client pays the dealer for the work and subsequently pays Zlot and Buell a fee. 'It is totally transparent,' says Zlot.[76]

They encourage their collectors to get involved with museums, whether by donating to them or working with their boards and acquisitions committees. Zlot and Buell also manage their clients' collections – 'every aspect of the main-tenance of their work over time'. This can mean shipping, insurance, museum loans, condition issues, strategy, acces-sions, de-accession – 'you know, *everything*' – 'and a great deal of our clients have more than one residence as well as a busi-ness. So, it is multilayered,' Zlot explains.

She continues, 'We're very discriminating about who we work with. We really work with people who are doing this for the right reasons, who aren't doing this, you know, from a purely investment perspective, who aren't doing this purely from a decorating perspective. We want people who are doing this because they're passionate about art. I want to go on a journey with them, I want them to be engaged. Collectors should be engaged citizens and connected to their local institutions [and] be part of a larger ecosystem of the art world.'

Zlot and Buell currently work with around thirty clients, and they comment that this makes them one of the 'biggest art advisories there are', but then qualify that the number of people they work with doesn't really represent any aspect of the volume or level of business they do. 'Seventy per cent of our clients are probably within California or the Bay Area,' Zlot explains. They're also wary of taking on too many clients, espe-cially in the same area, as one legitimate concern is that they

might have to manage a situation where clients are in competition for the same works.

Like Gnyp, Zlot and Buell mention the importance of acquiring information early as one of the primary competitive advantages an art advisor can have – highlighting the insularity of the upper echelons of the art world. Buell explains, 'We're in touch with every major gallery and every major private dealer and auction house in the world, and all of them are constantly having shows, doing fairs, getting offered secondary works; so people are in touch with us in an overwhelming way. A typical day for us is responding to a number of offers, being on the phone with lots of different people, [and meeting with a prominent international] dealer, a curator or artist [since when they are in San Francisco] we're always the first person that they call...to tell us what they're up to.'

And this information flow doesn't just relate to what's going on now. Zlot says, 'We are very connected to what curators are choosing and showing and thinking about and looking at, and [we know about] shows that are going to happen in three years.' Buell adds, 'It's all about information. We have access to incredible information. We have a wide and very established network, especially because Mary has been doing this for so long that we really are tapped into what the important conversations are.'

Buell says this 'special information' comes in a variety of different forms. One form is getting the word early when a gallery that knows how to take artists 'to the next level' takes on a new artist – due to the fact that you have a strong relationship with the gallery. Another is, based on your relationships with curators and institutions, knowing which artists curators are visiting and whether those artists are going to be included in the next Whitney Biennial or Venice Biennale.

Buell says a lot of her information comes from her posse of curator contacts and other close contacts. 'I have a crew of about six or seven really close curator friends, and we get

together and just start talking and by the end of a two-hour conversation, everything is so distilled about what's going to happen in the next couple of years. And then the other thing is when you are really connected to trustees at various museums around the country...you know what artists they're looking at and what artists they're adding to their collection. That makes a big difference because there's this trickle-down thing where it goes into the collection of a trustee, it ends up being in the collection of the museum, or the curators end up working with those objects in their exhibition. These are all those kinds of insights or things that come truly from having close, trusting relationships that inform the way you move in the market. And then there's also the other kind of specifically market relationships, where you know [someone] who owns something...[and] is selling it at auction or you know the third party that has a vested financial interest in something that's coming up in a sale...or you can get a sense of how many bidders there are going to be; that kind of stuff really will help inform decisions you make about buying things in the public markets. So, in this way, after years and years and the relationships you have built up, you're gaining advance information on what's going on,' Buell says. With all of this access and information, Buell and Zlot admit one of the hardest parts of their job is keeping up. 'Honestly, we get hundreds of previews a day. I don't understand how advisors who don't have a real team doing this 24/7 even stay on top of all the information,' Buell says.

Like Gnyp, Zlot and Buell travel often for their work. Unlike Gnyp, they do this primarily because they want to be with their clients. Art fairs are one of the top priorities for their clients, which they see as necessary for them to attend and especially as a good way for people who don't live in large art centres (like San Francisco) to get exposure to work. Zlot explains, 'We can have seven or eight clients who all want to be at the opening in Basel [in Miami].' They also emphasize the importance of travel

in general to their clients (both to fairs and other events), and term it 'eye mileage'. They even recommend clients not to start buying contemporary art until they have travelled to see what is out there in the art world for at least one year.

Buell explains, 'While San Francisco has really improved in how much you can see in this city, it still doesn't compare to being in a place like New York or London, or even Los Angeles. So, we're always encouraging our clients to travel with us and go see things. Because we have such a big team, we can have people all over the place [to make these trips] and we're always tag-teaming. I just got back from New York. We were both in Pittsburgh for the Carnegie [International exhibition] and then before that for [an] opening at the Guggenheim.'

Zlot explains, 'I want our clients to understand what the artist is thinking. I want them to see more than one piece. I just think, honestly, probably sixty per cent of our job is education. It's about understanding art of our time. It's about understanding art history – and if the client doesn't see these things, you're just a reporter. Our clients are so smart and become so much more educated by doing that, that it makes it so much more rewarding.'

Buell adds, 'And the dialogue that you have in front of a work of art...is pretty important. You end up having reactions and having thoughts and ideas that you share with your clients – or your client shares with you – that I think are invaluable.'

'And sometimes it begins to define their collection,' says Zlot.

At the same time, even though fairs are a top travel priority, Zlot has some reservations about them. 'There's an awful lot of [them now]...When I started, there was Basel [in Basel] and then Chicago, and now we are all over the world. I feel like there's too many, personally, and I think it really is hard for gallerists to get really great work all the time because I think their artists can't produce quality work that fast and in those numbers. So, I think it's a detriment actually.'

Apart from their management of travel and the information they impart to their clients, Zlot and Buell also have to manage and discuss (and sometimes debate) the information clients manage to get on their own, which is a major change from just a decade ago. Zlot explains, 'Our clients can [now easily] look up auction prices. It used to be we'd buy these great big books [which had] the compilation of the previous year's auctions. It was gigantic. Mayer was the publisher. [And they would be ours.] And that's not true any more. Now our clients can look online [at any time] and get all this information. In a way it's great, because they have a lot more information [than they used to], but in a way [not so great as] they have information without any background. They see [for example] something didn't sell for very much and it should have gone for more...and they don't understand that it's about condition...So many factors [and] nuances [can be] missed.'

Buell adds, 'And building on that, I think with how global everything has become and also because of social media and everything you see on Instagram and everywhere, there are so many more people that are interested in art, and there's also so many more choices that you have. If you're going to start out collecting now, even ten years ago there were fewer galleries, fewer artists, fewer choices you had to make. Now, there's like a billion ways you could go. I think that this has only made the role of an advisor more important and more necessary, because I honestly cannot even imagine how you would begin to navigate this enormous world without having really educated advice.'

'And access,' Zlot adds.

Buell continues, 'In a way, it's really awful because the art world is not fair, you know. I don't like that part of it. The reality is, you may have the same amount of money as one of our clients, but you don't get offered the piece that our clients get offered – and that's because, as an advisor who has

relationships with all the galleries, [the galleries] know that our clients aren't going to buy something and put it up at auction. And they just don't know that about somebody else who walks in and just wants it. So, it isn't fair, but that's kind of the way it works now.'

Chapter 13

Auctions

It's October, and I am back in New York during the fall auctions – one of the most important moments in the international art world calendar. This is the time when major auction houses offer some of the most significant works of modern and contemporary art for sale, for tens if not hundreds of millions of dollars.

Because of sales like these, and particularly the prices that come out of them, auctions attract the attention of a lot of people who may not otherwise be interested in contemporary art. The estimate and eventual purchase prices become front-page news because they seem preposterous to the average person, who would never have access to such money or dream of spending it on a piece of art.

Sotheby's and Christie's are the two largest and most influential auction houses in the world, and it's their sales that command the headlines. Recent triumphs, at the time of writing, have been major paintings by David Hockney and Leonardo da Vinci. Hockney's *Portrait of an Artist (Pool with Two Figures)*, from 1972, sold for $90 million, making him briefly the most expensive living artist. At $450 million, Leonardo's *Salvator Mundi* – which was strategically included in Christie's sale of post-war and contemporary art because of the dominating appeal of the category of new art – became the most expensive work ever to be sold at auction, dwarfing the previous record of $179 million (set in 2015 at Christie's for Picasso's *Women of Algiers*).

Such prices have established auctions as a central institution for the art world, since they allow for the highest prices to be

offered and paid for works of art – better than (almost) all private deals and gallery sales. High auction prices also encourage the owners of other works to consider sending them to auction: people see the successes, and want to enjoy some of their own. Because they publish the estimate and sale price of every work sold at auction, auction houses are also the source of the only consistently recorded artwork values in the art world – this kind of openness is very inconsistently found in the gallery world, despite the ongoing efforts of sites such as Artsy. In a growing community of art buyers, where more and more people want reassurance that they are buying something for an appropriate sum, such transparency is increasingly valuable.

Auctions make money in a few different ways. Historically, when people would consign a work to an auction house to sell, they would pay the house a commission on the resulting sale. This would be calculated on the basis of the item's value. The buyer would also pay what is called a premium to the house, based on a similar sliding scale according to the artwork's value. So the auction house would make money in two ways from each sold lot. Yet because of the competitive nature of the business, with more sales (now happening online too) and auction houses competing against each other to lure in the best lots, houses have occasionally started to charge sellers less of a commission. And on the buyer's side, the auction houses have started taking out their percentage of the buyer's premium and giving it back to the seller – this is called 'an enhanced hammer', and can generally range from 2 to 10 per cent. In recent years it has also become more common to provide the seller with a guarantee that they will receive a certain amount– so if the work does not sell, they still get this amount of money. In exchange for this assurance, the seller agrees that a percentage of the upside above that guarantee will go to the auction house, or be split between the house and an outside third party, which takes on the risk of the guarantee. In this scenario, for example, for a $3–5 million dollar object, if the seller takes a $3 million

guarantee and the object sells for more, the house would get a percentage of the overage above $3 million; and in the case of a third-party guarantor, the percentage would be split between the house and the guarantor. But again, this is only an example, and according to auction house specialists – who rarely (if ever) divulge the specifics of how different sales are organized – every deal is different, and the upside spread varies.

Auction houses have also increasingly built out what are called their private sales departments. In a private sale, a work is consigned to the auction house and then sold to someone without there being an auction for it – much like a straightforward sale from a gallery to a client, or through a private dealer. For auction houses, there are many advantages to private sales. Certain works that are given to the house for the purpose of auction may have only a few potential buyers, or even just one – limiting the possibility of a profitable bidding war. There's also the fact that certain works don't really fit the auction template. This, for one, pertains to works that are too big to be able to fit into an auction showroom. And then there are works that, owing to their lack of a great back story, simply aren't exciting enough to justify a marketing campaign. By handling items like these in a private sale, the auction house is able to make a significant profit while saving money – money that would have been spent on storing, shipping and marketing another auction lot.

One of the major decision-makers involved in Christie's fall sales – and as such, a highly influential person in the world of modern and contemporary art – is Sara Friedlander, who is the International Director, Head of Post-War and Contemporary Art.

I've come to Christie's today to meet with Friedlander and to get some more information about the fall sales – and maybe hear about what might be coming up in the future, if she can share anything with me. Friedlander's career trajectory, which

started in an entry-level role, offers a good picture of what goes on today in a major auction house, from the life cycle of an artwork, to the responsibilities of certain jobs, to the hierarchy of professional roles and the marketing and sourcing of artworks.

Friedlander's first job was cataloguing objects as they came in for sales. She would do this in what Christie's employees call 'the warehouse', which is a space below ground in Christie's Rockefeller Center headquarters – kind of a ground zero for what they do. Almost all of the artwork that goes into auctions is stored in the warehouse. Friedlander tells me that just for the last evening sale, this amounted to over a billion dollars' worth of art.[77] (So picture yourself standing on an art goldmine next time you visit Rockefeller Center.)

Cataloguing is a critical job at an auction house. It's in many respects the start of the auction house's formal relationship with an object. It represents the moment when someone physically takes in an object from a seller, inspects it and records all aspects of its physical appearance. Accurately recording the physical details of a work dramatically affects its value, for better or for worse, and the predominant role of the cataloguer is to miss nothing – because once their work is done, the auction house applies an estimate of what the work could be sold for.

After Christie's catalogues a work, the heads of sales come down to the warehouse and organize what is referred to as a 'hill session'. Friedlander explains the name: 'It used to be that there was…a big ramp in [Christie's] London where you lined [up] all the pictures – and it was like a hill.' The heads of sale then look at the cataloguers' manuscripts – the research and write-ups they have prepared for the artworks – and check everything to make sure that no details are missing. Among other things, they make sure that the condition is accurately presented, that all of the details about an artwork's appearance are included, that the artwork is listed and discussed consistently

with how works by that artist have been represented in the past and that any past auction records are included. (The latter are usually accessed through Artnet's auction record database, which is the most comprehensive online listing for historical auction results and has become a standard resource.) Additionally – if there is one – they check the 'comp', which is shorthand for a comparable work by that artist or another artist that helps strengthen its value (e.g. by showing that it looks like or is in the same grouping as something that has sold well before, or bears a striking resemblance to – or better yet, predates – the work of a better-known artist).

Friedlander did the work of a cataloguer for four years. Then she was promoted to head of the First Open Sale, which was a new kind of slant for the auction house on selling less valuable contemporary works. The head of an auction house sale is the go-to for anyone at Christie's who wants to put something in that sale, and the person who manages the hill session for the sale. The head is also in charge of marketing the sale – sending out imagery to the right people to get them excited about the work, and creating a catalogue that presents the work in the best possible light.

Even though we live in the era of everything being accessible on your mobile device, the auction business still interestingly prioritizes heavily illustrated, expensive printed catalogues for their sales. Potential buyers receive these often hundred-page-long books that include commissioned essays about the works. And auction houses position the works they most want to promote on the cover or in the first few pages. Producing such volumes may seem strange in a world dominated by digital media and screen consumption, but auction houses regard them as essential for marketing works of art. Friedlander explains, 'There's a big segment of the art world that believes that everything should be digital, which I think is relatively ironic given that this whole business is objects, right? We're selling things that people look at physically...and

so you need a book.' And yet, she says, the industry is still strug-gling with the issue. 'Fifty per cent of the people that I talk to say to me, "your catalogues are so beautiful; they're like art history textbooks" and...particularly in markets that are non-Western...the catalogue is like a testament; it validates the work to a degree. And then fifty per cent of the people you talk to say "take me off of your list for the catalogue subscription. They're too big. I don't want them. I look at them online."'

In her role as the head of the First Open Sale, most of Friedlander's time was spent pricing works – and the volume of work seems staggering. She recalls, 'I'd get a hundred emails every day, with lists of things to price. A lot of it was reactive, making sure that things were priced correctly that were already coming into Christie's – and some of it was proactive.' It seems Friedlander was doing a good job of this, as she raised the First Open sales figures at Christie's from four to ten million dollars. 'It was a real growth opportunity,' she says. 'It was interest-ing because it used to be the sale we would just dump into all the lower value things that didn't make it into the day sale... So we'd sell Warhol works on paper with furniture and rugs and Chinese export porcelain.' After about a year, Friedlander was promoted to the head of the afternoon sale, which was sold to her as a significant job change. But she says, 'In a way, it wasn't – I mean, because [looking at] a $2,000 object isn't really that different than looking at a $200,000 object or looking at a $2,000,000 object. You just see what the object is and understand how it fits into the rest of the artist's work, and you see whether it's in good condition and look up the Artnet result.'

At that moment – and like many people who work for years in fast-paced auction house environments – Friedlander real-ized she needed a break. It was time to do something else. She explains, 'I [felt like] I'd been there. I'd done everything I had felt like I could do. I'd started as an administrator answer-ing the phone, and I'd moved to taking over a sale and then

another sale and I was like, "I'm done." And I think that for anyone who really, really loves art at the auction houses, you get a little bit fed up with the volume, with the pressure, with the sort of unending cyclical nature of the business – like it's all about feeding this larger beast of putting product out into the market.' Yet Friedlander's respite from the world of auctions was short-lived. She worked briefly at the esteemed Paula Cooper Gallery, but Christie's then recruited her back to take over the evening sale – and eventually the whole department.

Friedlander's current job is now less about managing a sale than about sourcing works, and making sure what comes in is great. Accordingly, one of her primary responsibilities is seeking out and managing relationships with high-value estates and collections around the world. This gives her an encyclopaedic knowledge of where all the top saleable contemporary artworks are, so she can figure out how Christie's might be able to broker the sale of such works through auctions or private sales – in which she is increasingly involved. She observes that such sales were 'essentially non-existent when I started but [are] now a very important component of, I would say, a hundred per cent of what we do'.

Friedlander spends a lot of her time travelling – 'at least once a week' – in order to identify these available artworks. 'You get on a plane. You go everywhere. You see everything,' she says. But the majority of this travel occurs within the US, because even though her responsibilities have a worldwide reach, she works with colleagues based in Europe and Asia who maintain the connections with collectors there on her behalf.

Friedlander stipulates that she doesn't meet with just any collector – only those who are 'serious'. They're not the people who are buying works that are 'bouncing around from booth to booth, from fair to fair, from auction to auction'. 'I'm interested in the people all over the country who have art on their walls, who've had it *forever*...For me, the big question is, "What is that collection in Milwaukee that has that amazing Ed Ruscha

that they bought directly from Ed thirty years ago?" It's going there twice a year to talk to them about where the market is, and where the buyers are, and it's not necessarily like, you've got to sell, sell, sell right now, but it's a larger conversation. That's really what I do.'

When I ask Friedlander if these people *want* to talk to her – obliquely asking whether or not they seem threatened by her as a salesperson – she laughs. 'That's a good question. I would say that my biggest handicap is that I work at Christie's, so I'm obviously biased, right? I'm not private, but I have this incredible access. So, I would say that yeah, they want to talk to me, yeah.' I get the impression she may have added the second 'yeah' to reassure herself that this is the case.

Friedlander then tells me what her next few weeks look like. On Wednesday she is going to the new Equal Justice Initiative's Legacy Museum and National Memorial for Peace and Justice in Montgomery, Alabama, and in the next month she will be spending a lot of time in Palm Beach, Florida. She says she'll probably go twice and spend about ten days there in total, 'talking to three collectors who have collected for a really long time and want to start thinking about the plan for their collection; what they want to give to their kids, what they might want to donate, what they might want to sell'. She then says that Christie's will be producing a book for the collection.

'A book?' I ask.

'Yes,' she says. She explains this is often done for people who have major collections, and it is part of Christie's relationship-building with them. The books are one-offs created just for the client; they feature professional photography, and often include original essays commissioned on the collection and individual pieces. The way Friedlander describes it, they sound a lot like they are presenting the work as it might be presented in an auction catalogue. To create the book, she will bring a photographer with her to Palm Beach to take pictures of the objects, and she'll also have multiple assistants there to

help her catalogue everything. Friedlander will additionally be identifying which institutions might want certain objects, and will put together a plan for writing potential charitable donation appraisals. Finally, she'll discuss pricing, and will present speculative estimates to the collectors on what the market might look like for their objects today, in two years and in five years. 'Some of [this] is guesswork, but some of [it] is thinking if you're going to do this in [the next] five years, you should sell these things now because the market's very strong now and the market might cool in five years.'

Christie's has a massive database of artworks around the world – insider information that employees accumulate about who owns them, what they have been appraised for and where they are – to make Friedlander's work easier. But to be the best in the auction business, people really have to have the information in their heads. The gallerist Larry Gagosian would supplement this recall with his own photographic database. Stories have been shared of him supposedly walking around people's houses (in their company or not) using a small camera to secretly record what they had. (He would then contact collectors out of the blue, offering them a buyer for a piece that they'd never intended to sell, and then personally profiting from brokering the sale.[78]) Friedlander has a photographic memory, which helps a lot. I ask her if she can walk around someone's house and remember everything in it. 'Pretty much, yeah,' she says, 'and a lot of it for me is *in situ*. So it's like, I know that the Warhol is hanging in the library below the Prouvé and that there's also a first edition of *On the Road*…and a Lalanne monkey, right there…My favourite thing is when I can continue to go back to somebody's house, I know when they've moved something, which is really interesting, right? Like the decision to move the Artschwager from their bedroom into their library,' she says. She doesn't know of other people who have photographic memories in her business, but adds that most talented people, even if they don't technically have

a photographic memory, are pretty good visually. 'They know where things are.'

When I ask Friedlander about her goals for the future, she immediately says, 'Have another baby' – but then, like other top auction people, she has major artwork goals. She tells me there are about five artworks she has had in her head since she started that she'd like to see come to auction, which would be a 'sensation'. Three of them are in America, one of them is in Europe and one is in Japan, but she can't tell me what they are. 'Our competitors would steal the idea,' she tells me. Auction people are also always asked what artists or genres are going to be big next, and they usually answer vaguely but politically. Friedlander responds in character. 'Having done this for a decade or so, you see what ebbs and flows and what feels cheap at one moment and expensive at another moment. What's interesting to me is that the very contemporary – and when I say contemporary, I mean artists making work now – has gotten so expensive on the secondary market. I think we're going to see a pullback from that and we're going to see more mid-career artists that haven't hit those big prices at auction making big money, and also older artists who might have felt [a softening] market...come back. So, for example, you know, Warhol is still pretty cheap when you look at it. [And yes,] it's funny to say an artist like Warhol will make a comeback. If you're talking about markets, someone like Gerhard Richter still feels sort of cheap, in a way. So, if you're asking what contemporary artists are coming, that's a harder question. I mean, I think trend-wise we're seeing a move away from the sort of – what I like to call – minimalist bling of abstraction into more figuration. I think that we're in a moment [where] curatorially we're reconsidering the gaps in art history in...post-war and contemporary [art, and] we'll also see those gaps being filled in at auctions. It's already happening with artists of colour and with women artists. I feel that's sort of an obvious answer, but I'm also a little bit suspicious of [it] because we've seen the

waves of underrepresented artists come and go too. Like in 2007, we had contemporary Chinese art in our evening sales in New York...[but now] Americans have sort of fallen out of buying that to some degree. Look, if I had that answer, I probably would be trading futures or commodities or something like that. It's such a hard question.'

Where does Friedlander go from here, job-wise and hierarchy-wise, given that she has already left the business once? 'Who cares,' she says. 'I don't think the title thing matters. My title is International Director, Head of Post-war and Contemporary Art. Does that job look different when I'm a deputy chairman, or a co-chairman? I think not, actually. And I think that the people who have risen within this company or other auction houses would say the same thing. The job is kind of still the same. Again, the endgame is bringing in business and connecting people with paintings, and in so many ways it's the same job as when I was an administrator answering the phone, like "Post-war and Contemporary, this is Sara, how can I help you?" It's the same gig.'

Conservators

Compared with some other areas of the contemporary art world, art conservation is not widely regarded as exciting. Many people, if asked to picture how an art conservator works, might imagine someone middle-aged, with glasses, in a smock, working on a painting with a tiny brush to make a minuscule fix that no one will ever see. And while Daniel Silva's bestselling series of mystery novels features a conservator, Gabriel Allon, as their main protagonist, being a conservator is only his cover; his more engaging secret life (and the one that sells the books) is as an international Israeli assassin.[79]

Conservation is broadly defined as any effort to maintain the condition of a work of art, or conserve or treat works of art that have been damaged or degraded over time. It attracts the most attention when masterpieces are conserved, or when significant artworks are spectacularly damaged and then treated. The conservation of the Sistine Chapel was worldwide news, and was probably the most hotly debated conservation project of the 20th century. A few years ago, at the Metropolitan Museum of Art, Tullio Lombardo's life-size *Adam* – one of the most important Venetian Renaissance sculptures that exists outside of the city – had to be recreated from hundreds of pieces, after its base collapsed out of nowhere and it crashed onto the Met's floor. Philippe de Montebello, who was the director of the Met at the time of the incident (October 2002), described it as 'about the worst thing that could happen' to a museum.[80] The conservation took twelve years, and the piece was triumphantly placed back on view in 2014. Further back in

time, the 1966 floods in Florence, which threatened more than a million books and almost a thousand paintings, frescoes and sculptures but whose damage was limited by an unprecedented and international conservation effort, attracted global attention as well. Priceless Renaissance artworks were saved by conservators, who set up emergency triage processes to quickly minimize damage.

Another recent high-profile case was that of casino owner Steve Wynn and his debacle with *Le Rêve* – Picasso's 1932 portrait of his mistress, Marie-Thérèse Walter – which Wynn bought in 2001 and sold, in 2006, to the hedge fund icon Steven Cohen for an astounding $135 million. (This was one of the highest prices ever paid for a work of art.) On the eve of shipping the work out to Cohen after the sale, Wynn was showing it off to some friends. Gesturing animatedly as he discussed its provenance, he accidentally stuck his elbow through the painting. His retinitis pigmentosa, an eye disease affecting the peripheral vision, was blamed (versus his negligence), and, as a result of the damage, the sale was called off. But this was not the end of the story. The conservation treatment for what one of Wynn's guests estimated was a 'forty-million-dollar elbow' turned out to be relatively quick and easy. A resale took time, but it was worth it: in 2013 Cohen agreed to purchase the painting (again) for $155 million.[81]

Even better known in the last few years has been the story of Leonardo da Vinci's *Salvator Mundi*. Both before and after sale, this work was a major conservation talking point. It had clearly had a lot of work done on it, based on historical photographs; it was even suggested by some that it had been over-conserved (by the highly respected conservator Dianne Modestini, who was a professor of mine at the Institute of Fine Arts), and that the conservation had made a good painting out of one that was originally not.[82] Thomas Campbell, former director of the Met, stirred up controversy when, after the historic sale, he called

Modestini 'inch for inch...among the most highly valued living artists in the world'.[83]

Conservation has long been a controversial topic for modern and contemporary artists, many of whom have created works with the express intention that they should not last. Pablo Picasso and Georges Braque were opposed to the varnishing of their canvases, because they felt it would ruin the texture they sought to create; Marcel Duchamp likened conservation to the embalming of works of art. And in the 1960s, some conceptual and performance artists – taking Duchamp's ideas to their most extreme form – made works that had no object, or were only meant to exist for a certain period of time. However, in the face of these efforts the art market, collectors and museums continued to place more and more value onto contemporary artworks, and sought to retain their value for as long as possible. So, ironically, alongside the avant-garde effort to make works that are not works or will not last, there has been a parallel effort to enlist the field of conservation – which has itself grown more and more sophisticated – to sustain them.[84]

In the field of contemporary art, Christian Scheidemann is one of the best-known conservators. He has been profiled in various mainstream publications, notably in an extensive *New Yorker* profile called 'The Art Doctor', reflecting his trusted ability to bring to art 'the care, precision and knowledge one expects of a medical doctor'.[85] Scheidemann and his company, Contemporary Conservation Ltd, have become over the last few decades the go-to firm for conserving contemporary art objects and paintings – particularly those that include challenging materials. An understanding of his work is a good introduction to the current state of the field.

The best-known conservation story involving Christian Scheidemann concerns a bag of doughnuts. It highlights what has become one of the most important skills of the best contemporary conservators: the ability to work proactively with

artists, getting involved before works of art are made, to ensure that the materials they use are going to last.

In the late 1980s, the influential American artist Robert Gober – known for his sculptures and installations featuring sinks, body parts and religious iconography – approached Scheidemann to help him with a sculpture he wanted to create. The work would be a meticulous recreation of some doughnuts in a crumpled paper bag, and the title would be *Bag of Donuts*. Gober knew how he would make the bag – out of archival paper – but the challenge for him was that he wanted to use real doughnuts and have them last over time, and not have things happen to the work when they degraded, such as the doughnuts' grease staining the bag.

(To those not involved with contemporary art, this project might sound ridiculous; or at least not up to what one might consider the expected standards of art. In response, someone involved with the contemporary art world might reply that we should understand Gober's work in the context of the history of imagery of food, which goes back as far as painting itself; this work is a 20th-century update on that, as well as a form of hyperrealism incorporating the advances of contemporary technology.)

Scheidemann was excited by the possibility of working with Gober on the project. He started to experiment, using 139 doughnuts that Gober sent to his Hamburg studio. After speaking with another conservator, Scheidemann figured out that the best way to remove the grease was to treat the doughnuts with acetone, the major ingredient in nail polish remover. This was tested in a treatment that spanned four days – and it eventually worked, though the doughnuts became dry and brittle. In response, Scheidemann took the step of injecting the doughnuts with an acrylic resin, which allowed them to maintain their shape. The sculptures were 'finished' with a topping of natural cinnamon, for 'enhanced verisimilitude'.[86] The piece, which was made in an edition of eight, has been a success. Thus

far, the doughnuts have lasted. They've also been embraced, to say the least, by the market. In 2006, one of the editions sold for $240,000 at a Christie's auction, even though the estimate was $60–80,000.

Scheidemann doesn't speak much in detail about what he does, owing to confidentiality agreements with clients. For the same reason, he does not let writers (or anyone who might be inclined to share what they see) into his studio without securing agreements and permissions from the parties that seek out his services: artists, galleries, museums, artist estates and foundations. He has humorously compared his profession to urology: you never talk about urologists publicly, but people need them and heavily value the good ones. At the same time, he believes there are certain things people should know about the business that might not be altogether clear.

First of all, he explains, while conservators' materials, research and treatments are what makes the newspapers, conservators in private practice often spend a great deal of their time writing condition reports for artworks that are going to be re-sold. A condition report is a conservator's honest assessment of the condition of an artwork for the client selling it, so that they can offer it to a buyer with full disclosure of the state it is in. The content of these reports can be highly sensitive, because any indication that a work is in less than perfect condition will have an effect on its value. A client, whether an individual or a gallery, might want a change of wording to make an assessment less extreme; a buyer might be happy about this, but might also want other information included. As such, the process can be 'a technical and diplomatic challenge', according to Scheidemann. Regardless, he says he doesn't feel like he is under a lot of pressure. 'We are independent. We only feel obliged towards the artwork.'

Scheidemann also prioritizes interviewing artists about their work. It might seem strange that a conservator, whose focus is on objects, should want to sit with an artist and speak

with them, but these interviews clarify an artist's intent with regards to their work, and particularly what they would want to happen to an artwork once they are gone. This, according to Scheidemann, is a huge help 'for the benefit and the survival of their artwork'. Not having this information can be quite damaging to an artist's work after they die, for a number of reasons. For one, it's important for artists working with ephemeral materials to clarify whether they want their works preserved or not, and if the answer is yes, how much or what quality of conservation they believe is appropriate. Also, artists are constantly creating works out of new materials and new processes – such as 3D printers. These new inventions consistently pose new challenges for how to 'touch and handle...carry, ship...and store [art]', according to Scheidemann, and without the artist's point of view, irreparable damage can be done to the artwork itself as well as its meaning if it is not preserved or presented in the right way.

One can also clearly see the business value in this, since if an artist passes away, based on this insider information, Scheidemann would be the contact to figure out how to manage any condition issues with their works. While museums generally gather this information when they acquire an artwork – The Whitney conservator Carol Mancusi-Ungaro has led the movement to make this happen, and nowadays it is generally accomplished through a video interview of the artist – it is not systematically done outside of museums.[87] According to Scheidemann, his close connection with artists such as Matthew Barney, Paul McCarthy, Chris Ofili and Gober is one of the most important parts of his job, particularly because 'artists ask [him] the questions nobody else would ask you'.

An artist's point of view is not the whole picture, though. According to another leading figure in the world of conservation, Michele Marincola, Sherman Fairchild Distinguished Professor of Conservation at the Institute of Fine Arts, NYU, the artist's point of view is important, but should not be considered

the entire picture. For one, she points out, it brings up the issue of 'what role should the artist play in the restoration of his or her work? Certainly, consultation and advice [but, if a work gets damaged and they are still alive], do you return the work to the artist for repair or re-fabrication? Will you get back the same work? Or a new one more in keeping with how the artist is working today?'[88] Also, Marincola explains, 'We talk a lot about artistic intention when deciding how to restore a modern work – but *which* intention do we mean? How the artist thought during its making? After it left the studio? After they spoke with a critic? And what happens when an artist changes his or her mind about past work? And should the artists' point of view – if available – always dictate how ephemeral materials are treated? Arguably all artwork is temporary – even if the lifespan is millennia, it is not eternal. But some materials artists work with don't hold their colour or form or integrity for more than a short period of time. What then? In essence, when should we treat a contemporary work of art like we treat an Old Master, where signs of age and change have value, and are retained?'

What this all points to is the fact that, according to Marincola, conservation is generally incorrectly understood as objective and based on scientific methodology. She says, 'Certainly science plays a large role in what we do, but there is no avoiding the reality that art conservation is an act of critical interpretation, and subject to the same biases as other acts of interpretation (like textual translation).' There is also the sense, according to Marincola, 'that our work is reversible. Some of it is for sure – fills and any retouching/inpainting should be able to be taken off – what a terrible thing to leave to the next conservator, if it becomes permanent! But there are many activities in conservation that are irreversible. Cleaning is perhaps the most important – you really can't put the dirt back on.'

Confidentiality issues – such as those I encountered with Scheidemann – are also critical to conservation, according to Marincola, because they stop the field from moving forward.

She explains, 'Here is how confidentiality concerns – and also our fear of criticism, especially irrational criticism from people with poor understanding of the technical challenges of conservation – impinges on conservation practice. It means we have less transparency in the field than we might, at least less public transparency. We are very open within the field – just look at the number of professional conferences each year, internationally, or the numerous online discussion groups that allow conservators to help each [other] around the world. The secrecy and blatant competition between studios of centuries past is gone. This is now a highly collaborative and sharing community. But we learned to be careful with sharing information outside. Technical information has been misinterpreted or taken out of context to prove a point, to the harm of the work of art (and its value). Speaking of value, look at the social media storm over the restoration of the...*Salvator Mundi*,' and she mentions Thomas Campbell's comment about the conservator. 'Properly speaking, that should have been meant as a comment about [the] marketplace value of a particularly rare work of art, and not (as it evidently was) a snide comment on extent of restoration. Yes, the painting is damaged – and there are many paintings in worse condition that we admire today on the walls of museums, to say nothing of fragmentary works from antiquity. I do see this impulse to limit access to conservation information eventually shifting [though] – the expectations of access wrought by the internet puts the pressure on museums to share information, and the benefits of digital humanities are well known and very exciting for scholarship. In addition, if we cannot make conservation and its concerns relevant to society, we risk losing support for what we do. Ours is an expensive practice, in terms of necessary training, time and money, and if the public does not understand why it is important to support the work we do, then support could go elsewhere, where the need and value to society are evident. Fortunately, the field is way ahead of me on this – take

a look at some of the blogs now running that explain conservation to the public,' she says.

One of the most interesting areas of conservation today concerns the management of time-based media art. This type of art is characterized by having a durational element – something like sound, performance, light, or movement – that is dependent on technology and unfolds to the viewer over time, typically via slides, film, video, software or the internet. Christine Frohnert of Bek & Frohnert LLC, a conservation studio she established with Reinhard Bek in 2012, is one of the pathbreaking conservators working with this medium.[89] She is also the coordinator of the first US programme to train conservators in time-based media art conservation, which was established in 2018 at NYU's Institute of Fine Arts Conservation Center.[90]

In her words, Frohnert focuses primarily on making sure 'video works are well integrated in the collection care structure of institutions and private collections', which means making sure video pieces are taken care of and their care is prioritized in art museums or collections. Because of the first part – the care of video works – her studio (or lab) contains a large quantity of electronics and digital forensics equipment used to assess the state of digital files, and probably more often seen in security firms and crime labs. One significant element is a large rack of machines including every type of media player imaginable: VHS, Betacam, Digibeta, Laserdisc, DVD, Blu-ray and so on. Another important item is something she calls a Write Blocker. This device ensures that any work Frohnert does on a digital file will not affect the file itself. She explains that confirming the state or safety of digital pieces only takes up half of her studio's time; the other half is reserved for working on artworks with stronger physical presence, such as kinetic artworks (artworks that have some moving parts) and light-based works. At present her studio contains works by iconic modern and some more recent artists working in this area, including Jean Tinguely (one of the founding figures

of kinetic art), Tom Lloyd, and Nam June Paik, the founder of video art.

One of the biggest challenges of Frohnert's work involves making decisions about when to use new technology to replace some component that has become unavailable in a work of art – for instance, light bulbs of a type that can no longer be sourced. It's always a very painful decision, she says to me. Her generation of conservators is the first to be faced with these decisions, and there is a certain level of discomfort around changing certain components of an artwork. It's undoubtedly true that, come the next decade, someone will question their decisions; but you have to make this choice, she says. Frohnert also struggles with artworks that depend on external factors which are no longer available, such as radio waves, or the analogue broadcast signal (discontinued in 2009 in the US). For example, Jean Tinguely created work using radio waves or radio broadcasts. When the work was made, these were freely available to anyone who wanted to tune in to them; but they no longer exist. How do you put such a work on display, then? Pre-recording compromises the work, but so does leaving it silent. A similar problem affects works that rely on analogue broadcast television signals, or artworks 'crawling' internet data; television technology has gone digital, and there is no guarantee that any online data will continue to be accessible in the future.

Accordingly – while many artists working with current technologies made these works with the understanding that they would not be shown indefinitely – if they are to be shown, the question for Frohnert and others in this field becomes, what are the conditions in which most of these artworks can be appropriately displayed? Frohnert says, 'We need to define the significant properties of an artwork to fully understand what can be changed and what cannot be changed. Therefore, we look at the larger conceptual framework developed for music or theatre theory, to understand the artworks as something

more close to a score. However, there is a very fine line, since the artwork is also anchored in the time of creation by the technology originally used.'

Frohnert sees the present day as a crisis moment for media art. 'I say that a high number of all media art is in unknown condition, and will be lost if not conserved now. It is our generation who has to do this. Otherwise, a very significant amount of the artworks of our time will be lost.'

Chapter 15

Storage, Shipping and Handling

I'm back in Chelsea for the final instalment of this story. It's a freezing fall day and I want to be inside, but the block where I find myself – of looming, converted brick factory buildings alternating with luxury high-rise developments – features hardly any address indicators at street level. Somehow I eventually locate my destination: number 525, the address of Crozier Fine Arts, one of the major art logistics companies in the world. I'm here to talk to them about art storage.

Art storage – the business of making safe and protecting some of the most fragile and important objects in the world – is a rapidly growing field. In the last eight years it has doubled in size, and it now does roughly $1 billion a year in business globally. This has mirrored the expansion of the self-storage industry, at least in the United States, where 8 per cent of all households now have a storage space (up from 3 per cent in 1980).[91] Currently, roughly 80 per cent of all of the world's art is in storage. This might feel like a staggering figure, but it reflects a long-term reality, and the percentage will probably only increase as the contemporary art business continues to expand.

What are the reasons for this? For one, there has always been much more art made than can actually be shown. Museums testify to this; only a small percentage (roughly 2 to 4 per cent) of the collections of most major museums is on show at any given time. Secondly, with the recent boom in art sales and the tendency to view art as an investment, more art than ever before is being bought and held not to show, but to resell – and thus rotated out of visibility.[92] Thirdly, as the risks

posed by global warming and natural disasters increase, artworks are harder to insure if they are not properly protected, and this can mean moving them from a private residence to somewhere more secure. For storage facilities, this has also meant maintaining more than one location, because it is regarded as a liability to keep all of their work in one place. Another factor is that as art fairs grow in number, dealers need more places to store works they plan to show at fairs but will never exhibit (or store) at their galleries; and because there is a tendency towards larger-scale contemporary artworks, many artists are making bigger and bigger paintings, sculptures and installations, which simply take up much more square footage than was previously available. The list goes on. And many high-end art storage facilities can now outfit a room however a dealer or gallery wants it for a client visit, or even an event; so storage can be just as effective a setting for art as a gallery's own space.

———

At Crozier, I'm retrieved moments after I enter the building and am led quickly and efficiently through a series of keycard-protected rooms, hallways and staircases, to the office of the person I came to see: Simon Hornby. Hornby, an affable, tall, pale-skinned British man with short, slightly greying dark brown hair and clear acetate-framed glasses, is the president of Crozier Fine Arts. Historically Crozier has had warehouses in Manhattan, Brooklyn, Newark, Delaware and Connecticut, but recently the company has become global, with nineteen locations in ten different markets. I assume this reflects the growth in opportunities and profits available for art storage, but it probably also has to do with the fact that Iron Mountain, an internationally renowned high-security storage firm, acquired Crozier in 2015. Iron Mountain's substantial resources and real estate holdings have enabled Crozier to be virtually anywhere it wants to be.[93]

I first ask Hornby about the 80 per cent figure for art storage, and he sits back and counters, 'It's probably more like ninety.'[94] According to Hornby, the clients using Crozier's storage facilities break down like this: 30 to 35 per cent of them are private collectors; another 30 to 35 per cent are galleries, dealers and auction houses; and the rest consist of artists, artists' studios, corporate collections and foundations.

And what does the home of 90 per cent of all the world's art look like? Although it houses the most visually engaging objects in the world, it is deliberately and intensely boring. On my tour of the Crozier facility, the 'highlights' are the building's security system: minimal entrances and exits; many locking doors; concentric circles of defence against theft; high-tech ventilation and ducting strategies, to maintain temperature- and climate-controlled spaces; and the large grey metal doors that close off its multitude of its private vaults. These vaults are one option for art storage. Another, generally less expensive, option is buying square footage on one of Crozier's managed or open storage floors, where your artwork will be stored alongside that of many other clients in a specific arrangement suiting Crozier's needs, taking into account size, medium and duration of time the work needs to be stored. These features are basically all that can be witnessed, since none of the art can be seen. This is deliberate; collectors don't want people to know what is in their collections, and nor do dealers.

But even if you were able to get into some of Crozier's private rooms to see the art, you wouldn't really be able to *see* it. Most of it is kept in crates. Hornby explains that exposing art even to the environmental danger posed by people (dirt or germs) can lead to damage, and this is not a risk Crozier is willing to take. 'Museums keep their works exposed because curators want to be able to look at and browse their collections [like scholars might a library], but we believe it's not worth the risk,' he tells me.[95] Depending on a client's contract, I

am told, crates can be opened and artworks can be checked on as much as one would want. But in practice, that doesn't happen often.[96]

So much of the world's art is not just in storage, but in purposefully banal, locked rooms, inside large wooden boxes. When I recently told a friend about this, he said it reminded him of where the Ark of the Covenant was being kept at the end of the Indiana Jones movie *Raiders of the Lost Ark*: in a massive government warehouse full of identical 'TOP SECRET' crates, far away from the world, ostensibly sealed to protect it against the passage of time.

Yet I am told one story, almost accidentally, about how stored art is actually enjoyed at Crozier. During my tour, Tim Valdez, who has helped manage the Crozier facility for over twenty-five years, tells me about one collector client who rents out a 500-square-foot room. According to Valdez, this collector has had the room painted and lit exactly to his specifications – for a single work of art. He visits the facility once a year to see only this piece; he goes into the room, spends a few hours with the work, and then leaves. Then he comes back a year later to do it all over again.

———

A week after my visit to Crozier I find myself in another art storage facility, this time in Long Island City. This facility is a massive and monolithic blue-and-white structure that can be spotted from blocks away, and it is owned by a company called Uovo.

I am here to meet Uovo's CEO, Steve Novenstein, and to explore their flagship facility: 280,000 square feet of immaculate, futuristic space that looks like it could have been built yesterday but is actually three years old. Novenstein has close-cropped hair, wears a jacket and no tie, and while he seems able to entertain a joke here and there, feels all business – and, with his PR person next to him, on message. He also looks

like he could physically wrestle me down; I envision him being someone who does Crossfit.

Uovo is the new kid on the block in the world of art storage, and the brainchild of Novenstein and art collector Steve Guttman. Novenstein and Guttman were real estate partners when Guttman bought a West Village townhouse and was looking to secure some storage space for his art. He wasn't happy with the options that were out there, so he started his own company. The first version was in a Bronx warehouse space in a building Guttman and Novenstein owned, but they soon realized they were on to something, and Uovo was born.

From the beginning, Uovo ('egg' in Italian – an apt and yet slightly fancy name for a storage facility) has been run like a tech start-up. Novenstein speaks to me of their interest in bringing a 'fresh perspective to the industry' and rethinking traditional practices (like, I assume, those of places like Crozier, which bills itself as 'the global leader in fine art storage and logistics'). Before deciding exactly what form Uovo would take, they undertook substantial research into the field and their eventual clients. They asked numerous people and institutions what they would ideally want to see in such a business, and what their biggest frustrations were with their current options. And then, according to Novenstein, they tried to say 'yes' to as many of the asks as possible.

The result is, as their minimalist website explains, an 'elevation' of art storage and services that seems to leave no aspect of the industry untouched. At Uovo – which now has three New York locations, spanning a total of 650,000 square feet – there are 'bespoke private rooms', nicer than most art gallery spaces in the world; 'concierge shared storage', which is a fancy name for the same kind of shared rooms that Crozier provides; wireless security padlocks for private storage spaces; and barcodes on everything, so clients can know exactly where their works are at all times, and can access the information anywhere through a cloud-based online database. This is clearly a highly

branded, top-of-the-line luxury experience – Novenstein says they specifically looked at the high-touch service industry (restaurants, hotels, luxury buildings) as a model – but it's also meant to be a place for people to engage with the work they store there, and often. Novenstein refers to the facility as a 'dynamic hub for clients', and for this reason they created a client cafeteria where visitors can have a meal or a cold brew coffee, or simply sit and work.

While I am very much taken by the cleanliness, organization and beauty of this enterprise, it's an open question for me how much the newness and finish and cutting-edge tech of an art storage facility really matters to the art itself – and how much people will actually use such a space on a day-to-day basis. But I am assured it's often used by gallerists and advisors, some of whom operate out of Uovo exclusively, as well as archivists, whose jobs are centred on working directly with the collections here. They also mention that conservators, photographers, registrars, collection managers and others spend extensive periods here working on projects. On a busy day, there will be a real dynamic community in the cafeteria. Maybe this is actually the future of the art world – that it is aggregated into one pristine, luxurious, incredibly safe building?

The other major parts of art businesses like Uovo and Crozier – contained in Crozier's use of the word 'logistics' – are shipping and installation. Shipping means transporting artworks between dealers, collectors, fairs, museums and any other place an artwork might need to be sent to, or brought back from; installation means doing everything that needs to happen to place an artwork on view, and then eventually to de-install it, getting it out of view and securely packed and stored.

Shipping is arguably just as important as storage. While it is taken care of by many global companies, only a handful are truly trusted by major art world institutions – and it is a

complex business, involving crates, shipping containers, fork-lifts and trucks, vans and planes. In the world of contemporary art, art fairs provide the biggest business opportunity for shipping. Enormous quantities of work are shipped from around the world for a week, and then hopefully shipped off again to buyers. Between fairs, there is still a constant flow of artworks to and from galleries and auction houses: galleries need work shipped from artists to exhibition spaces, or to collectors who have purchased it. Auction houses need works shipped in for sales and then out again to buyers. Shipping is also important for museums, which are always under pressure to show the best and greatest art, and often achieve this by shipping in entire shows from other venues ('travelling' exhibitions) to their own.

The most significant individual involved in storage, shipping and installation is the 'art handler'. Relative to most other art world professionals, art handlers tend to be fairly anonymous – and perhaps they prefer it that way, because if they are remarked upon, it is usually because something has happened to the art they are taking care of. At the same time, their expertise is invaluable to the art world, and great art handlers are a top priority for the institutions that employ them, for their work is one of the key elements enabling the art world to function. It could be argued that without them – almost to the same extent as artists – the art world could not move forward.

Art handlers work in galleries, at museums, for collectors, at storage facilities – and they are sometimes, although not always, artists themselves. An artist might do some art handling as a day job to support their studio and make their own work; but as the art world has grown significantly over the last few decades, art handling has increasingly become a long-term career option.

At the lower end, an art handler might work in a gallery on a part-time basis putting up paintings or photographs, installing sculpture, packing up works that have been sold or maintaining the walls, exhibition surfaces and storage areas. At the higher end, in a major gallery or institution, art handlers are more

likely to be long-term employees who manage highly complex, large-scale sculptural or video installations and operate heavy machinery to get works into exhibition spaces. They are expert logisticians, and during major installations they work long and highly stressful hours to make shows happen. They also have to respond to gallerists' or museum curators' and directors' curatorial choices, which can be unpredictable. It's not uncommon for a curator to tweak a show repeatedly before it opens, which can mean repositioning cumbersome artworks again and again for incredibly nitpicky reasons.

It's during the mesmerizing process of watching a few of these expert art handlers at Uovo move a crate, delicately unpack a painting and then methodically install it in one of the facility's immaculate viewing rooms, that this story – spanning a single year in the world of art, from artists to gallerists, from museum directors to conservators to this moment in a Queens warehouse – concludes. As I stand looking on, I think about how, even after this year of inviting myself into so many people's offices and projects and discussing their struggles and triumphs, my curiosity about the art world is not at all satisfied.

Almost every visit, conversation and effort to record what I've learned has led me to think about all the other topics I could address, the other people I could speak with; how I could ask better questions and tell better stories. And the term 'time capsule' has repeatedly come into my mind. How will this snapshot of the art world look from a distance of five, ten, twenty or even thirty years? I wonder who will still be in their jobs and who will not; what big structural changes will happen to affect how people work; which artists will be fought over and who will be forgotten.

A lot of change will happen, that's inevitable – as it is with everything in life. I hope that I will still be here to observe and discuss it all, and then try to digest it for others; to continue to express my fascination with and curiosity about the world of contemporary art.

Notes

Introduction

1 Henri Neuendorf, 'It's Official, 80% of the Artists in NYC's Top Galleries Are White', *Artnet*, 2 June 2017, https://news.artnet.com/art-world/new-york-galleries-study-979049 (last accessed 11 October 2019).

2 See the study *Diversity of Artists in Major US Museums* by Chad M. Topaz, Bernhard Klingenberg, Daniel Turek, Brianna Heggeseth, Pamela E. Harris, Julie C. Blackwood, C. Ondine Chavoya, Steven Nelson and Kevin M. Murphy, https://arxiv.org/pdf/1812.03899.pdf (last accessed 11 October 2019).

3 Mariët Westermann, Roger Schonfeld and Liam Sweeney, *Art Museum Staff Demographic Survey 2018* (New York, 2019), https://mellon.org/media/filer_public/e5/a3/e5a373f3-697e-41e3-8f17-051587468755/sr-mellon-report-art-museum-staff-demographic-survey-01282019.pdf (last accessed 11 October 2019).

Chapter 1 **A Studio Visit**

4 All quotations from Taryn Simon, unless otherwise noted, are from conversation and correspondence with the author.

5 See Taryn Simon, 'Freedom Row', *The New York Times Magazine*, 26 January 2003.

6 See https://www.artangel.org.uk/project/an-occupation-of-loss/ (last accessed 11 October 2019).

Chapter 2 **Fabricators**

7 This range of pricing was given by Ted Lawson in correspondence with the author, 29 May 2019.

8 Tim Schneider, 'Who Needs Assistants When You Have Robots? Jeff Koons Lays Off Dozens in a Move Toward a Decentralized, Automated Studio Practice' *Artnet*, 17 January 2019, https://news.artnet.com/art-world/jeff-koons-downsizing-1442788 (last accessed 11 October 2019).

9 Allison McNearney, 'Whatever Happened To Jeff Koons' $25m NYC Steam Engine?' *Daily Beast*, 20 May 2017, https://www.thedailybeast.com/whatever-happened-to-jeff-koons-dollar25m-nyc-steam-engine (last accessed 11 October 2019).

Chapter 3 **A Gallery Director**

10 See Magnus Resch, *The Global Art Gallery Report 2016* (London, 2016), pp. 11–12.

11 See *Artnews Top 200 Collectors 2017*; according to their list, 39.5 per cent of their collectors worked in finance. The next-largest category was real estate, at 17 per cent. Available at http://www.artnews.com/top-200-collectors/ (last accessed 11 October 2019).

12 Evan Beard, 'The Four Tribes of Art Collectors', *Artsy*, 22 January 2018, https://www.artsy.net/article/evan-beard-four-tribes-art-collectors (last accessed 11 October 2019).

13 See Clare McAndrew, *The Art Market 2019* (Basel and Zurich, 2018), https://www.artbasel.com/about/initiatives/the-art-market (last accessed 11 October 2019), p. 21.

14 All quotes from Adam Sheffer are from conversation with the author, 21 December 2018.

15 Magnus Resch, *Management of Art Galleries* (Ostfildern, 2014), pp. 29–31.

16 Ibid., p. 40.

17 Ibid., p. 27.

18 Ibid., pp. 19 and 59.

Chapter 4 **Museum Directors**

19 See Roberta Smith, 'Here's How to Rescue a Museum at the Brink', *New York Times*, 7 December 2008, https://www.nytimes.com/2008/12/08/arts/design/08moca.html (last accessed 11 October 2019).

20 See Edward Wyatt and Jori Finkel, 'Soaring in Art, Museum Trips Over Finances', *The New York Times*, 4 December 2008.

21 Ibid. Also see Mike Boehm, 'Jeffrey Deitch Resigns as Head of LA Museum of Contemporary Art', *Los Angeles Times*, 24 July 2013.

22 Wyatt and Finkel, 'Soaring in Art'.

23 Deitch was a curator for a year in Massachusetts at the De Cordova Museum in Lincoln, MA. He also curated several museum exhibitions and contributed to many museum exhibition catalogues. For more on his background, see http://www.deitch.com/about (last accessed 11 October 2019).

24 See Boehm, 'Jeffrey Deitch Resigns'.

25 See Christopher Knight, 'A To-Do List for MOCA's New Director, Klaus Biesenbach', *The Los Angeles Times*, 1 August 2018, https://www.latimes.com/entertainment/arts/la-et-cm-klaus-biesenbach-moca-moma-20180801-story.html (last accessed 11 October 2019).

Chapter 5 **Art Fairs**

26 See McAndrew, *The Art Market 2019*.

27 Anna Brady, with additional reporting by Anny Shaw, Margaret Carrigan and Lisa Movius, 'Fair's Fair? The Murky World of Stand Costs', *The Art Newspaper*, 27 September 2018, https://www.theartnewspaper.com/analysis/fair-s-fair-the-murky-world-of-stand-costs (last accessed 11 October 2019).

28 James Tarmy, 'Art Fairs Are Popping Up Everywhere. Do They Make Any Money?' *Bloomberg*, 6 March 2018, https://www.bloomberg.com/news/articles/2018-03-06/art-fairs-are-popping-up-everywhere-who-profits (last accessed 11 October 2019).

29 Nate Freeman, 'What It Costs Galleries to Go to Art Basel', *Artsy*, 15 June 2018, https://www.artsy.net/article/artsy-editorial-costs-galleries-art-basel (last accessed 11 October 2019).

30 See McAndrew, *The Art Market 2019*.

31 See Tarmy, 'Art Fairs Are Popping Up'.

32 Y-Jean Mun-Delsalle, 'The Art Fair Boom Is Forever Changing the Way the Art Market Does Business', *Forbes*, 7 April 2016, https://www.forbes.com/sites/yjeanmundelsalle/2016/04/07/the-art-fair-boom-is-forever-changing-the-way-the-art-market-does-business (last accessed 11 October 2019).

33 Ted Loos, 'A Worldwide Focus on Hong Kong for Art Basel', *The New York Times*, 26 March 2018, https://www.nytimes.com/2018/03/26/arts/art-basel-hong-kong-asia-market.html (last accessed 11 October 2019).

34 Rachel Cooke, 'Hans Ulrich Obrist: Everything I do is somehow connected to velocity', *The Guardian*, 8 March 2015, https://www.theguardian.com/artanddesign/2015/mar/08/hans-ulrich-obrist-everything-i-do-connected-velocity-interview (last accessed 11 October 2019).

35 Ibid.

36 See 'Artiquette: Mavens and Manners for the Art Collectors of Silicon Valley', *The Economist*, 18 June 2015, https://www.economist.com/books-and-arts/2015/06/18/artiquette (last accessed 11 October 2019).

37 All Hans Ulrich and Jeff Koons quotes from this event are taken from Hans Ulrich Obrist, 'Jeff Koons on His Five Most Ambitious Unrealized Projects', *Artsy*, 2 April 2018, https://www.artsy.net/article/artsy-editorial-jeff-koons-five-ambitious-unrealized-projects (last accessed 11 October 2019).

38 This has catalyzed a number of Obrist's personal curatorial projects, such as an Agency of Unrealized Projects and the exhibition 'Unbuilt Roads', among others.

39 McNearney, 'Whatever Happened...'.

Chapter 6 **Artist Estates**

40 Andrew Russeth, 'With a Focus on the Estates and Legacies of Artists, a New Advisory Opens for Business', *Artnews*, 29 September

2017, http://www.artnews.com/2017/09/29/with-a-focus-on-the-estates-and-legacies-of-artists-a-new-advisory-opens-for-business/ (last accessed 11 October 2019).

For more on this issue, see Mike Scutari, 'A New and Growing Force: Inside the World of Artist-Endowed Foundations', *Inside Philanthropy*, 15 October 2018, https://www.insidephilanthropy.com/home/2018/10/15/a-new-and-growing-force-inside-the-world-of-artist-endowed-foundations (last accessed 11 October 2019).

See Peter Schjeldahl, 'The Bohemian Rhapsody of Peter Hujar', *The New Yorker*, 5 February 2018, https://www.newyorker.com/magazine/2018/02/05/the-bohemian-rhapsody-of-peter-hujar (last accessed 11 October 2019).

According to Stephen Koch. This anecdote and all other quotes from Koch are from conversation and correspondence with the author, 22 September 2018 and 5 March 2019.

Schjeldahl, 'Bohemian Rhapsody'.

This interview is also supported by and includes text from an article Koch wrote about his experience managing Hujar's work, 'The Pictures: Securing Peter Hujar's Place among the Greats', which was published in *Harper's*, May 2018, https://harpers.org/archive/2018/05/the-pictures/ (last accessed 11 October 2019).

Andy Grundberg, 'Review/Photography; Photos by Peter Hujar, A Mapplethorpe Precursor', *The New York Times*, 2 February 1990, https://www.nytimes.com/1990/02/02/arts/review-photography-photos-by-peter-hujar-a-mapplethorpe-precursor.html (last accessed 11 October 2019).

Chapter 7 Art Writers

See 'Authors Guild Survey Shows Drastic 42 Percent Decline in Authors' Earnings in Last Decade', 5 January 2019, https://www.authorsguild.org/industry-advocacy/authors-guild-survey-shows-drastic-42-percent-decline-in-authors-earnings-in-last-decade/ (last accessed 11 October 2019).

48 All quotations unless otherwise noted are from conversation and correspondence with the author, 4 January 2019 and 2 March 2019.

Chapter 8 **Curators**

49 All quotes from Gioni, unless otherwise noted, are from conversation with the author, 11 December 2018.

50 Unless otherwise noted, all quotes from Kholeif are from correspondence with the author, 15 December 2018.

51 All Kouoh quotes, unless otherwise noted, are from conversation with the author, 31 January 2019.

Chapter 9 **Biennials**

52 See Ben Cranfield, 'Is It Time to Call an End to Biennials?' *Apollo Magazine*, 15 September 2018. For an attempt at a full list of all biennials, see 'Directory of Biennials', biennialfoundation.org (last accessed 11 October 2019).

53 Henri Neuendorf, 'Art Demystified: Biennials, Explained', *Artnet News*, 2 June 2016, https://news.artnet.com/exhibitions/art-demystified-biennials-506903 (last accessed 11 October 2019).

54 Henri Neuendorf, 'François Pinault's $8.9 Million Baselitz Spending Spree at Venice Biennale', *Artnet News*, 12 May 2015, https://news.artnet.com/market/francois-pinault-georg-baselitz-venice-biennale-297073 (last accessed 11 October 2019).

55 See Sam Sherman, 'Seeing in a Different Light: A Profile of Ralph Rugoff', *The Brooklyn Rail*, 4 November 2007, https://brooklynrail.org/2007/11/artseen/seeing-in-a-different-light-a-profile-of (last accessed 11 October 2019).

56 All Ralph Rugoff quotations are from conversation with the author, 5 October 2018.

57 Claire Selvin, 'The Year in Protest: From the Met to Chapel Hill to Kochi and Beyond', *Artnews*, 21 December 2018 (last accessed 11 October 2019).

58 For a brief history of the Biennial and its place in the history of

American art see Matthew Israel, 'Six Reasons Why the Whitney Biennial Matters', *Artsy*, 5 March 2014, https://www.artsy.net/article/matthew-six-reasons-why-the-whitney-biennial-matters (last accessed 11 October 2019).

59 Ibid.

60 'The Most Curious Woman in the World: Rujeko Hockley', *M.M.Lafleur*, 31 July 2017, https://mmlafleur.com/most-remarkable-women/rujeko-hockley (last accessed 11 October 2019).

61 See https://stateoftheart.crystalbridges.org/ (last accessed 11 October 2019).

Chapter 10 **Art Schools**

62 See http://www.macp.sva.edu/abouttheprogram (last accessed 11 October 2019).

63 For further examples of other type of programmes, see http://www.collegeart.org/pdf/publications/CAA-directory-art-history.pdf (last accessed 11 October 2019).

64 In other parts of the world and particularly in non-art-world centres, the costs for the MFA are much lower or non-existent.

65 Steven Henry Madoff (ed.), *Art School (Propositions for the 21st Century)* (Cambridge, MA, 2009).

66 Ibid., 'Introduction', x.

67 See Seth Cameron, 'Broken Toilet: BHQFU is Dead', *The Brooklyn Rail*, 17 September 2017, https://brooklynrail.org/2017/09/art/Broken-Toilet-BHQFU-is-Dead (last accessed 11 October 2019).

68 Artsy was first registered in 2009. In April 2011, Artsy renewed the contract for another two years, extending the registration through the end of 2013. Subsequently, as conflict in Syria escalated, the company realized it might not be possible to renew the domain again due to US sanctions. We also did not want a domain that could be construed in any way as supporting the Syrian government. As such, Artsy purchased the Artsy.net domain in 2012 in preparation for a transition later in 2013. But in 2012, after an unprecedented disruption to the website's service,

the company decided to accelerate the transition, and Art.sy changed to Artsy.

Chapter 11 **Art Online**

68 One initial idea was to find a corpus of all of the writing ever done on art, and then locate all of the data in it that would identify certain artists and artworks. Unfortunately, art writing and art history have not been that systematic.

70 All Due quotes, unless otherwise noted, are from conversation and correspondence with the author, 3 October 2018 and 21 March 2019.

71 See Kate Brown, '"This Could Really Be Art for All": Why Daniel Birnbaum Is Leaving His Job as a Museum Director for a Career in VR', *Artnet News*, 10 July 2018, https://news.artnet.com/art-world/acute-art-daniel-birnbaum-1314710 (last accessed 11 October 2019).

72 Ibid.

73 Hettie Judah, 'Is Virtual Reality Art the Real Deal?' *Garage*, 24 January 2018, https://garage.vice.com/en_us/article/gyw7xw/is-virtual-reality-art-the-real-deal (last accessed 11 October 2019).

Chapter 12 **Art Advisors**

74 This quote and all following quotes are from conversation and correspondence with the author, 18 October 2018 and 5 February 2019.

75 All quotes from Mary Zlot and Sabrina Buell are from conversation and correspondence with the author, 5 November 2018 and 5 February 2019.

76 Mary Zlot, correspondence with the author, 22 October 2019.

Chapter 13 **Auctions**

77 Notably, this number is based on the amounts the artwork sold for.

78 For one account of this, see David Segal, 'Pulling Art Sales out of Thinning Air', *New York Times*, 7 March 2009, https://www.nytimes.

com/2009/03/08/business/08larry.html (last accessed 11
October 2019).

Chapter 14 **Conservators**

79 For more on Silva and the series, as well as the conservator Allon is
based on, see e.g. Geoff Edgers, 'Daniel Silva, Best-Selling Mystery
Writer, Has a Secret: The Expert Who Keeps Him True',
The Washington Post, 16 January 2015, https://www.washingtonpost.
com/gdpr-consent/?destination=%2fentertainment%2fmuseums%
2fdaniel-silva-best-selling-mystery-writer-has-a-secret-the-expert-
who-keeps-him-true%2f2015%2f01%2f15%2f63ee0bd8-9a6c-
11e4-a7ee-526210d665b4_story.html%3f (last accessed 11
October 2019).

80 See Carol Vogel, 'Recreating Adam, from Hundreds of Fragments,
after the Fall', *The New York Times*, 8 November 2014, https://www.
nytimes.com/2014/11/09/arts/design/recreating-adam-from-
hundreds-of-fragments-after-the-fall.html (last accessed 11
October 2019).

81 See Nick Paumgarten, 'The $40 Million Elbow', *The New
Yorker*, 23 October 2006, https://www.newyorker.com/
magazine/2006/10/23/the-40-million-elbow (last accessed
11 October 2019).

82 A fascinating website has recently been created to present
Modestini's conservation of *Salvator Mundi*: www.
salvatormundirevisited.com (last accessed 11 October 2019).

83 See Hannah Ellis-Petersen and Mark Brown, 'How *Salvator Mundi*
Became the Most Expensive Painting Ever Sold at Auction', *The
Guardian*, 16 November 2017, https://www.theguardian.com/
artanddesign/2017/nov/16/salvator-mundi-leonardo-da-vinci-most-
expensive-painting-ever-sold-auction (last accessed 11 October
2019).

84 To get a sense of the pathbreaking conferences, research projects
and publications that have shaped the conceptual framework of
contemporary art conservation as a whole, see for example the

symposium *Modern Art: Who Cares?* at https://www.incca.org/events/symposium-modern-art-who-cares-1997 (last accessed 11 October 2019).

85 See Rebecca Mead, 'The Art Doctor', *The New Yorker*, 11 May 2009, https://www.newyorker.com/magazine/2009/05/11/the-art-doctor (last accessed 11 October 2019).

86 The description here is taken from Mead as well as from Scheidemann's conversation and correspondence with the author, 27 June 2018, 3 July 2018 and 4 March 2019.

87 Mancusi-Ungaro's project is called The Artist Documentation Program. See https://www.menil.org/research/adp (last accessed 11 October 2019).

88 All quotes from Michele Marincola are from correspondence with the author, 7 and 8 June 2018 and 3 March 2019.

89 All Frohnert quotes, unless otherwise noted, are from conversation and correspondence with the author, 3 July 2018 and 12 March 2019.

90 For more on this programme, see https://www.nyu.edu/gsas/dept/fineart/conservation/time-based-media.htm (last accessed 11 October 2019).

Chapter 15 Storage, Shipping and Handling

91 See Esther Fung, 'Self-Storage Boom Shows Signs of a Slowdown', *Wall Street Journal*, 11 July 2017, https://www.wsj.com/articles/self-storage-boom-shows-signs-of-a-slowdow-1499811468 (last accessed 11 October 2019).

92 According to the Deloitte Luxembourg and ArtTactic *Art & Finance Report* 2016, 76 per cent of art buyers viewed their acquisitions as investments, compared with 53 per cent in 2012. See report at https://www2.deloitte.com/lu/en/pages/art-finance/articles/art-finance-report.html#.VCVAUhYZUsB (last accessed 11 October 2019).

93 From interview between the author and Simon Hornby at Crozier Fine Arts, New York, 19 October 2017.

94 For 80 per cent figure, see Georgina Adam, 'Where Does All the Art Go After a Fair?', *The Art Newspaper*, 15 June 2017, https://www.

theartnewspaper.com/news/where-does-all-the-art-go-after-a-fair (last accessed 11 October 2019). Quote is from Hornby interview, 19 October 2017.

95 Hornby interview, 19 October 2017.

96 From interview between the author and Tim Valdez at Crozier Fine Arts, New York, 19 October 2017.

Acknowledgments

It takes a village to publish a book. As such, I would like to acknowledge the many people and institutions who helped, directly and indirectly, to support *A Year in the Art World*.

First off, I would like to thank Roger Thorp and Thames & Hudson for taking a chance on this project and encouraging its formal and conceptual growth (in so many ways). At Thames & Hudson, I am also indebted to the often-daily and innumerable efforts of Amber Husain and Kate Edwards to make this book a reality. Special thanks also go out to Angelika Pirkl for all of her help with image rights as well as to Camilla Rockwood for her substantial editing support.

Secondly, I'd like to thank all of the brilliant and talented people who are the content of this book—those generous enough to agree to take time out or their lives and speak to me about their experiences (and offer feedback on various drafts to make the chapters more accurate and insightful). In order of appearance, they are: Taryn Simon, Chris Grant, Ted Lawson, Adam Sheffer, Klaus Biesenbach, Hans Ulrich Obrist, Jeff Koons, Stephen Koch, Jarrett Earnest, Massimiliano Gioni, Omar Kholeif, Koyo Kouoh, Ralph Rugoff, Rujeko Hockley, Jane Panetta, Steven Madoff, Seth Cameron, Irene Due, Isabella Herig, Marta Gnyp, Mary Zlot, Sabina Buell, Sara Friedlander, Christian Scheidemann, Michele Marincola, Christine Frohnert, Simon Hornby, and Steve Novenstein. Behind all of these people are the various institutions and individuals who helped support their involvement. They are, as follows (again, in order of appearance): Sara Douglas at Taryn Simon studio, Standard Sculpture, Prototype, Leah Glimcher at Pace Gallery, Sarah Lloyd Stifler at the Museum of Contemporary Art Los Angeles, Susan Cernek at David Zwirner,

Paul Jackson at the New Museum, Bruce High Quality Foundation University, Artsy, Acute Art, Rebecca Riegelhaupt at Christie's, Milena Sales at Crozier, and Anne Maso at Uovo.

Thirdly, I want to express my gratitude to the amazing editors and writers—Sasha Levine, Alexxa Gotthardt, Scott Indrisek, and Yukiko Yamagata—who read through an early draft of this book and gave me highly valuable feedback.

The support of family and friends can also not be underestimated. To be able to take the time to write a book entails a bedrock of love, support, sacrifices, and well-timed pep talks from others. Among my family and friends, I would first like to thank my wife, Samara Shapiro, and my children Ben and Amina for their love, patience, and support during the many hours it took to research and write this book. Samara, you have been my main champion, confidant, and top advisor at almost every professional step of my life. Your love for me, and the joy and energy you bring to our lives together, make anything seem possible. And Ben and Amina, your love and existence added an energy to my work I could have never anticipated. (Amina, I am also acknowledging Xiuhtezcatl Martinez for you, as promised, because of your belief in climate justice.)

Additionally, I would like to thank my parents Beth and Stephen Israel for their support, enthusiasm, and unwavering belief in me and how I have wanted to live my life. I would like to also thank my brother Jesse Israel, my sister-in-law Karen Israel, my nieces Kate and Emma, my in-laws Alan Shapiro and Priscilla Harmel, my sister-in-laws Michal Shapiro, Ava Shapiro, and Sasha Levine, and my grandmother, Evelyn Winer, and my friends Jesse Krotick, James Foster, Teddy Klein, and

Mary Ellen Obias, for all of their love, encouragement, humor and much-needed writing breaks.

Finally, I would like to acknowledge Robert Storr and Molly Nesbit, the two major forces in my academic life. Molly was the reason I was able to have some of my first experiences in the New York art world, and her lectures at Vassar made me feel contemporary art could be magical. Rob was the ideal mentor for me throughout my PhD, and I cannot thank him enough for his support of my writing and my career.

Credits

1 Graham Carlow, courtesy Frieze

2 Kathy deWitt/Alamy Stock Photo

3 Photo Thilo Frank/Studio Olafur Eliasson, courtesy
ARoS Aarhus Kunstmuseum, Denmark. © Olafur Eliasson

4 Rineke Dijkstra

5 , 6, 7 © Taryn Simon. Image courtesy the artist

8 Photo Naho Kubota. © Taryn Simon. Image courtesy
the artist

9 Esther Ruiz, courtesy Standard Sculpture

10 Photo Gregory Halpern/Magnum Photos. © Ted Lawson,
courtesy the artist

11 A. Astes/Alamy Stock Photo

12 Thomas Loof, courtesy Pace Gallery

13 Shaun Mader/Patrick McMullan/Getty Images

14 Photo Anthony Wallace/AFP/Getty Images. © Jeff Koons,
courtesy Jeff Koons Studio, New York

15 Anthony Wallace/AFP/Getty Images

16 Art Basel

17 Courtesy Pace/MacGill Gallery, New York and Fraenkel Gallery,
San Francisco. © 1987 The Peter Hujar Archive, LLC

18 Bob Peterson/The LIFE Images Collection/Getty Images

19 Polly Braden, courtesy Frieze

20 Photo Christy Gast. © Christy Gast, courtesy the artist

21 Vincenzo Lombardo/Getty Images

22 Courtesy Cornerhouse Manchester

23 Matthias Nareyek/Getty Images

24 Tiziana Fabi/AFP/Getty Images

25 Mauro Carli/Alamy Stock Photo

26 Scott Rudd, courtesy the Whitney Museum of American Art

27 Ed Lederman, courtesy the Whitney Museum of American Art

28 Magnus Pettersson, Courtesy GNYP Art Advisory

29 Justin Buell, courtesy Zlot Buell + Associates

30 Courtesy the artists and Acute Art

31 School of Visual Arts, New York

32 Courtesy Bruce High Quality Foundation University

33 Nicole Craine

34 Carl Court/AFP/Getty Images

35 Delia Müller-Wüsten

36 N.L. Roberts, courtesy The Institute of Fine Arts, New York

37 Tom Powel Imaging, courtesy Crozier Fine Arts

38 Bryan Anselm/The New York Times/Redux/eyevine

39 Ray Tang/Anadolu Agency/Getty Images

Index

Matthew Israel is a curator, writer and Ph.D. art historian based in New York. From 2021 to 2023 he was Commissions Lead at Open Arts at Meta. From 2019 to 2021, he was Co-Founder and Chief Curator of Artful, a company focused on contemporary art travel, and between 2011 and 2019, he was the founding Director of The Art Genome Project at Artsy and later Artsy's Head Curator.

Matthew is the author of three critically acclaimed books on contemporary art: *Kill for Peace: American Artists Against the Vietnam War* (2013), *The Big Picture: Contemporary Art in 10 Works by 10 Artists* (2017) and *A Year in the Art World: An Insider's View* (2020).

www.matthewisrael.com